DREAMSCAPES
Magical Menagerie

Stephanie Pui-Mun Law

IMPACT
CINCINNATI, OHIO
www.impact-books.com

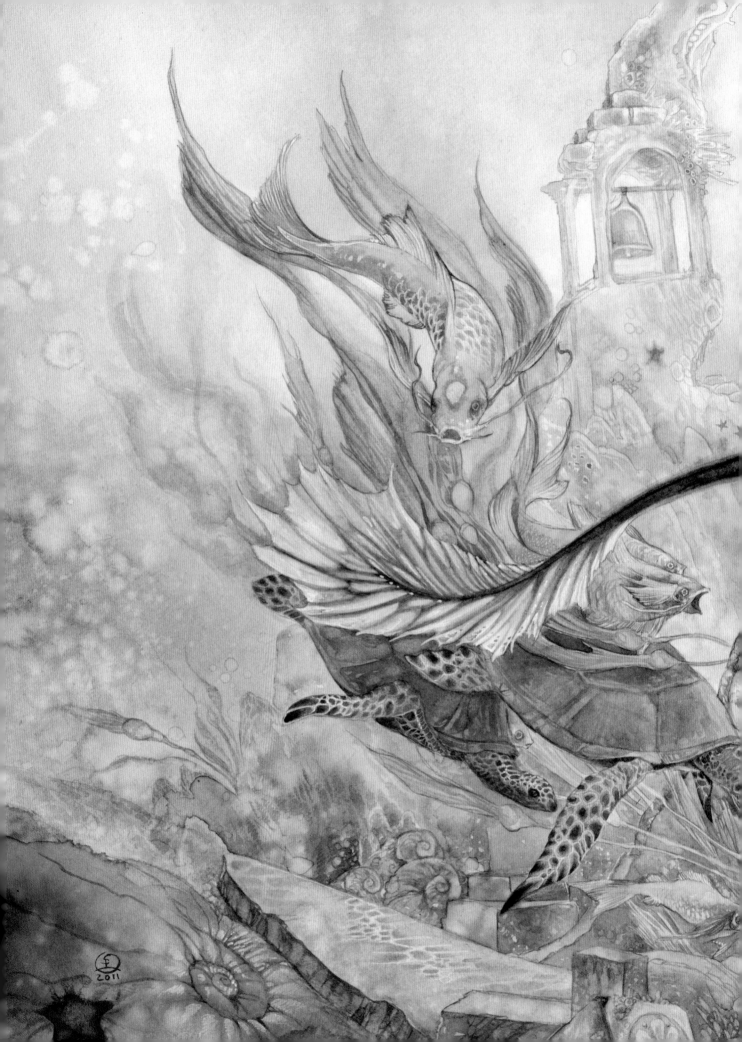

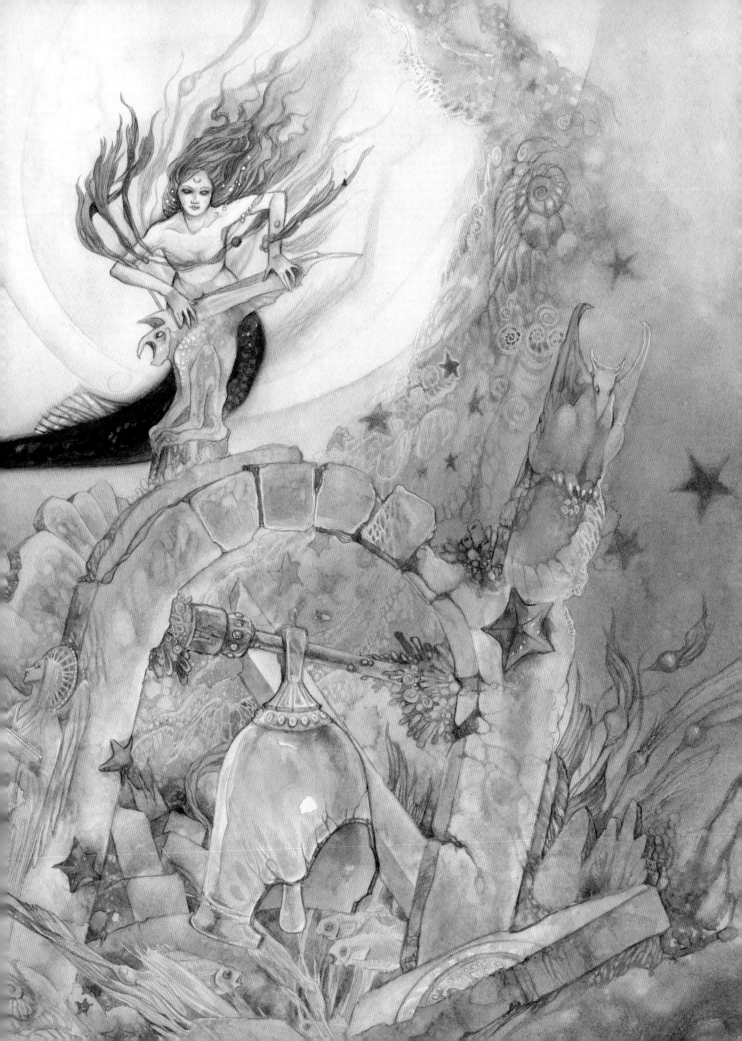

Table of Contents

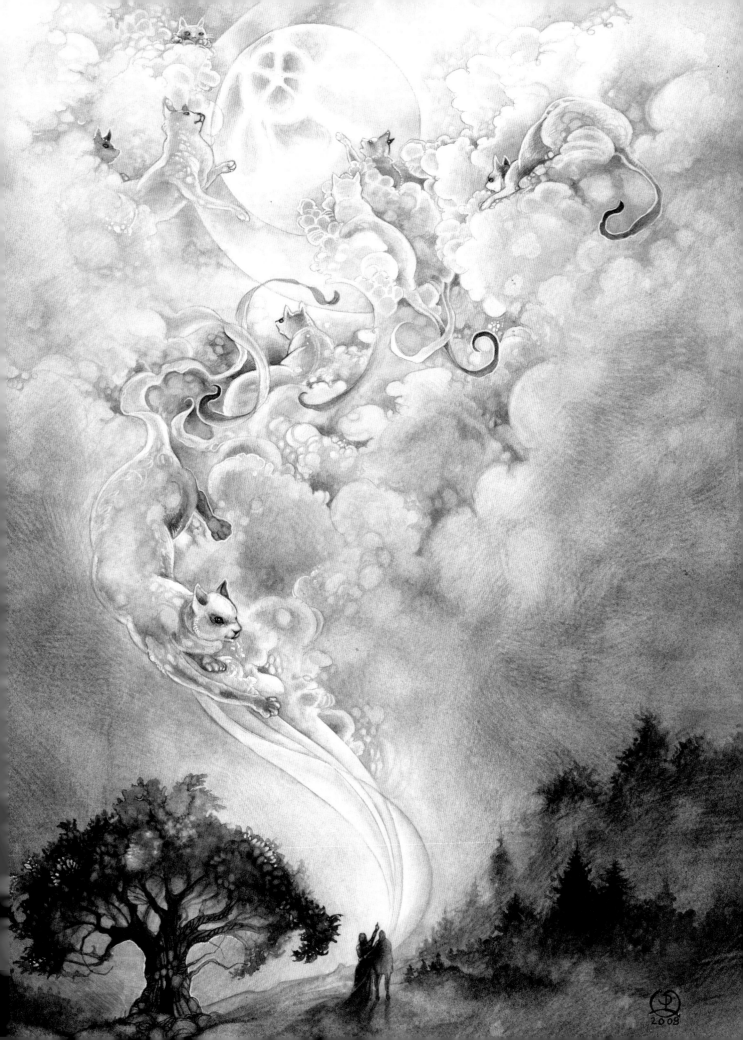

\mathscr{I}ntroduction

WHEN I WAS STUDYING AT BERKELEY, I CAME ACROSS A STORY about a man who had the (mis)fortune to be loved by two women, both of whom came into his life under mysterious circumstances. One of the women was eventually revealed to be a ghost, and the other a fox spirit. The story lingered in my mind. I found I could not stop thinking about it, just as the man in the tale could not stop obsessing over the two trickster creatures who had possessed his mind and life.

Years later I attempted to hunt the story down with the scant information I had. Used bookstores abound in Berkeley—you could visit a different one each day of the week. I loved to spend long hours browsing the aisles filled with relics and treasures of paper and ink. For years I haunted the folklore shelves, until finally one day I came across a book entitled *Chinese Ghost and Love Stories*. It had a horrid yellow cover, and the binding was coming apart. In a roundabout route of translations, it had arrived in the English volume I held in my hands via German from the original Chinese. But it contained the story I was searching for, as well as many other Chinese fairy tales about ghosts and fox spirits.

The morality of the supernatural creatures in these tales is not quite in step with that of humans. They are drawn to and fascinated by humans. The ghosts long for an essence they no longer possess, and the fox spirits never possessed it to begin with. Like moths to a flame, they hover around the bright flare of humanity, sometimes wreaking havoc with the strength of their yearning. And yet they are an integral part of the world and the natural order of the universe they exist in. There is an intimacy and a naturalness to their stories—they slip into the lives of the protagonists the same way they slipped into my art.

One can draw and paint animals for mere love of nature and wildlife. There is undoubtedly that aspect to my pursuit of the natural world in artwork. But there is a mythic tie that myriad creatures in uncounted cultures have had to humans and to gods. They are a reflection through which we can see ourselves, with our most noble qualities as well as our most base, simplified and distilled into the traits and characteristics of the natural world that we are surrounded by. And so, as our stories through time are filled with rich metaphors and fantastical creatures, there is a wealth of inspiration to draw from in artwork.

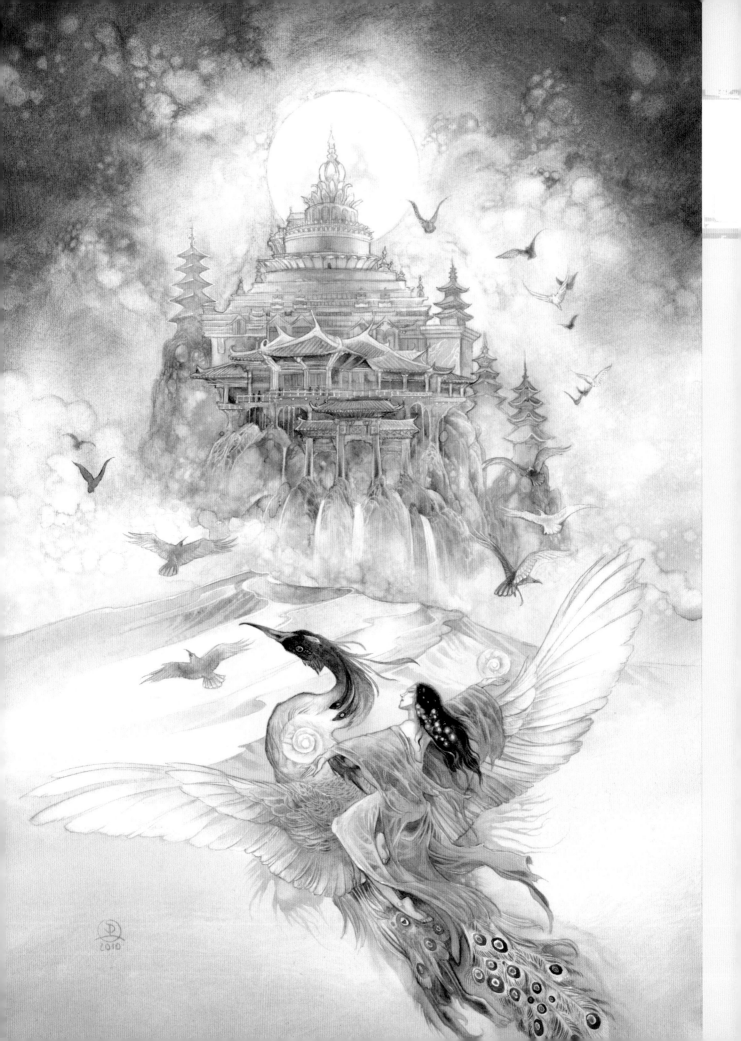

Part One
MATERIALS & TECHNIQUES

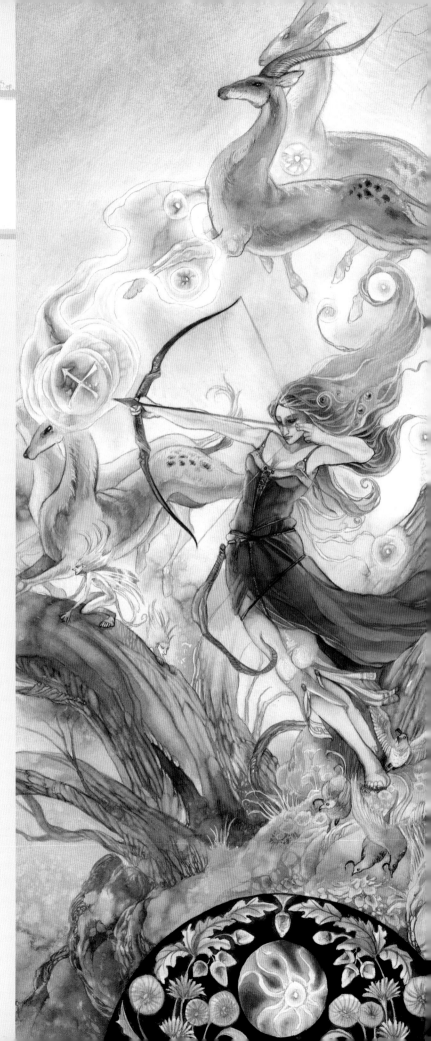

It can be a daunting task, indeed, to sit in front of a blank sheet of paper with the expectation of creating something magical. Yet possibilities and inspiration lie all around you. From the myriad of legends and stories of the past, to the works of other artists, to the inherent beauty that exists in nature, there is no shortage of places to look for ideas. Even the mistakes you make when painting—those unplanned, and at times, highly frustrating marks or spills—can be utilized to create unexpected and unique results. So, while it certainly can be intimidating to stare at a stark white piece of paper and wonder how your composition will turn out in the end, don't let fear hold you back.

The good news is this: By obtaining knowledge about the tools of the trade and being familiar with the basic watercolor techniques at your disposal, you can help ease the transition from nebulous imagination to successful painting. With time and experience, the medium will simply become an extension of your imagination. After all, practice is the only way to turn a once-blank sheet of paper into a colorful, whimsical and magical world filled with iconic figures of fantasy.

Selecting Pencils

IN THIS BOOK YOU'LL USE PENCILS IN YOUR studies of drawing ethereal fantasy creatures with the goal of a painted end result. Though the focus here is on painting with watercolors, pencils are a viable tool for completed works of art.

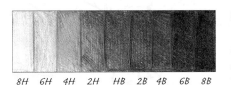

8H 6H 4H 2H HB 2B 4B 6B 8B

Leads Are Available in Varying Degrees of Hardness

8B is the softest lead, while 8H is the hardest. HB is a medium hardness. The softer the pencil lead, the darker your mark. If you use too soft a lead, the pencil will smear and make your painted colors look dirty. If the pencil lead is too hard, you will have to press harder to draw your lines, creating indentations on your watercolor paper with the point. For this reason, HB and 2B pencils are good choices for sketches that are going to be painted over.

Selecting a Pencil

Traditional wood pencils are a good all-around choice. They have an expressiveness that tends to get lost with mechanical pencils. Mechanical pencils, however, are convenient and consistent. They come in a variety of thicknesses and don't need to be sharpened. The downside of mechanical pencils is that you lose the organic flow that a uniform thickness of line cannot accommodate.

If you're planning to paint on the surface afterward, don't use much shading if you wish to keep the colors pure. If you are just sketching for ideas or doing a pencil drawing, then go all out. A lead holder is a particular joy to use in that case. A lead holder is similar to a mechanical pencil but can hold a much thicker lead so you can draw with its edge or sharpen it to a point.

Traditional no. 2

Mechanical (3 thickness)

Lead holder

Selecting an Eraser

Vinyl erasers work fine for sketches, to clean up a piece after all the painting is completed and for removing bits of dried masking fluid. Kneaded erasers are needed only if your intent is to create finished pencil drawings, because you don't want to lay in heavy graphite under your watercolors—it will muddy the colors.

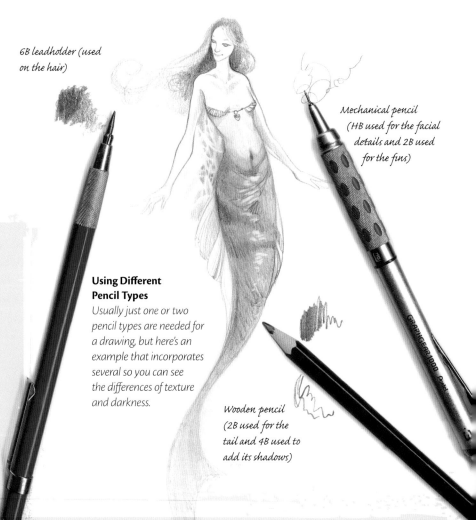

6B leadholder (used on the hair)

Mechanical pencil (HB used for the facial details and 2B used for the fins)

Using Different Pencil Types

Usually just one or two pencil types are needed for a drawing, but here's an example that incorporates several so you can see the differences of texture and darkness.

Wooden pencil (2B used for the tail and 4B used to add its shadows)

Choosing Brushes and Other Tools

THE TWO MOST COMMON TYPES OF BRUSHES ARE FLATS and rounds. Flats are useful for creating large areas of even color. Rounds work well for shaping certain areas and adding details. Items like salt and rubbing alcohol are great for adding unique textures to your painting.

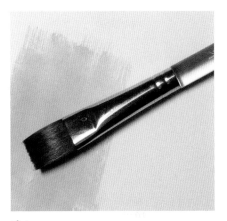

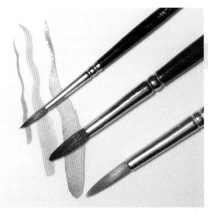

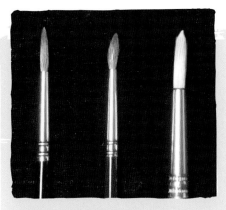

Flats
A ½-inch (12mm) flat is a good brush for doing washes in large areas. If you decide to work with bigger paintings in the future, you should eventually acquire bigger flats that can cover a larger area with one stroke. A ½-inch (12mm) flat is suitable for working in areas up to 11" × 14" (28cm × 36cm). For surfaces larger than this, you'll need a larger flat to hold the necessary water and pigment.

Rounds
Having an assortment of brush sizes gives you a nice base of tools to work from. Rounds in nos. 0, 2, 4 and 8 are a good starter set. You can add to your collection as you gain more experience with painting and find yourself in need of a better selection. Sometimes you can purchase a starter brush set that includes three to five brushes of different sizes for a reasonable price.

Very fine work and details like leaves, eyes and scales require a small brush with a good point such as a no. 0 round, while a large round such as a no. 10 or bigger is useful for irregularly shaped washes.

Sable or Synthetic?
Brushes range in quality from synthetic fibers to top-of-the-line kolinsky sable hairs. If you are just getting started, you might not want to splurge on the most expensive brushes. Many reasonably priced mixed synthetic and sable or pure sable options are of good quality. What you want to look for in a brush is the ability of the hairs to hold a point when wet (if the hairs splay outward or don't stick together, the brush isn't good), and the resilience and bounce of the hairs (when bent, they should spring back to shape).

Cheaper brushes eventually lose their point as the hairs get splayed or bent, but do not toss these old brushes out. They are good utility brushes to use when you need to lift paint or apply masking fluid. When you don't want to spoil your nicer brushes with rough treatment, grab an older one.

Salt
Sprinkle salt into wet paint. The crystals pull the pigment as the liquid dries, leaving a random starlike, mottled effect. Brush away the salt crystals after the painting has dried.

Rubbing Alcohol
Sprinkling rubbing alcohol onto wet paint causes the pigment to push away, leaving an interesting splotched effect.

Finding Paints

WATERCOLOR PAINTS COME IN TUBE AND CAKE form. Don't feel like you are limited to pans or tubes, however. You can always mix and match—get a pan set for a basic starter set. Then, when you need additional colors that are not included, purchase tubes.

Tubes or Cakes?

Advantages of tubes:

- *Offer more control over the intensity of color.*
- *Easy to acquire in a variety of pigments so you can custom select the array of colors.*
- *Easy to get the amount of pigment you need by squeezing a tube rather than trying to work it up from a dried cake.*

Advantages of cakes:

- *Starter sets offer a good variety of preselected colors.*
- *Less cleanup is needed because a cake is more self-contained.*
- *Easy to take with you when traveling or painting on site—perhaps to a forest or garden for inspiration.*

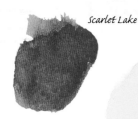

Scarlet Lake

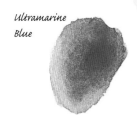

Ultramarine Blue

Cadmium Yellow

Primary Colors

The primary colors (red, yellow and blue) are three basic colors to get you started. In theory, the entire spectrum of colors can be mixed from them.

White Gouache

Gouache is an opaque watercolor paint. When used sparingly, white gouache can be an effective way to add some white over a finished area. However, it is the transparent quality of watercolor that really makes a painting glow. When you apply opaque colors, you step away from that look. The white of untouched paper will always be brighter and more pure than the opaqueness of white gouache.

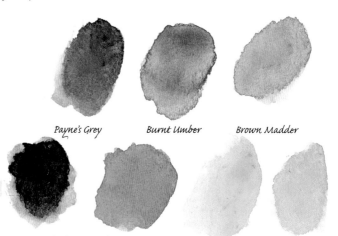

Payne's Grey Burnt Umber Brown Madder

Lamp Black Alizarin Crimson Sap Green Viridian Green Cerulean Blue

Expanded Palette

Having more colors gives you a brighter palette to choose from. You can mix a lot of shades from a limited set, but if you want a very bright and light color like pale pink, or a light shade of a primary color, you should purchase a tube or cake of that color.

Cadmium Yellow Naples Yellow

In addition to red, yellow and blue, I recommend some of the colors shown above. Starter sets of cake paints usually include most of these colors, though if you go with tubes you can individually select them yourself. As you gain more experience, you can add to your selection of colors.

 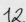

Gathering Extras

Water Container

A bowl or cup of water is needed for washing off your brushes. Take time out to freshen the water every once in a while. Don't be lazy and let your water get too dirty and cloudy! Doing so will make your colors look muddy.

Palette

A lot of cake paint sets have a built-in palette for mixing colors; therefore, it may not be necessary to purchase a separate one. However, if you are using only paint tubes, you will need a palette to set out and mix your colors.

Absorbent Paper Towels

Keep a supply of paper towels on hand for mopping up excess moisture from a painting.

Masking Fluid and Old Brushes

Also called liquid frisket, masking fluid is a liquid latex that you paint directly on your surface to retain white areas before applying paint. Never use a good painting brush for applying masking fluid. Save old brushes for this purpose, and clean them with soap and water right after you finish. Once the frisket has dried on the paper, you can apply washes of color over it. When the paint is fully dry, remove the masking by rubbing gently with your fingertip or an eraser. The areas underneath will be white and unpainted.

Color Shapers

These rubber-tipped tools with either a chisel or pointed tip are often used for sculpting or acrylic painting. Because a color shaper has no individual bristles, dried liquid frisket will not harm it, and it can be used just like a brush to apply the masking fluid. When finished, simply wipe off the tip with a paper towel.

Mixed Neutrals on Your Palette

Although it is important to keep colors clean and separate (especially when using pale colors like yellows, oranges, pinks and light greens), letting colors run together on your palette can create mixed neutral tones. Use them to paint subtle shadows and in-between shades, instead of a flat pure color. The less vibrant hues and neutral shifts will lend a subtle realism to your painting.

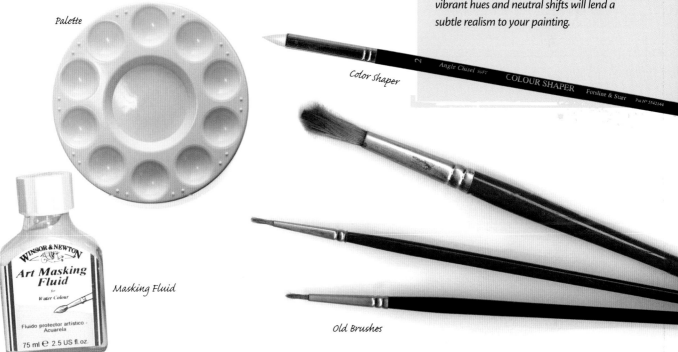

Palette

Color Shaper

Masking Fluid

Old Brushes

Selecting Paper

THE TYPE OF PAPER YOU CHOOSE TO PAINT on is as important as your brushes and paints. Papers are categorized according to the surface texture, commonly referred to as a paper's tooth: rough, cold press or hot press.

Watercolors are most suited to rough or cold-pressed papers because they absorb the pigment quickly. Hot-pressed paper is better for more opaque techniques such as working in acrylics or gouache paints and drawing with inks and pencils.

Selecting a paper is also a matter of personal preference. I prefer to work on lightweight illustration board, but you should try out different textures and types of surfaces to see for yourself how the paints behave.

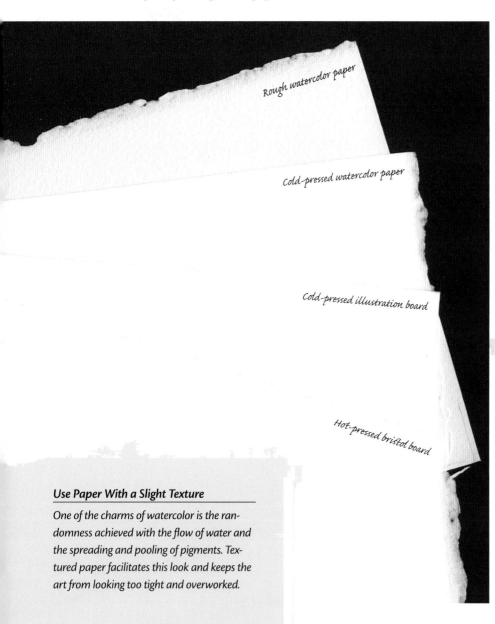

Rough watercolor paper

Cold-pressed watercolor paper

Cold-pressed illustration board

Hot-pressed bristol board

Selecting a Surface

- **Rough surface**. *This finish has the most pronounced peaks and valleys. It is not recommended for a beginning watercolorist, as mistakes are hard to hide and paint can pool into the valleys.*

- **Cold-pressed surface**. *This surface has a medium tooth and allows the water and pigment to be absorbed quickly. The surface is also resilient to rough treatment and can handle lots of layering and lifting. Cold-pressed paper is a good type of paper to start out with.*

- **Hot-pressed surface**. *This surface is extremely smooth and nonporous. Watercolors tend to pool and bleed a bit more since the liquid isn't rapidly absorbed into the paper. However, this does make blending easier.*

An Alternative to Watercolor Paper

Illustration board serves as a good alternative to watercolor paper. It comes in cold- or hot-pressed finishes, though even the cold-pressed tends to be on the smoother end of the spectrum. Illustration board does not get as warped from repeated washes as watercolor paper does, and it does not need to be stretched. Tape it down to a Masonite board for easy transportation and to prevent damage to the corners.

You can also use bristol board, but it does not take water very well and warps easily. Bristol board is better suited for pencil or ink drawings that have very little color.

Use Paper With a Slight Texture

One of the charms of watercolor is the randomness achieved with the flow of water and the spreading and pooling of pigments. Textured paper facilitates this look and keeps the art from looking too tight and overworked.

Basic Watercolor Technique
STRETCHING WATERCOLOR PAPER

Unless you use prestretched watercolor paper or illustration board, you must stretch your watercolor paper to prevent it from becoming swollen with water and warping.

MATERIALS LIST

Surface ~ Watercolor paper (cut to size)

Other ~ 4 pieces of acid-free masking tape cut to the width and height of your paper, bowl of water, drawing board, paper towels

1 Wet the Paper
Take the sheet of paper and soak it thoroughly in water.

2 Remove Excess Water
Wipe away excess moisture with a paper towel.

3 Let the Paper Dry
Take the paper by the corners and lay it flat on the drawing board. Tape down all four sides with acid-free masking tape. Let the paper dry completely. When it is dry, the paper is ready to be painted. Don't remove the paper from the board until you've finished your painting.

Understanding Color

THE BASIC COLOR WHEEL CONSISTS OF THE primary colors red, yellow and blue. From these three basic colors, the rest of the spectrum can be created. The secondary colors are orange (mixed from red and yellow), green (mixed from yellow and blue) and violet (mixed from blue and red). The six tertiary colors result from mixing a primary with a secondary color.

Generally reds, oranges and yellows are considered warm colors while purples, blues and greens are considered cool. Being aware of a color's temperature can help you manipulate the mood of your paintings.

Mixing Lively Grays and Blacks

Grays and blacks straight from the tube are sometimes referred to as dead colors. This is particularly true of black, as it is completely neutral (neither warm nor cold) and often results in a flat finish that draws the viewer's eye toward it. As such, it's best to use black paint from the tube sparingly.

A nice alternative to pure black is to create a black mixture. After all, few things in the world are truly black; even a black object has light and shadows and is affected by the surrounding colors. Burnt Umber and Ultramarine Blue make a great combination for an artificial black. Add more Ultramarine Blue to the mixture for a cooler black or more Burnt Umber for a warmer cast.

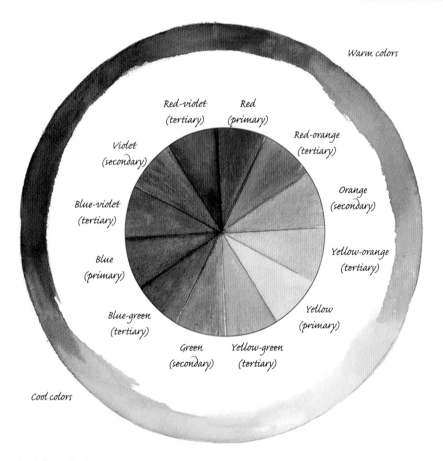

The Color Wheel
Being familiar with the color wheel will help you when it comes to mixing your watercolors and determining the color scheme of a painting.

Complements and Color Mixing
Complementary colors sit opposite each other on the color wheel. Complementary pairs are red/green, blue/orange and purple/yellow. Mixing complementary colors together results in a muddy brownish-gray tone. The more colors you mix, the muddier the mixture becomes. Try to mix only two or three colors at most to get the color mixture you need.

Suggesting Edges and Incorporating Spills

THE BEST PAINTINGS ARE A MIXTURE OF control and random accidents. Most artists evolve beyond the frustration of not being able to control their paint, to using an iron fist and killing all the spontaneity of watercolors, to finally finding a happy medium that uses the natural tendencies of watercolors while maintaining knowledge and control over the results.

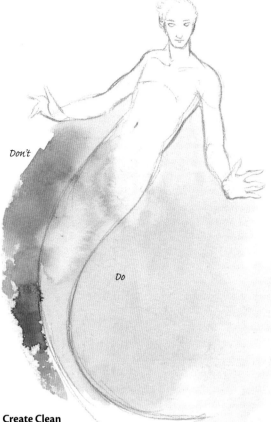

Don't

Do

Create Clean Edges by Working Wet-On-Dry
On the left side, the blue wasn't dry before the green was applied, so the blue spilled over into the tail. Be patient—a minute spent waiting now will save you much hair-tearing and regret later when trying to correct an error. This technique of working wet-on-dry can help you create crisp edges.

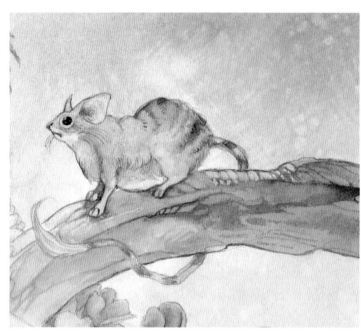

Make Crisp Edges
To create details or a crisp edge, do not paint a layer of color near another wet color or it will bleed from one section to another. You can create fine-edged details only with dry adjacent colors. When in doubt and something is wet, wait.

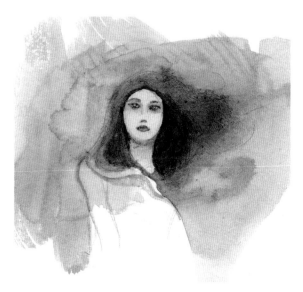

Take Advantage of Spills
Sometimes spilling color can be a good thing. You can use the effect purposely as a technique. Her hair blends into the background in a cloudy haze that works quite well in this instance.

Receive a free bonus demonstration from the original *Dreamscapes* at **impact-books.com/DreamscapesMenagerie**

17

Basic Watercolor Technique
LAYING A FLAT WASH

Washes, the most basic of watercolor techniques, are for covering large, flat background areas or for laying in basic colors on smaller elements of a painting.

MATERIALS LIST

Surface — Cold-pressed watercolor paper or illustration board, drawing board

Brushes — ½-inch (12mm) flat

Watercolors — Ultramarine Blue

Other — acid-free masking tape

1 Wet the Paper
Secure your surface to a drawing board. Position your paper at a slight angle toward you (prop some books underneath the top if you don't have a slanted drawing table). Use a ½-inch (12mm) flat to wet the entire area of the wash.

2 Add Pigment
Load a ½-inch (12mm) flat with Ultramarine Blue. Drag the brush across the top of the paper. Since the surface is at an angle, the paint will drip toward the bottom of the page.

3 Add More Pigment
Before the previous stroke dries, drag a second stroke across the paper, right below and slightly overlapping the first stroke. Make sure you catch the drips from the first stroke for an even wash.

4 Create the Final Layers
Keep layering pigment, following steps 2 and 3 until you get to the bottom. If too much paint runs to the bottom edge, reduce the angle of your work surface. Avoid going back and retouching areas you have already painted until the surface is dry. Small variations and inconsistencies will smooth themselves out as the water flows and the paint dries.

1

2

3

4

Basic Watercolor Technique
LAYING A GRADED WASH

For a graded wash, dilute the paint with each consecutive stroke so the pigment eventually fades into clear water and the white of the paper. It's important to let the paint dry. Do not fuss with it too much or you may make inconsistencies more obvious.

Use graded washes to change the colors of the sky's horizon or to create the vibrant edge of a rose petal fading to the pale pink heart.

MATERIALS LIST

Surface ~ Cold-pressed watercolor paper or illustration board, drawing board

Brushes ~ ½-inch (12mm) flat

Watercolors ~ Ultramarine Violet

Other ~ acid-free masking tape

1 Wet the Paper and Add Pigment
Secure your surface to the drawing board. Prop the surface up, angling it toward you. Wet the area with a ½-inch (12mm) flat, then load it with fairly concentrated Ultramarine Violet. Drag the brush across the paper's top with a horizontal stroke.

2 Add Lighter Pigment
For the next stroke, dilute the paint a little bit so that it is slightly lighter than the first stroke. Drag the brush across the surface, overlapping the first row.

3 Continue to Add Layers
Keep layering pigments, following step 2 until you get to the bottom. Remember, dilute the paint for each row.

4 Let the Surface Dry
After you've covered the whole area, don't fiddle with it because this will only mar the smoothness of the wash. Minor inconsistencies will smooth themselves out as the surface dries. Practice this a few times until you can create an evenly graded wash.

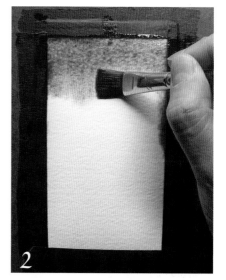

Applying a Graded Wash in a Curvy Area

Create graded washes in areas with curves and edges by slowly building a series of washes in the area. Start with a very pale wash, let it dry, then continue building layers. This method gives you much more control .

Receive a free bonus demonstration from the original *Dreamscapes* at **impact-books.com/DreamscapesMenagerie**

Glazing

To give your colors a glowing gem-like quality, consider using the glazing technique. A glaze is a translucent wash applied directly on top of an existing layer of color. This technique not only adds an essence of shimmer to your paintings, but also results in a subtle shifting of colors that direct mixing can't accomplish. Each time you add a color on top of another color, it changes the tone in a way that is distinctly different from mixing the wet colors directly before painting. And, of course, you aren't limited to just two layers—you can add as many layers as necessary to build up the colors and create the tones you desire.

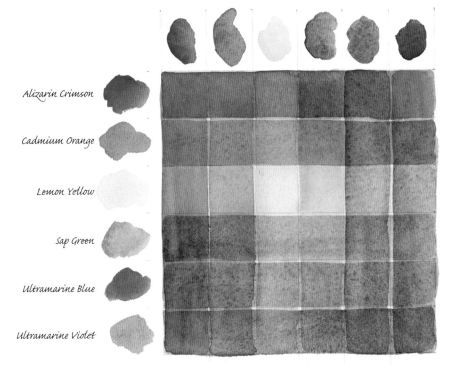

Alizarin Crimson

Cadmium Orange

Lemon Yellow

Sap Green

Ultramarine Blue

Ultramarine Violet

Creating Dazzling Results With Glazing
This chart shows what happens when you use the glazing technique. Notice how a color's intensity increases when another layer of color is added to it. Layering complementary colors results in muted brown and neutral tones.

Creating a chart like this with your various pigments is a great starting point to help you determine which colors to glaze. You'll be able to see in advance how the colors look when one pigment is layered over another.

Glazing in Action
I used glazing here to give the skin a transparent quality. The shadows were laid in first using Indigo, then a very pale glaze of Naples Yellow and Alizarin Crimson was added to suggest the main fleshtones. I also glazed small nimbuses of Lemon Yellow around the bits of jewelry to add even more intensity. This gradual buildup of colors produces a much richer composition than if it were done in one pass with the colors premixed on the palette.

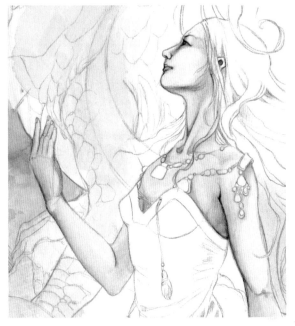

20

Basic Watercolor Technique
LAYERING GLAZES

A dryad reaches up, stretching her leafy fingertips toward the light, so a graded wash makes the perfect background. Using a rich, verdant green for the base best complements the nature of the subject, and each added layer of color helps to define even the subtlest of details.

MATERIALS LIST

Surface — Illustration board

Brushes — ½-inch (12mm) flat, nos. 0, 1 and 4 rounds

Watercolors — Burnt Umber, Indigo, Viridian Green

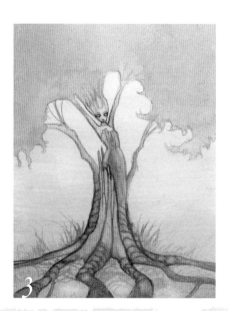

1 Finish Sketch and Lay a Graded Wash
Sketch the dryad with a pencil. Turn the paper upside down and use a ½-inch (12mm) flat to apply a graded wash of Viridian Green so the darkest area falls at the bottom of your sketch.

2 Glaze the Dryad
Apply a layer of Burnt Umber with a no. 4 round to the tree trunk and roots. Since the previous layer is darker toward the bottom, the roots will seem to darken toward the shadows in the foreground. Apply a layer of Indigo to the upper leaves and very lightly to the dryad's face.

3 Add the Final Details
With a no. 0 round, paint her features and the details along the trunk with Burnt Umber. Paint some grass with Viridian Green. Lift out some highlights on the trunk with a no. 1 round. Notice that since Burnt Umber lifts more easily than Viridian Green, the lifted highlights show the tints of green peeking through.

Glazing Creates a Subtle Color Change
Here are the colors used in this demonstration in their pure forms, that is, straight from the tube. When they are layered on top of each other, they interact and mix, creating a much more subtle effect and more interesting shades and variations of tone that straight mixing cannot achieve.

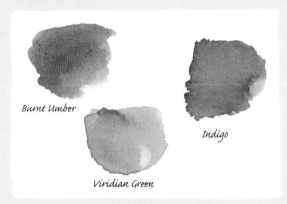

Burnt Umber

Indigo

Viridian Green

Receive a free bonus demonstration from the original *Dreamscapes* at **impact-books.com/DreamscapesMenagerie**

ℬlending

WHEN IT'S TIME TO BLEND THE TONES OR colors in your painting, choose one of two approaches…

Blending Wet

When dealing with large areas, graded washes work well for blending from one tone to another or from color to the white of the paper. For smaller areas though, it can be a bit unwieldy. Blending with your brush while the paint is wet can give you more control.

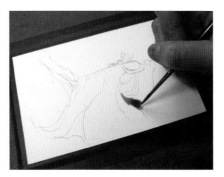

Start in the Corners

It can be tricky to blend a background around the tight corners of a foreground element. Select a round brush that is big enough to hold a lot of water, yet get into tight corners. Charge the brush with moderately diluted pigment, using just enough water to flow but not so much that the tones become too pale.

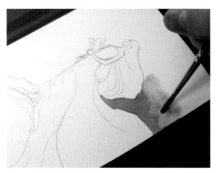

Blend Outward

As you move out from the foreground element you are painting around, start diluting the paint on your brush with water. Paint fairly quickly to keep the forward edge that you are working along wet. If it dries, a noticeable seam of pigment will show.

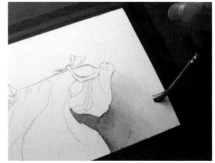

Blend Until Clear

As you pull the forward line outward, keep diluting the paint on your brush until it runs clear.

Blending Dry

Blending dry works well for softening edges, blurring for distance or shading. Transitions will not appear as smooth as they do when blending wet. Results vary depending on how amenable the particular color is to lifting, as well as the paper type.

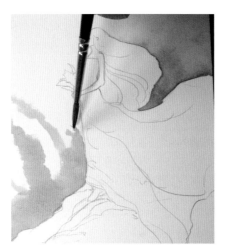

Establish Basic Forms

Lay in the basic forms for the area you are painting.

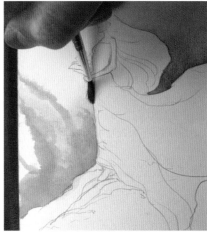

Lift Along the Edges

A brush with stiff bristles works best for this. After the initial layer has dried, load the brush with water and scrub along the edges of the paint to lift and soften the transition.

Using Salt

SALT IS AN EXCELLENT ADDITIVE TO HELP indicate texture in your paintings. It works well in creating a nice base for organic backgrounds like leaves and foliage as shown on this page. However, it can sometimes be tricky to achieve a controlled result. By its nature, salt creates a randomizing effect, so be prepared to relinquish some control when using it. To a certain extent, you can control the type of effect created, depending on the type of salt you choose to work with. Sea salt, which is coarser and more irregularly shaped, generates large splotches of differing shapes and sizes. Table salt, on the other hand, is very fine and more uniformly shaped, yielding a consistent splotched texture.

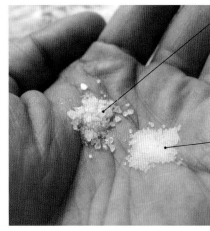

Sea salt— the rough, irregularly sized grains result in splotches of varying shapes and sizes.

Table salt—the standardized size of these fine crystals produces a more regular texture.

Sea Salt Versus Table Salt

Getting Started
Lay in some wet paint, then sprinkle salt into the area you wish to texturize.

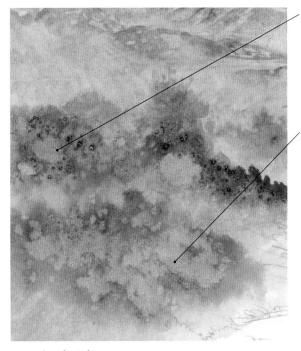

If you wait until the paint is completely dry before removing the salt, little outlines of pigment will remain behind. This will yield a very feathery, delicate, starry texture.

If you very lightly brush the salt away (using a paper towel) when the paint is almost dry, you can avoid the dark outlines. This also blurs the starry texture a bit, resulting in a more nebulous blob shape.

Watching Texture Form
As the salt works, the grains suck in moisture, creating a distinctive starry texture on the paper.

Removing the Salt
When the paint is nearly dry, you can remove the salt by lightly brushing it with a paper towel. The timing for this is something you have to experiment with. It varies depending on how wet your initial wash is, how much salt you use, how absorbent your paper is, and what effect you are attempting to achieve. Try it on scrap paper first if you're uncertain about how it will work.

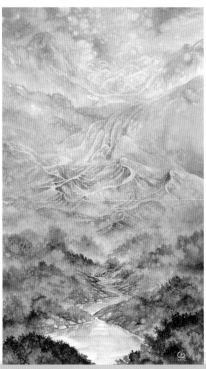

Random Effects of Salt

More Watercolor Techniques

1

2

3

1 Layered Graded Wash

By combining graded washes and glazing, you can create a multicolored melding of tones. Use a ½-inch (12mm) flat to apply a graded wash with one color. When that has dried completely, paint a second graded wash with a different color (or use the same color to intensify its appearance). Repeat this until you get the appearance you desire. Use this technique for complex backgrounds.

2 Drybrush

Like the name suggests, this technique employs a dry brush (a brush with little to no water). Just load some paint on the brush, then dab it in a paper towel to get rid of excess moisture. Experiment with varying amounts and take note of the results. With less moisture, the brush will skip over the texture of the paper, and the individual hairs of the brush will be evident in each stroke. With more water, you will get a very smooth, unbroken line similar to a wash. Drybrushing can be used to paint fine details in foliage, grass and hair.

3 Dry-Into-Wet

When using this technique, wet only the areas you will be working on with clear water. Then, with a brush loaded with relatively dry paint, work through those wet areas. The wet parts will dilute the pigment, while the dry areas hold the paint still. This technique can be used for surface ripples of water.

4 Wet-Into-Wet

If you want to achieve an organic look in your painting or to blend your colors in a looser fashion, simply use the wet-into-wet technique. To begin, wet the entire surface of the area you will be working on with clear water, then take a brush loaded with color and paint into the wet areas. The water will dilute the edges of the painted areas and pull the pigment away from the center, creating a softer, more natural look.

Secrets to Successful Lifting

Certain colors respond very differently to lifting. Blues lift very easily (for this same reason, blues are sometimes difficult to glaze because the color insists on lifting as you apply a second wet layer). Reds, on the other hand, can be extremely stubborn and require much more force to lift. The paper also affects your ability to lift a pigment. Pigments on hot-pressed paper lift easily since the paint sits mostly on the surface. A very rough cold-pressed paper might be more resistant to lifting. Cheaper papers also have a tendency to suck up the pigment and very reluctantly release any of it.

5 Lifting From a Wet Surface

Lifting is when you remove pigment from the paper after it has been applied. You can lift from a wash that is still wet by taking a paper towel, tissue or sponge and dabbing at the paint. The drier the paint gets, the less color you can remove.

6 Lifting From a Dry Surface

To lift color from paint that has already dried, you must apply water. Do this by dropping water onto the dried surface and letting it sit for a moment before lightly scrubbing it with a paper towel. You can also wet a brush with water and use it to lightly scrub the surface. Using a smaller brush gives you more control over what is lifted. This technique is very useful for distant foliage, tree bark, stars, mermaid scales or for creating highlights.

7 Plastic Wrap Texturing

If you want to add extra texture to your painting, lay a wash, then while it is still wet, lay a piece of plastic wrap on top. After the paint has dried, remove the plastic wrap. This technique works well for rock textures or stained glass.

8 Rubbing Alcohol Texturing

You can also create texture using rubbing alcohol. Start by laying a wash, and while it is still wet, sprinkle it with rubbing alcohol. The pigment will push away from the rubbing alcohol and leave an interesting speckled pattern. This technique is great for suggesting distant foliage or bubbles in an underwater scene.

Flow With the Medium, Don't Fight It

If you find yourself struggling too hard to accomplish a certain effect, it might be time to take a step back and reconsider your approach. Sure, there are some unpredictable elements to painting with watercolors, but they can be controlled—to some extent—by your choice of materials and techniques. For example, wet-on-dry usually stays where your brush paints it. If you use more liquid, the stroke will be smooth. Less liquid will create a broken line, dry-brush effect.

Wet-into-wet, on the other hand, will cause colors to bleed and bloom across the wet zones. If you find details are hard to paint because everything is becoming blurry, think about the surface you are painting on. Is it wet? Is it too wet? Is the paper too rough? Are your brushes too big?

By familiarizing yourself with the characteristics of watercolor materials and techniques, and applying this knowledge to your paintings, you can avoid frustrating mistakes and enhance your watercolor experience.

Positive and Negative Space

POSITIVE SPACE REFERS TO THE OBJECT YOU'RE dealing with. The two-dimensional shape of the areas that surround the object is known as negative space. Either one can be the main focus of the piece; being defined as "negative space" doesn't mean that part of your image isn't important. Being aware of the shape of the negative space will have impact on your composition and the balance of your piece.

Positive Space

Negative Space

Positive and Negative Space Enhance Depth

Effective use of positive and negative space as well as the ability to switch back and forth between painting the two can greatly enhance a painting and add to the perception of depth.

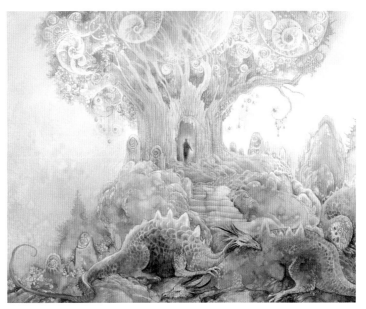

Impact for Watercolors

When working in watercolors, you generally don't paint light areas but instead constantly push dark areas darker, allowing the white of the paper to be the "lightness" showing through. Any time you leave lighter areas unpainted and paint darker color around an object, you're working in that object's negative space.

Notice how the positive space of the lighter, unpainted areas of the jellyfish, fish and merpeople's bodies contrasts with the darker, heavily painted areas of the deep blue sea in this image.

Switching Between Positive and Negative Space

Because watercolor is transparent and you work from light areas into dark, you often have to paint around portions of the picture that you wish to keep a lighter color. Even if the lighter portion is what you want the viewer to focus on, you have to mentally switch modes when working on the negative spaces around your highlights instead.

The dragon is the main focus of this piece, but in order to create the scale pattern and pull the plate ridges into the viewer's attention, it was necessary to paint in the negative space around them. The ability to switch from one to the other helps your images meld into a flowing composition of foreground and background, rather than feeling like cutout pieces arranged on a background. It brings various elements together into a cohesive whole.

Spatial Relationships

Negative space focuses the viewer's attention on the shape of the area around an object. Be conscious of the push and pull of the foreground and background and the relationship between objects and surrounding space as you work.

The two critters and the tree they're hugging inhabit a positive space, but in relationship to the tree branch that cuts across in front of them, the tree trunk becomes the negative space for the foreground element. In order to help it recede and not compete for attention with the foreground, the contrast of the bark texture is played down (by brushing some clean water over the surface to blend and soften the lines and edges blend and soften), and the color is darker than the highlights along the edge of the tree branch in the foreground.

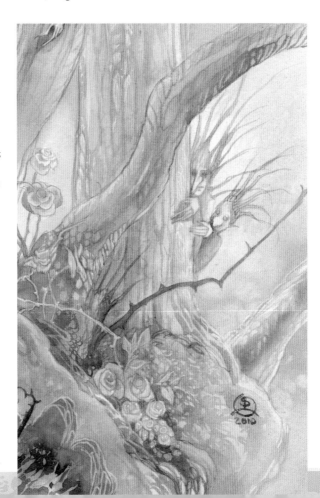

Using Opaque Whites

WATERCOLOR PURISTS WOULD NEVER EVEN think of using anything opaque. For the most part, I am like-minded. Once you start depending on being able to work light on top of dark, you lose a lot of the wonder and magic of watercolors. Part of the beauty of the medium is the transcendent glow that can only be achieved with the transparency of watercolors.

So keep in mind that with these opaque techniques, you're not replacing the transparency of the paints or compensating for "forgetting" to leave whites. It's more of a complement to the other techniques being employed.

A Touch of White
If used sparingly, a touch of white can enhance a piece. There are numerous materials to choose from:

- *white watercolor from a tube (still fairly translucent)*
- *white corrective liquid (available in pen form)*
- *white gel pens (my personal favorite)*
- *white gouache (similar to watercolors but much more opaque)*
- *white gesso (very bright and opaque)*

Working Into Wet
While the area is still wet, add some scribbled highlights. As it dries, the wetness of the underpainting leaches the white out, softening the edges. I used a white gel pen here, but much of the same can be accomplished using other white mediums.

Working Into Dry
Go back in after the paint has dried and brighten up some areas with a second layer of gel pen on the dry surface. For harder, more defined edges, draw directly on dried areas.

Make the White Pop

After drawing some loose textures with the pen, go back in with dark color on a brush and paint some more layers of color around the pen lines. This makes the white stand out by contrast.

You can also brush clean water along the edges of where you've drawn the white. This will blend it into the surrounding colors a bit better and make the transitions more subtle. You can even use your finger to blend a little bit right after you've drawn—smear the ink outward a bit while it is still wet.

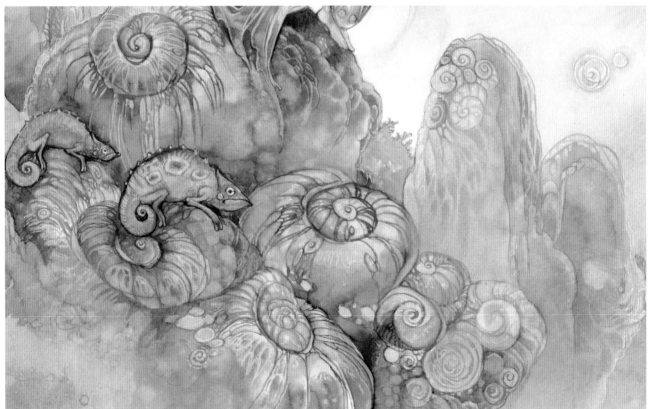

Lifting Out

WHEN PAINTING LARGE SWATHES OF SMOOTH background, it's sometimes hard to avoid painting over bits of the foreground.

Use Broad Brushstrokes on the Background

There's no need to be fastidious when you work. Sometimes you have to use broad brush-strokes to achieve that smoothness of the background, and you don't want to disturb the paint too much by being fussy and trying to paint around every corner and crevice.

Old Brushes Are Great for Lifting

After the background dries, take a round brush with a little bit of water and scrub at the edges of the foreground element to lift out the errant color. Stiff brushes work better for this because they give more resistance. Use your older or synthetic brushes for this purpose rather than your new ones with nice points. A retired brush that has lost its point for fine work is perfect for lifting.

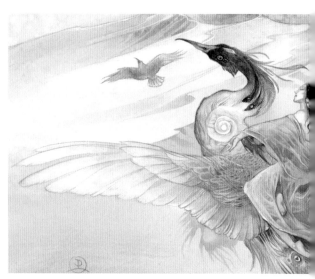

Masking Fluid Also Works

Of course, you could use masking fluid to avoid painting over certain areas, but masking leaves a very hard, rough edge.

Lifting Blends Elements

Lifting is a much softer approach than masking fluid and helps blend elements into one another so the foreground does not seem pasted on top of the background. The foreground and background are integrated because lifting doesn't pull all the color out, just most of it.

Drawing on Inspiration

FOR CENTURIES NOW, MYTHOLOGICAL SUBJECT matter has been a source of inspiration to many artists, whether gleaned from the living stories and tales of one's time or from long-ago legends cloaked in magic and mystery. The faery tales that have inspired so many can also spark your artistic imagination. Your local library and bookstores have shelves filled with mythologies of the world. Browse through a sample of these texts to arm yourself with the concepts necessary to create innumerable creatures, heroes and goddesses.

Once you've found the perfect inspiration for a painting—whether it's a piece of existing art, a photo you have taken or a sketch you've done on flimsy scrap paper—you'll need to copy the image to an appropriate painting surface. Employing a grid method will help you transfer your reference and maintain proper proportion and balance.

Alternate Methods for Transferring Your Image

Artist transfer paper (a product similar to carbon paper) is available at most art supply stores. Just lay the transfer paper (dark side down) on your painting surface, place your drawing on top and secure both to your painting surface. Then trace over the lines of your drawing. Be careful not to press too hard or you will leave grooves on the painting surface where liquid and pigment will pool when you start to paint. If you can't find transfer paper, use this trick: Make sure all the lines on your sketch are dark, then turn it pencil-side down on your painting surface and tape it in place. With a dull pencil (or anything that can serve to burnish) scribble on the back side of your sketch wherever your sketch lines are. The original drawing will be transferred in reverse onto your painting surface.

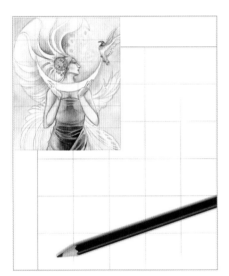

Lay out a Grid on the Image and Your Surface

Select a picture or study. Mark off a grid on the image with a pencil or pen and a ruler. If you have a computer, you can scan the image and digitally mark off a grid.

Mark your blank drawing paper lightly in pencil with the same number of gridded subdivisions. Your paper does not need to be the same size as your gridded photo. Just be sure the grids have the same proportions of width and height.

Begin to Map out the Image

Using the gridded photo or study as a reference, draw small sections of the image one at a time. Concentrate on one square at a time and try not to think of the picture as a whole figure, but just as lines and shadows. Look at where the lines are in each square of your grid. Notice how the eye is three-quarters of the way across one square. Relying on the preconceptions your brain has of the figure and of what things should look like can lead to an inaccurate drawing.

Complete the Sketch

Continue fleshing out the details and light shading. It's important to keep any shading very light if you plan to paint over the sketch. If the pencil lines are too dark, the paint's colors will appear dirty. After you finish sketching, erase the grid lines.

Using Ideas Around You

IT'S EASY TO START A COLLECTION OF REFERENCE images for your paintings—anyone can do it. Just take a camera and sketchbook along to any outdoor location and capture those scenes or elements you might find useful.

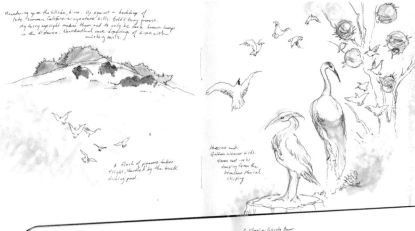

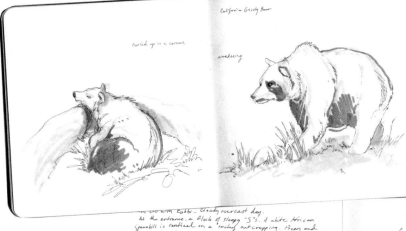

Keeping a Sketchbook

Use a thin pocket-size sketchbook for recording what is around you or for whenever inspiration strikes. Try to keep a sketchbook with you at all times because the best ideas may come unexpectedly. Sketchbooks are also great for idle moments sitting in a café, at a park or waiting for the bus. Training yourself to draw quickly and to sketch people in motion will also enhance your more polished pieces.

Zoos

For both land and air creatures, find inspiration at your local zoo—ideas abound. Horns and antlers top off fantastical creatures. A snake's body can become a base for a dragon. An antelope's grace can animate a unicorn. Snap some shots of creatures in action—walking, resting, stretching—for a full spectrum of poses. Bring your sketchbook for some gestural drawings to capture the immediacy of motion and action on the spot.

Look Up

Look above you and watch birds wheeling in the sky. Observe the fluidity and grace of their movements. Take some snapshots with your camera. Sketch quick gestural drawings from a park bench.

Your Own Environment

Take a look at your own surroundings. Don't neglect your own backyard and environs as sources of inspiration. Live oaks and redwoods and the creatures who call these woods their homes are a continual source of inspiration for my own art.

Botanical Gardens

The profusion of colors and shapes found in a garden can be a fantastic source of ideas for backgrounds and surroundings.

Aquariums

Aquariums can be an amazing source of inspiration. The beauty and colors of ocean life are riveting, and some of the almost alien-looking underwater life-forms are a fountain for ideas in creating fantasy creatures. With so much biodiversity, you can find myriad elements to integrate into your creations. If a public aquarium is unavailable, a tropical fish or pet store can provide just as much fodder for your imagination.

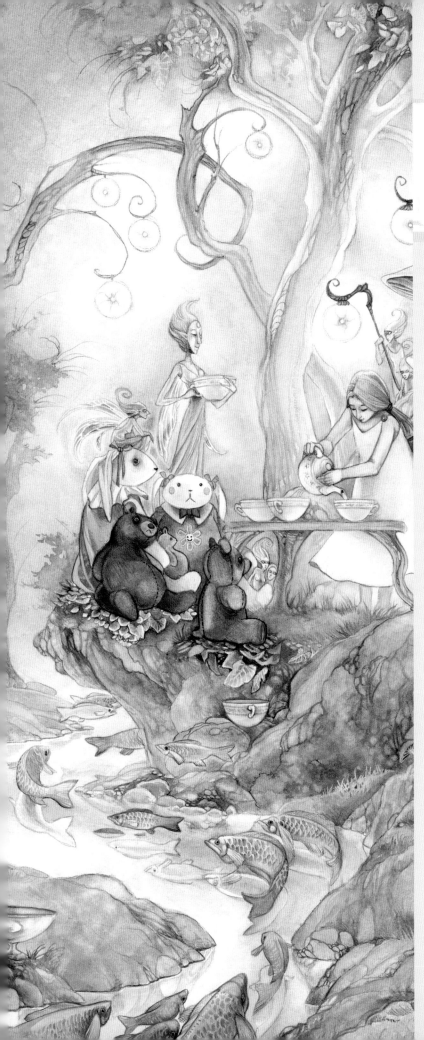

Part Two
WATERS

WATERS CHURN IN STREAMS AND RIVERS AND SEAS and oceans. The liquid element contains a wealth of varied creations: fins, flippers, tendrils, bioluminescence, scales, spines. The waters of the world overflow with endless diversity and provide a lifetime of inspiration, whether you paint the ordinary versions of the creatures or their mythical counterparts. Both the siren song of the deep and the lifeline flow of the currents weave through them all.

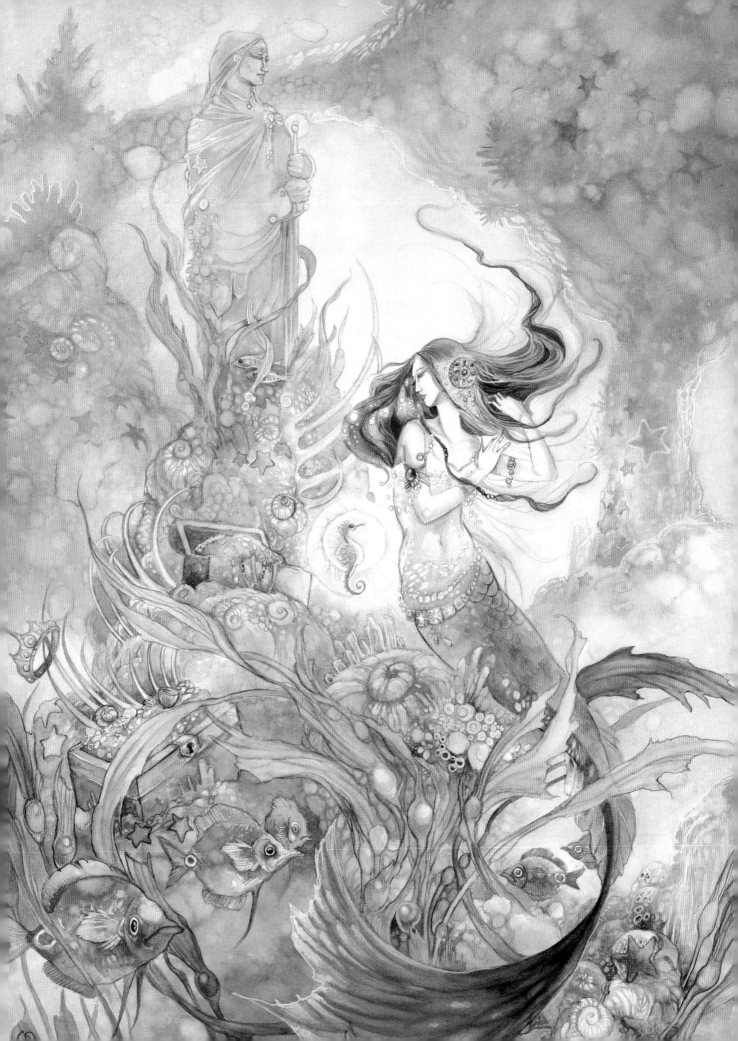

\mathcal{F}ish

Characteristics

dorsal fins- frequently more elaborate on tropical fish

tail- can be pointed, rounded, long and trailing or short and flat

eye, round and unblinking

mouth

gills

fins

Scales
Fish scales are layers of over-lapping little platelets.

Scales drawn flat to the viewer

Scales at an angled plane

Scales at an angled plane, following the gentle curve of a fish's body

Fins
Fins take many forms.

rounded and minimal like on a clown fish

long and flowing like a goldfish

angular like an angelfish

spiny like a salmon

bladed like a lionfish

Use Detail Sparingly When Depicting Scales
Most of the time, it's best not to depict each and every scale when drawing fish, as you don't want to overwhelm the viewer with miniscule and trivial details. Depending on the way light strikes and the way shadows fall, scales may appear seamless and not so readily apparent and distinct. Sometimes all you need to do is hint at the scale texture with judicious focus.

Range of Motions

A fish's body is fairly simple in its range of motions. It propels itself through the water with side-to-side movement of the tail. Think of the body as a tapered, flattened tube. The spine doesn't bend up or down. The body doesn't fold into squiggles or S-curves (unless it's an eel); it only bends one way or the other.

Lionfish

A lionfish has a deadly array of spiny fins fanning up from its body. The body itself is rather square and boxy. Seen from the front, it appears wide and fat.

Angelfish

Some fish, like angelfish, are very flat. When viewing them head-on, there's very little to see. From the side, however, you can see the long tapered mouth, the bulging dome of the body and the fanciful fins.

Demonstration
PAINT KOI

In many ancient cultures, fish were symbols of faith, abundance, fertility and plenty. They have always been the living harvest of the ocean, surging in infinite plenty upon the blue waters of life.

MATERIALS LIST

Surface ~ 6" × 5" (15cm × 13cm) illustration board

Brushes ~ nos. 0, 1, 2, 4 rounds

Watercolors ~ Burnt Sienna, Burnt Umber, Cadmium Orange, Cadmium Red, Cadmium Yellow, Lemon Yellow, Naples Yellow, Payne's Grey, Prussian Blue, Sap Green, Ultramarine Violet, Viridian Green

Other ~ salt

1 Sketch the Koi and Paint the Murky Waters
Sketch the koi swimming through the water. Include a water lily or lotus (a symbol of enlightenment) above the surface.

Apply a mix of Viridian Green + Payne's Grey with a no. 2 round, leaving some white bits. Paint over distant fish—you will glaze them in as darker shadows later. Sprinkle salt on the upper half of the piece (water surface). Remember to brush the salt away once it is dry.

2 Paint Shadowy Fish and the Water Surface
Apply a mixture of Prussian Blue + Burnt Umber + Payne's Grey to the fish with a no. 2 round. Blend the edges running parallel to the crosshatching strokes, showing the under layer for a hint of scales With a no. 4 round, glaze diluted Prussian Blue under the waterline. Then use a no. 2 round and a mixture of Viridian Green + Prussian Blue to glaze the ripples.

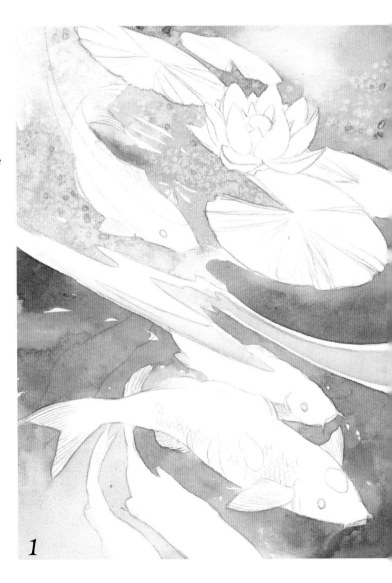

1

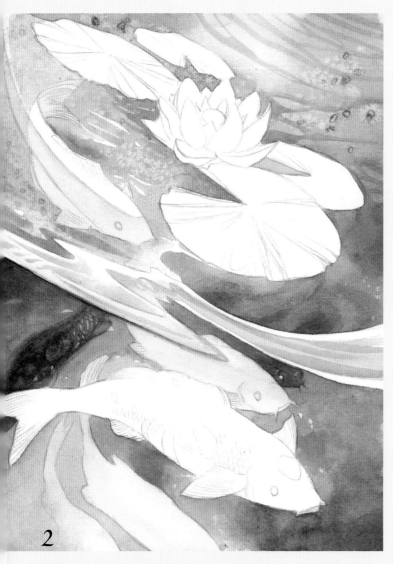

2

4

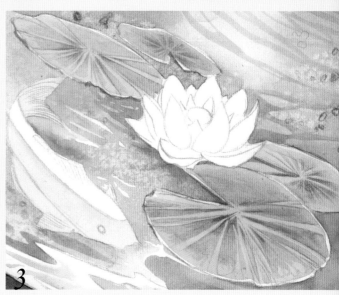

3

3 Paint the Lily Pads

Apply color to the lily pads with Sap Green and a no. 2 round. Use Burnt Sienna and a no. 1 round to create creases in the lily pads radiating outward from the center. The centers of the lily pads are under the water and should appear more shadowy. To achieve this effect, apply a light glaze of Prussian Blue with a no. 0 round.

4 Paint the Flower

Apply Burnt Sienna with a no. 1 round to create the shadows, making sure to leave some white edges. With a no. 2 round, apply a Lemon Yellow glaze on the flower and the edges of the surrounding lily pads. Leave the tips of the flower white. Create shadows in the deep crevices of the flower with Ultramarine Violet and a no. 0 round.

Receive a free bonus demonstration from the original *Dreamscapes* at **impact-books.com/DreamscapesMenagerie**

Above the Surface, Below the Surface

There is a contrast of textures when depicting above or below the surface of the water, whether combined into one piece as in this demonstration, or you are simply painting one or the other.

Above

The surface of the water is harsh with edges. Reflections and shadows appear on the water's surface. There may be ripples, waves and splashing droplets. It can be a mirror of reflective glass or a turbulent shifting chaos. Use texturing techniques on the surface of water. Use masking fluid if necessary for spraying wave droplets. Use high contrast for the ripples and waves.

Below

Beneath the surface of water, everything softens. In open sky, things in the distance become hazier due to atmosphere and interference. The same is true underwater, only more so. Even the clearest of water limits the range of vision, and distant objects rapidly become obscured into murky and blurred shadows. Use wet-on-wet techniques to blur edges and blend. Use graded washes for the background, blending it smooth with flat brushes. Use more subtle shading, and remember that lighting comes from above, lining the upper edges of objects with sunlight, unless you choose to have some alternative light source under water.

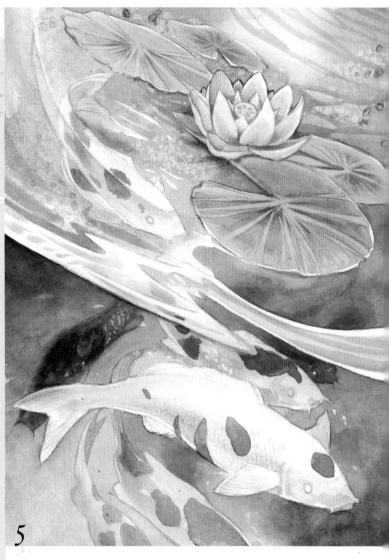

5

5 Paint the Fish Bodies

Using a no. 2 round and a mixture of Viridian Green + Ultramarine Violet, glaze in the shadows of the fish. Then apply a diluted glaze of Cadmium Yellow on the tops of the fish with a no. 4 round. Glaze various spots on the bodies of the fish using a no. 1 round and a mixture of Cadmium Orange + Cadmium Red.

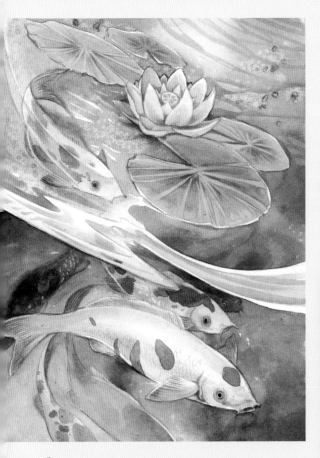

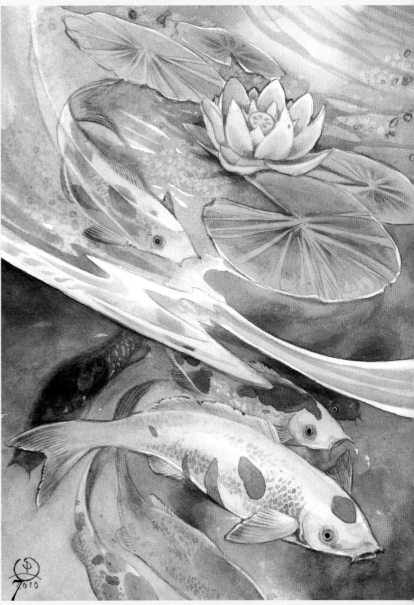

6 Finish the Bodies and Paint the Fins and Tails

Using a no. 0 round, glaze Cadmium Yellow on the body of the top fish. With Payne's Grey, glaze spots on the tops of the fins and tails. Continue adding texture to the fins, tails and shadows around the eyes.

Switch to a no. 1 round and with diluted Viridian Green, lightly brush over to soften the texture on the fins and tails. Run a strip of Cadmium Yellow glaze down the back of the largest fish with a no. 1 round.

7 Add Scales to Finish

With a no. 0 round, add scales on the white areas of the fish using a mixture of Payne's Grey + Ultramarine Violet. On the gold areas and upper sides, add highlights with Naples Yellow. You don't need to depict all of the scales. Just hint at them on the foreground fish.

Demonstration
PAINT AN EEL

In Polynesian lore, there are many stories of Te Tuna, the god of eels, who was husband to the goddess Hina before she left him for the hero/demigod Maui.

MATERIALS LIST

Surface — 4" × 4" (10cm × 10m) illustration board

Brushes — ½-inch (12mm) flat, nos. 0, 1, 2 rounds

Watercolors — Burnt Umber, Cerulean Blue, Naples Yellow, Payne's Grey, Prussian Blue

Other — sponge

1 Sketch the Eel and Paint the Background

Sketch an eel sliding along the sandy ocean floor, with its sinuous body whipping through the waters. Paint Naples Yellow into the background with a ½-inch (12mm) flat. Dab with a sponge to create texture while the paint is still wet.

Using a ½-inch (12mm) flat and Prussian Blue, start at the top of the page and glaze a graded wash going down about halfway. Switch to a no. 2 round and drybrush in some sandy shadows with a mixture of Burnt Umber + Prussian Blue, letting the brush skip a bit.

2 Paint the Eel

Use a no. 1 round and a mixture of Burnt Umber + Payne's Grey to paint the pattern on the eel's body. Mix more Payne's Grey as you move back toward the tail.

With a no. 0 round, paint Burnt Umber in parallel strokes along the fins. Blend and smooth the texture by running a stroke of clean water with a no. 2 round along the length of the fins.

With a no. 2 round, glaze Cerulean Blue along the underside (belly) of the entire length of the eel. Glaze along the top of the eel with Naples Yellow.

3 Add Spots and Other Details to Finish

Add spots along the body using a no. 0 round and a mix of Payne's Grey + Prussian Blue. Leave a rim of white on each spot. Finish the details of the eye and mouth with concentrated Payne's Grey. Add a touch of shadow on the underside of the body.

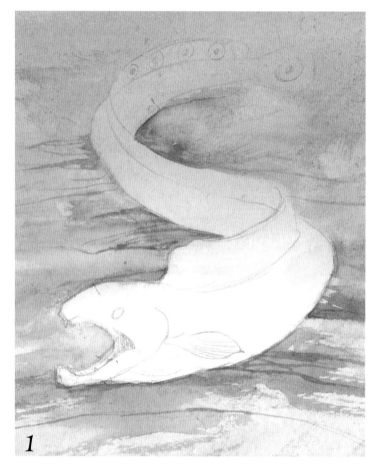

1

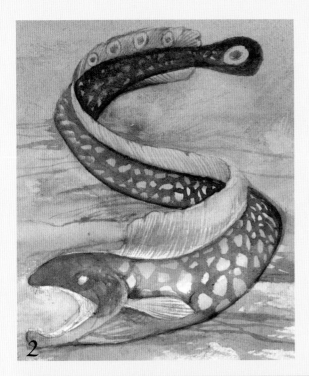

2

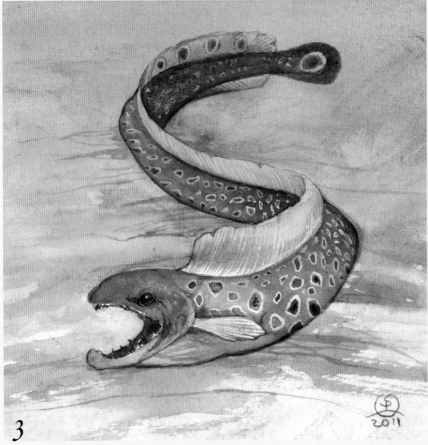

3

ea Horses

A SEA HORSE'S LONG TAIL IS FLEXIBLE. IT WINDS around underwater plant life and coral as the sea horse moves about, anchoring him against the swaying currents. The tail twines around objects, the same way a snake winds around a branch.

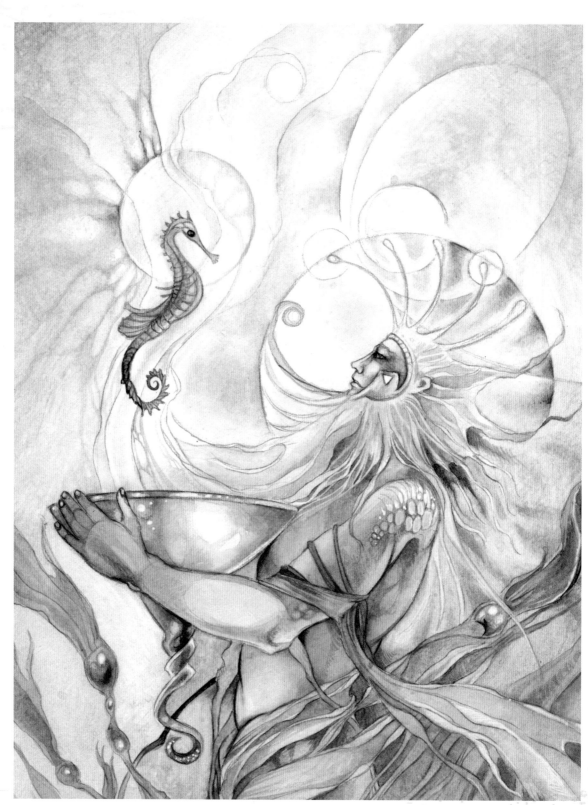

Demonstration
DRAW A SEA HORSE

The basic shape of a sea horse is very simple. Its body has a spiny exterior with segmented ridges.

MATERIALS LIST

Surface — acid-free art paper

Other — eraser, pencil

1

2

3

4

5

1 Sketch the Basic Form
Sketch a serpentine shape for the body and a trapezoid-shaped head (like a horse with an elongated snout). Make a bulge at the midsection and a hooked tail.

2 Draw Vertical Guidelines
The body is ridged and segmented, so start off by delineating these segments vertically.

3 Draw Horizontal Guidelines
Using light strokes, delineate the horizontal segments as well. You will use these mostly as guides mostly as guides.

4 Add Texture and Fins
Add the spikes and prickles based on the segments you outlined in the previous two steps. Add the fin along the back and the small fin along the head.

5 Add Final Details
Finish up with shading and painting. Add any markings and patterns you like.

Demonstration
PAINT A SEA HORSE

Sea horses are symbols of power, strength and tenacity—emblems of Poseidon. With their sinuous bodies and fantastical spiny forms and colors, they are real-world sea dragons. Sailors in times of old often saw them as symbols of good luck.

MATERIALS LIST

Surface ～ 6" × 5" (15cm × 13cm) illustration board

Brushes ～ ½-inch (12mm) flat, nos. 0, 1, 2, 4 rounds

Watercolors ～ Alizarin Crimson, Cadmium Orange, Lemon Yellow, Naples Yellow, Prussian Blue, Ultramarine Blue, Ultramarine Violet, Viridian Green

Other ～ rubbing alcohol, salt

1 Sketch the Sea Horse and Paint the Background
After you sketch the sea horse and coral, paint the background waters using a ½-inch (12mm) flat and a mix of Prussian Blue + Viridian Green. Concentrate the color toward the corners so the areas nearest the sea horse are lighter. While the paint is still wet, flick some rubbing alcohol into splattered droplets with a no. 4 round. This adds texture and bubblelike lighter areas.

With diluted Ultramarine Blue, use a no. 4 round to bring the background in closer to the edges of the sea horse and all the nooks and crevices. Blend outward into surrounding areas with clear water. Paint a thin glaze along the bottom edge of the page, about a quarter of the way up, blending into the surrounding blues. While the paint is still wet, sprinkle with salt. Brush the salt away when the paint has dried.

2 Paint the Coral
Paint the coral with a no. 2 round and a mix of Ultramarine Violet + Alizarin Crimson. Leave a thin edge of white paper showing through for highlights.

Use a no. 1 round and a mix of Viridian Green + Ultramarine Violet to add some latticework texture to the coral. With clean water, lift along the white edges with a stiff no. 1 round. It is easiest to brush parallel to the edge that you are lifting from. Lift out little bits from the textured areas in the main body of the coral as well.

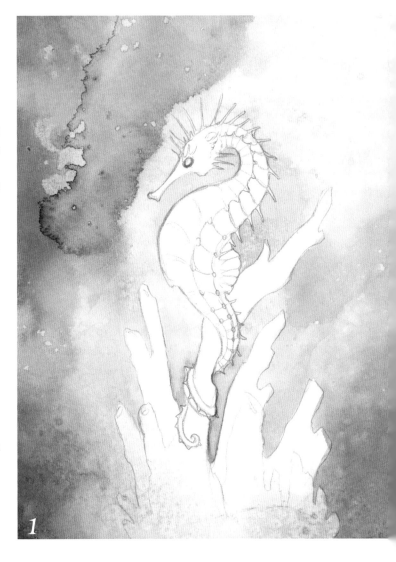

1

2

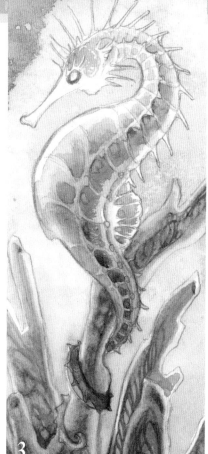

3

Paint the Sea Horse

Paint wet-into-wet with a no. 1 round. Start with Lemon Yellow on the head, dabbing in Naples Yellow, Cadmium Orange and bits of Ultramarine Violet as you move down the length of the body. Let the colors spread into one another.

Mix Alizarin Crimson and Cadmium Orange. With a no. 0 round, paint along the ridges of the sea horse's back, making sure to allow the previous layer of colors to show through for highlights. Working wet-on-wet, dot a little bit of Prussian Blue toward the left edge. As you move down the tail, use more Alizarin Crimson and less Cadmium Orange so the tones slowly darken.

Continue along the front side of the sea horse with the same sort of treatment. Use Naples Yellow on the belly for the base tone, and dot wet-on-wet Ultramarine Violet toward the right side. Leave the outer left edge white. Do the same for the back fin.

Add Final Details

Use a no. 0 round to glaze the head and area around the eye, with a mix of Alizarin Crimson darkened with a bit of Prussian Blue. For the spines down the back, paint with Alizarin Crimson using a no. 0 round. With some clean water, trail the tips of the spines outward so they blend into the surroundings. Darken the underside of the belly with a bit of Prussian Blue mixed into the Alizarin Crimson. Use this same mixture to finish the eye.

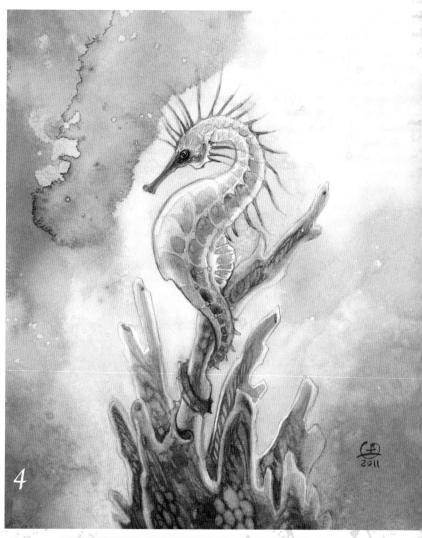

4

Demonstration
PAINT A SEA TURTLE

In Punalu'u, Hawaii, legend tells of a turtle who pulled herself from the sea and laid an egg in the black sands before returning to the water. From the egg hatched a young girl who was gifted with the powers of shape-shifting. She was named Kauila. At night she changed into a sea turtle. By day she played with and protected the children of Punalu'u, as well as protect the pure spring in the area. The people of Punalu'u loved her for that.

MATERIALS LIST

Surface ～ 6" × 7" (15cm × 18cm) illustration board

Brushes ～ ½-inch (12mm) flat, nos. 0, 1, 2, 4 rounds

Watercolors ～ Burnt Umber, Cadmium Yellow, Lemon Yellow, Naples Yellow, Payne's Grey, Prussian Blue, Sap Green, Ultramarine Blue, Ultramarine Violet, Viridian Green

Other ～ salt

1 Sketch the Piece and Paint the Background

Sketch a sea turtle gliding through the ocean waters with a school of fish.

With a no. 4 round, paint Ultramarine Blue into the background and blend outward with water. Don't worry about painting over some of the more distant background fish, as they will be layered with more blue later. The foreground fish will eventually be painted yellow, so maintain the white of the page fro those.

Mix Viridian Green + Prussian Blue. With a no. 4 round, fill in the rest of the background, blending out into the Ultramarine Blue. Sprinkle with salt while the paint is still wet. Brush the salt crystals away once the layer is dry.

With a ½-inch (12mm) flat brush, lightly glaze a mix of Payne's Grey + Prussian Blue in the upper left and lower right corners. This will smooth out the textures a bit and help focus the viewer's attention on the turtle.

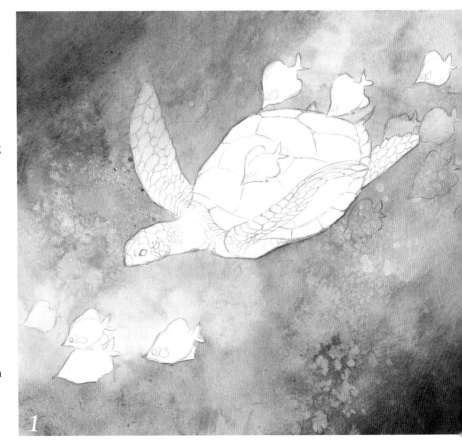

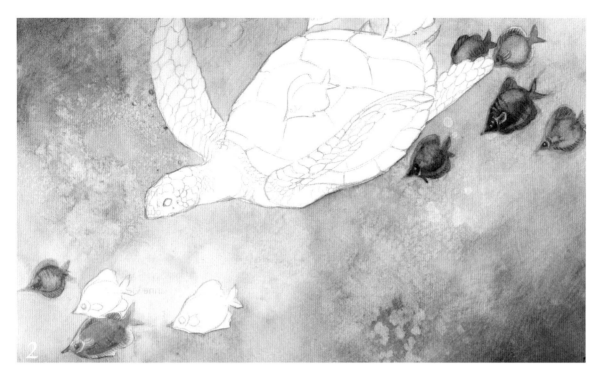

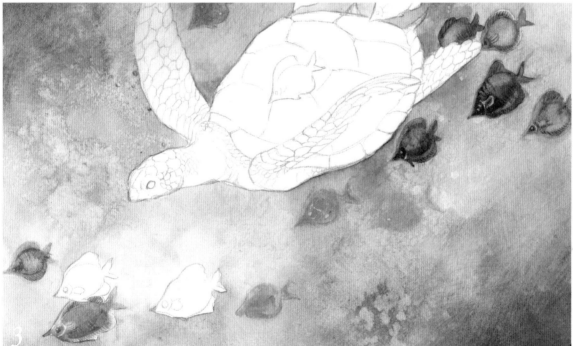

2 Paint the Background Fish

Paint the more distant fish with a no. 2 round and a mix of Payne's Grey + Prussian Blue. Be sure to leave some fish for the foreground later.

With a stiff-bristled no. 2 round, lift some highlights on the fish bodies and dab along the edges of them to soften the outlines a bit.

With the same mixture of Prussian Blue + Payne's Grey, use a no. 0 round to fill in some finer shaded detail on the fish. With short parallel strokes, add some texture to the fins and darken the area around the eyes.

3 Add Some Hazy Fish

Add a few more hazy fish with a no. 1 round and Prussian Blue. Blend their edges into the surrounding waters. I purposely did not use pencil to sketch these fish so they would have completely soft edges.

Receive a free bonus demonstration from the original *Dreamscapes* at **impact-books.com/DreamscapesMenagerie**

4 Paint the Turtle Base Colors and Scales

Mix Sap Green, Burnt Umber and a touch of Prussian Blue. Glaze the body of the turtle with a no. 2 round. While the paint is still wet, trail some Lemon Yellow along the front of both flippers and across the top of the head. Leave edges of white highlights. Use a mixture of Sap Green and Burnt Umber with a no. 2 round for the carapace, and trail Lemon Yellow wet-on-wet along the carapace on the turtle's left side.

Mix Naples Yellow and Prussian Blue with a little bit of Burnt Umber. Use a no. 0 round and variations of this mixture for the turtle's scaly skin. Use more Prussian Blue in the mixture on the top of the head and the underside of her left flipper. Allow the previous layer to show through between the scales for the webwork texture.

With a no. 2 round, glaze Ultramarine Blue on the underside of the turtle's left flipper, being careful to leave the edge of Lemon Yellow untouched.

With a no. 0 round, dot the centers of the larger scales with a glazed bit of Viridian Green. Mix Payne's Grey with Viridian Green to shade the underside of the body with a no. 2 round.

Add a little more color variation to the scales by dotting centers of the scales on the tips of the flippers and head with a no. 0 round and a glaze of Ultramarine Violet. Darken the eye and add some shading underneath where the carapace meets the body with Ultramarine Violet.

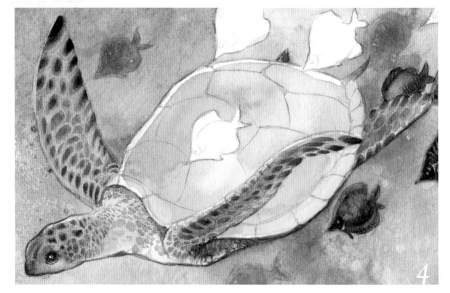

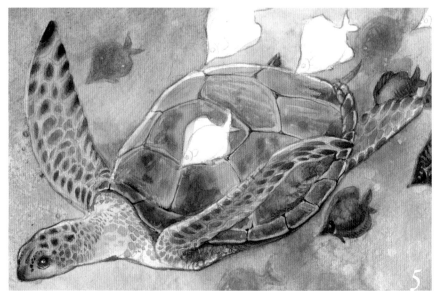

5 Paint the Carapace

Using a no. 2 round, paint the carapace with a mixture of Viridian Green and Payne's Grey, streaking wet-on-wet with some Ultramarine Violet. With a no. 2 round, glaze the carapace with a very light layer of Lemon Yellow to soften and blend the edges a bit. Dot wet-on-wet with Ultramarine Violet along the lower half. Keep the top edge white. With a no. 0 round, use Payne's Grey on the cracks and crevices of the carapace.

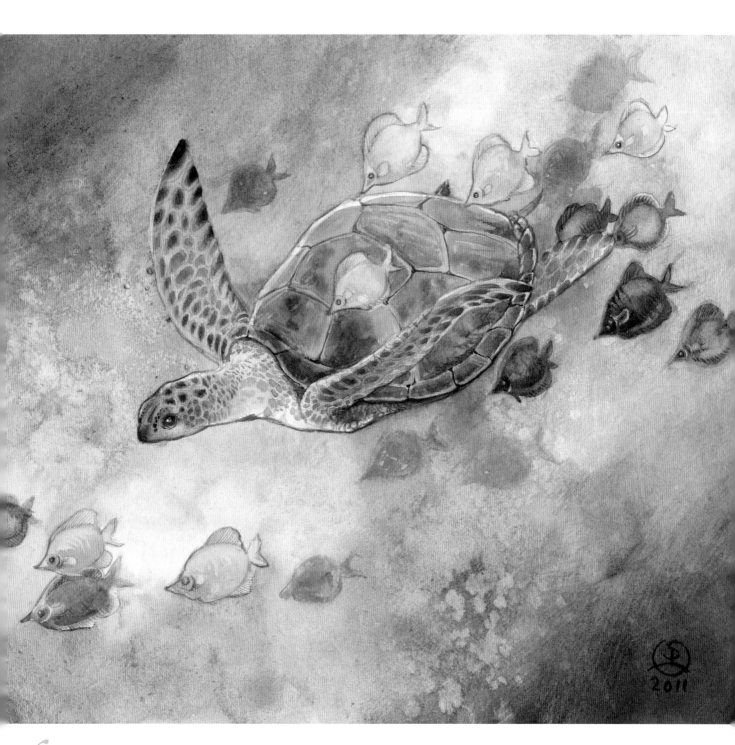

6 Paint the Foreground Fish to Finish
Use a no. 2 round and Cadmium Yellow to paint the fish. Add shading
with a no. 1 round and Naples Yellow. Use a no. 0 round and a very fine touch
to add short parallel strokes of Payne's Grey to the fins for texture. Then dot
the eyes and the edges of the gills.

Ys

Many legends speak of vanished cities sunk beneath the hungry ocean waves. One of the most famous is the beautiful city of Ys. Legend tells us there was once a King of Brittany named Gradlon. He fell in love with a sorceress, Malgven, and she gave birth to their daughter, Dahut, on the shifting ocean waves.

Malgven died in childbirth. To honor her, King Gradlon built the most glorious and beautiful city whose white towers speared the skies. Ys was protected from the deadly waters by bronze walls and a gate to which Gradlon held the only key.

Gradlon doted on his daughter, Dahut, who grew to be a lovely young woman, but she reveled in debauchery. Ys was transformed into a haven for her wicked ways.

One day a mysterious red knight came to her and convinced her to steal the key to the city gates. The knight turned out to be the devil. The gates to Ys were opened, and a raging storm came crashing through the bronze doors, flooding the city.

Gradlon understood what happened when he found the key missing. He raced through the palace to his magical steed, Morvarc'h. They flew up above the waves that were quickly enveloping Ys in their saline embrace.

Gradlon caught sight of Dahut and pulled her up behind him on Morvarc'h, attempting to fly away. Time and again she slipped, and Morvarc'h struggled to stay above the clawing waves. A saint appeared to Gradlon telling him, "You must abandon the demon who sits behind you." Gradlon resisted, but eventually Dahut slipped from his grasp, falling back into the ocean where she was transformed into a mermaid, forever to swim among the ghostly Ys.

Sea Dragons

Sea dragons are often described as serpentine—sliding and coiling through the dark waters. The crests of their backs are like rolling, towering tidal waves. Their thunderous voices can be heard in the echoing crash and elemental fury of the open ocean. The terror of the sea dragon is tied to the unknowable fathoms that lie far beyond the threshold of where man can delve.

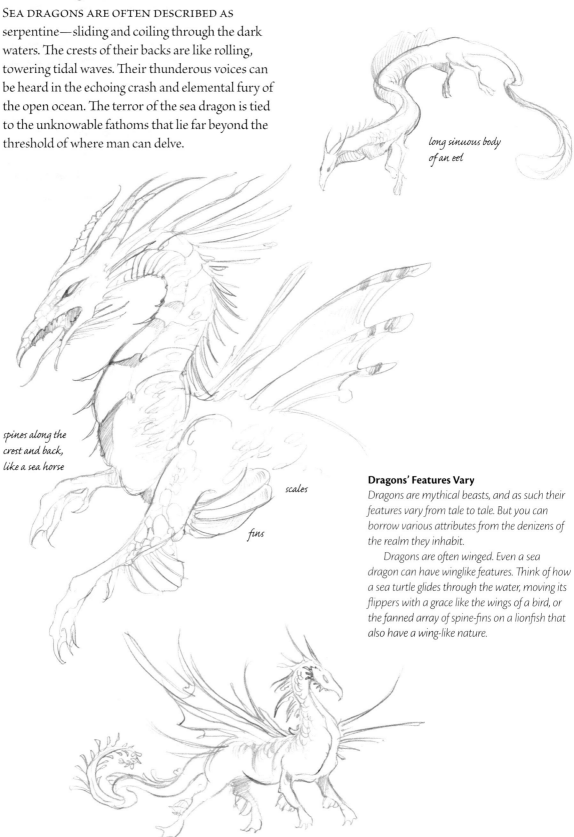

long sinuous body of an eel

spines along the crest and back, like a sea horse

scales

fins

Dragons' Features Vary

Dragons are mythical beasts, and as such their features vary from tale to tale. But you can borrow various attributes from the denizens of the realm they inhabit.

Dragons are often winged. Even a sea dragon can have winglike features. Think of how a sea turtle glides through the water, moving its flippers with a grace like the wings of a bird, or the fanned array of spine-fins on a lionfish that also have a wing-like nature.

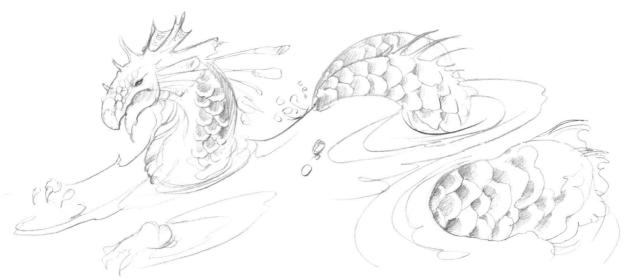

Let the surge of surf along a shoreline or the deeper roiling troughs and crests of the open ocean be the inspiration for the coiled lengths of a sea dragon's body.

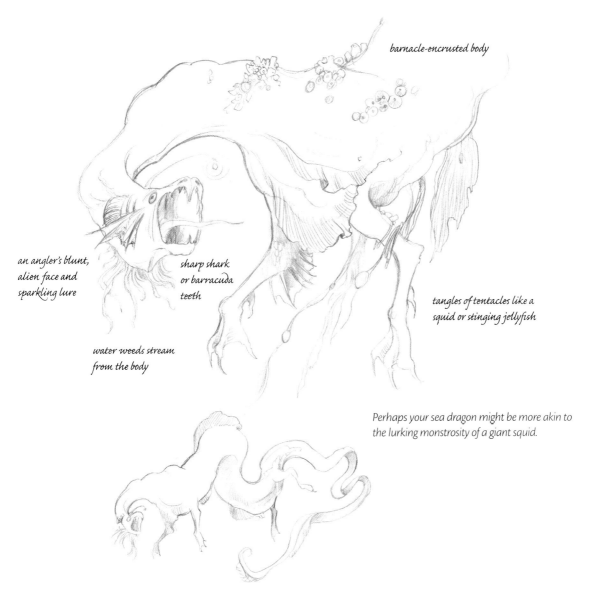

barnacle-encrusted body

an angler's blunt, alien face and sparkling lure

sharp shark or barracuda teeth

tangles of tentacles like a squid or stinging jellyfish

water weeds stream from the body

Perhaps your sea dragon might be more akin to the lurking monstrosity of a giant squid.

Demonstration
PAINT A SEA DRAGON

In Babylonian mythology, Tiamat was a primordial goddess of the ocean and chaos and creation. From her body the world of heaven, earth and sea was created. In modern interpretations, she is often depicted as a sea dragon, and she spawned many dragons, serpents and scorpion men.

MATERIALS LIST

Surface — 7" × 10" (18cm × 25cm) illustration board

Brushes — ½-inch (12mm) flat, nos. 0, 1, 2, 4 rounds

Watercolors — Alizarin Crimson, Cerulean Blue, Ivory Black, Naples Yellow, Payne's Grey, Prussian Blue, Sap Green, Ultramarine Blue, Viridian Green

Other — paper towels, rubbing alcohol, salt

1 Sketch the Piece
Sketch a sea dragon's body melding into the roiling, churning waves as if it were an elemental incarnation of the very waters themselves.

2 Paint the Underwater Background
With a ½-inch (12mm) flat, wash a mix of Cerulean Blue + Ultramarine Blue into the underwater background. Work wet-on-wet and wash diagonally over the hazy seaweed with a no. 2 round and Payne's Grey + Cerulean Blue. It is okay to paint over the seaweed, but try to paint around the dragon's legs. Glaze a layer of Payne's Grey + Prussian Blue in the lower corners of the piece with a ½-inch (12mm) flat.

3 Paint the Seaweed
With a no. 2 round, glaze a layer of Payne's Grey + Naples Yellow over the three strands of seaweed that flow across the front from the bottom left. (For a brighter tone, use only Naples Yellow.) Use the same mix of Payne's Grey + Naples Yellow with a touch of Prussian Blue for the remainder of the foreground seaweed. Apply a light glazing of Prussian Blue to the more distant stalks of seaweed.

1

2

3

4

5

Paint the Sky
Paint the sky with a no. 4 round and Ultramarine Blue. Then splatter with rubbing alcohol.

Paint the Clouds
Paint the clouds with a no. 2 round and a mix of Ultramarine Blue + Payne's Grey. Be sure to leave some white. With a ½-inch (12mm) flat, glaze Payne's Grey and water into the upper corner toward the right. While the paint is still wet, dab it with a paper towel to add more cloud highlights.

Add detail to the clouds with a no. 2 round and a mixture of Ultramarine Blue + Payne's Grey.

Paint the Water Surface
Begin painting the surface of the water with a no. 2 round and Ultramarine Blue. Sprinkle with salt. When the surface is dry, brush away the salt.

Blend the Waves, and Add Shadows and Highlights
Glaze a light mixture of Viridian Green + Prussian Blue over the water surface with a ½-inch (12mm) flat. Blend the paint using brushstrokes that follow the contours of the waves.

Use mixtures of Prussian Blue + Viridian Green and Ultramarine Blue + Payne's Grey with a no. 1 round to add shadows and highlights on the ripples of waves. Follow the contours of the troughs of the waves.

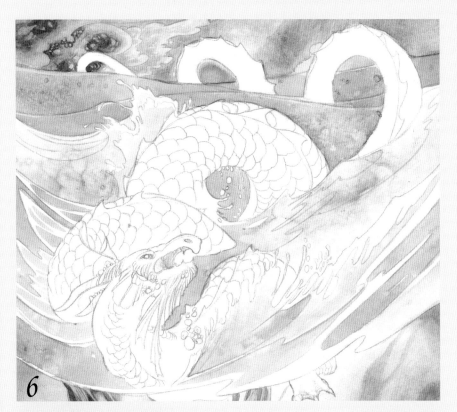

6

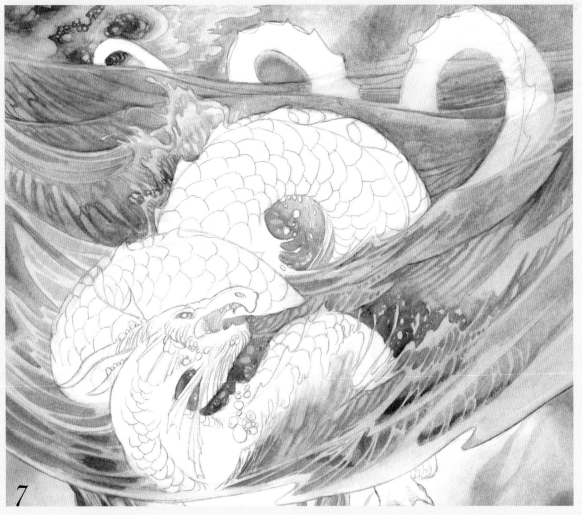

7

8 Begin Painting the Sea Dragon

With a no. 2 round, paint the dragon's head with Naples Yellow. Begin painting the body with a wet-on-wet mix of Prussian Blue + Sap Green + Viridian Green, increasing the concentration of blues as you near the tail.

9 Paint the Scales

Paint the scales using nos. 0, 1 and 2 rounds and Prussian Blue + Viridian Green with a touch of Payne's Grey. Add more blue under the waterline as you work back toward the tail.

With a no. 4 round, using brushstrokes that follow along the length of the body, paint a diluted mixture of Payne's Grey + Ultramarine Blue along the shadowed areas.

Apply Prussian Blue + Viridian Green with a no. 0 round to darken the scales and add some shadowy bits of green color in the water.

10 Add Details to Finish

Use a no. 0 round and Payne's Grey mixed with a tiny bit of Alizarin Crimson for the inside of the mouth. Leave little white fangs for the teeth. Apply Payne's Grey to the nostrils and horns, and lift out highlights on the horns. Add Naples Yellow along the underside of the face, and glaze it lightly along the spine of the dragon as well. Paint the eye Ivory Black.

8

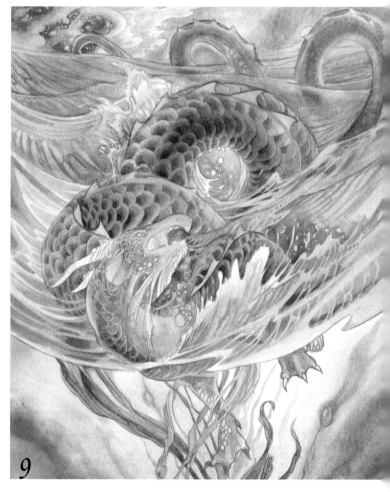

9

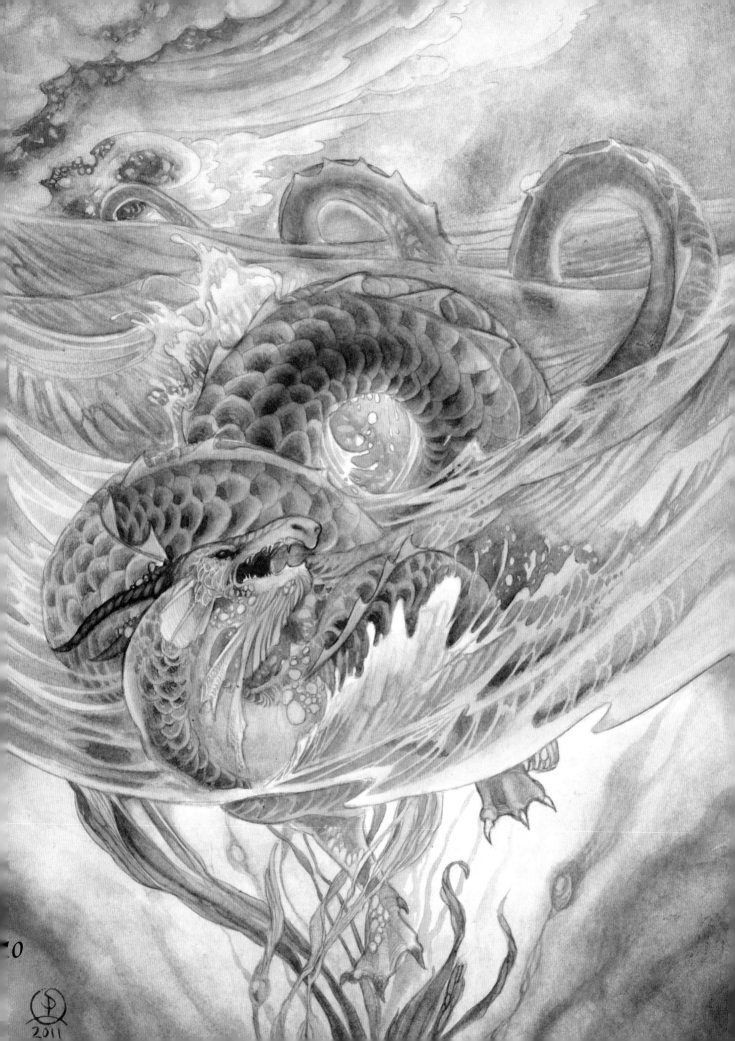

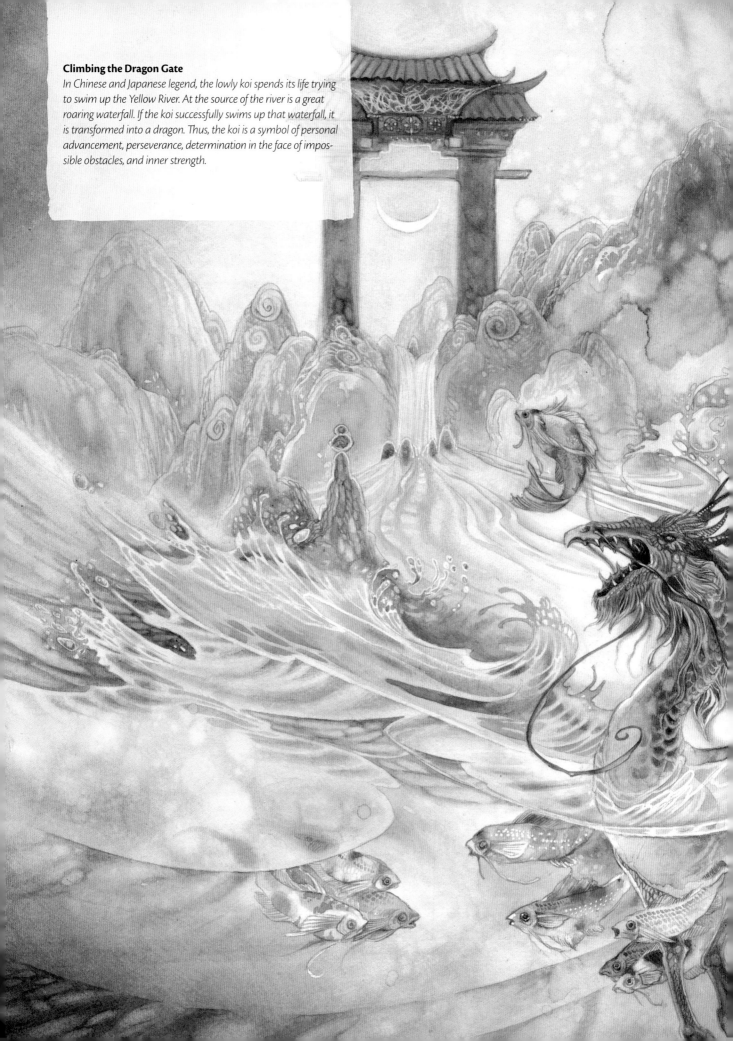

Climbing the Dragon Gate
In Chinese and Japanese legend, the lowly koi spends its life trying to swim up the Yellow River. At the source of the river is a great roaring waterfall. If the koi successfully swims up that waterfall, it is transformed into a dragon. Thus, the koi is a symbol of personal advancement, perseverance, determination in the face of impossible obstacles, and inner strength.

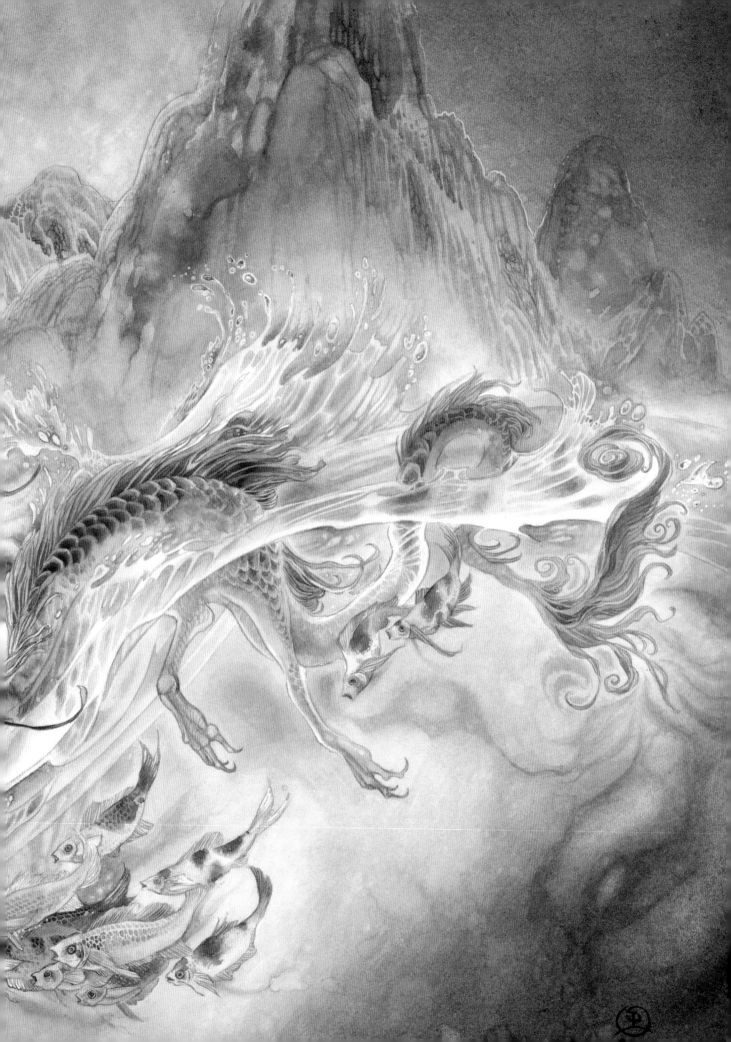

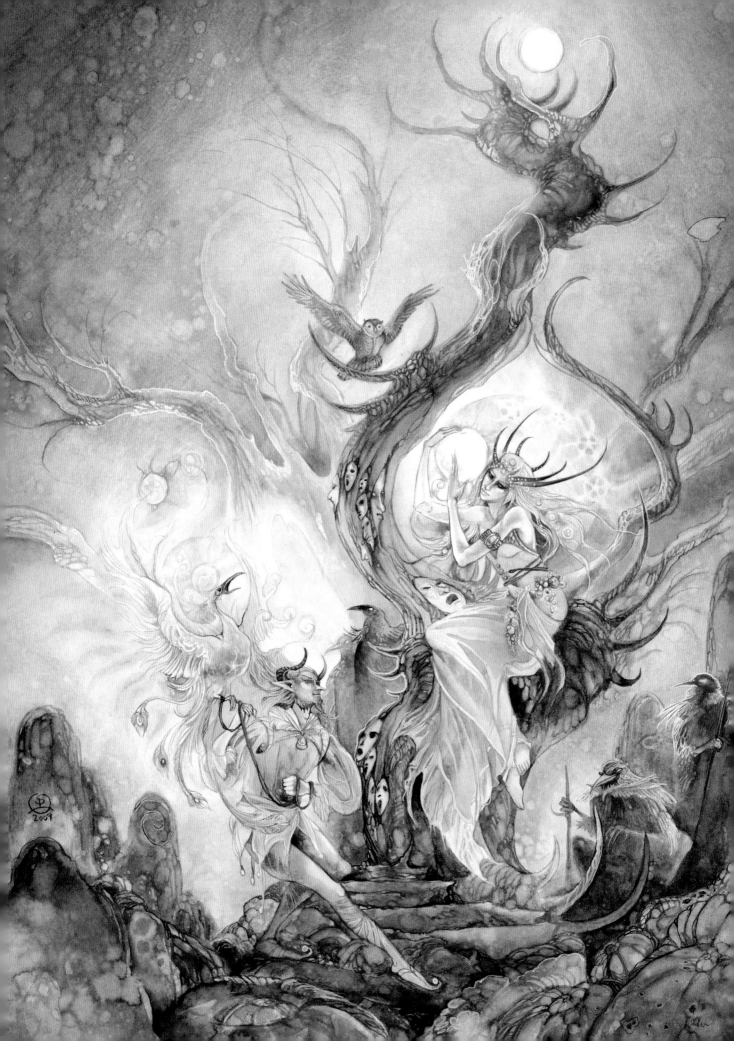

Part Three
SKIES

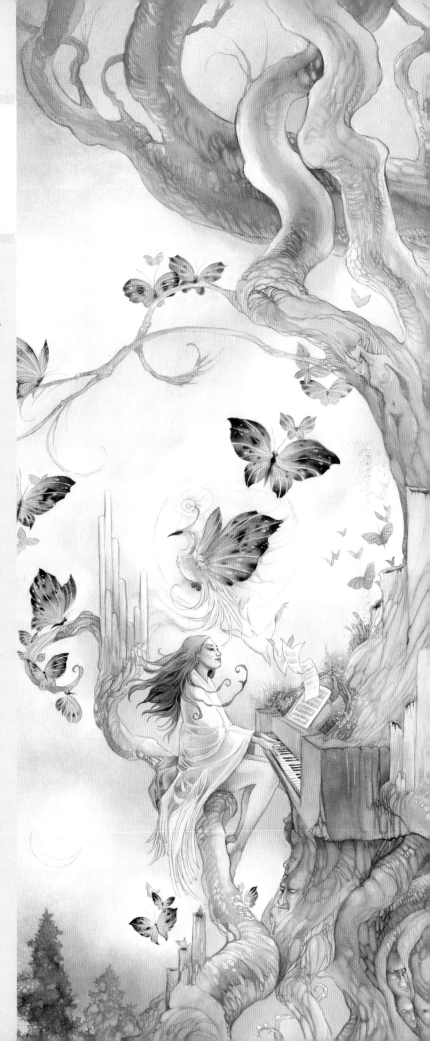

WINGS HAVE ALWAYS HAD A TRANSCENDENTAL
association in the minds of men. What we would give to
fly with the effortless wonder of birds and their kindred!
With that endless yearning in our hearts, it is no wonder
myths are riddled with winged ones as messengers and
companions to gods, bringers of blessings or curses and
creatures of omen and portent.

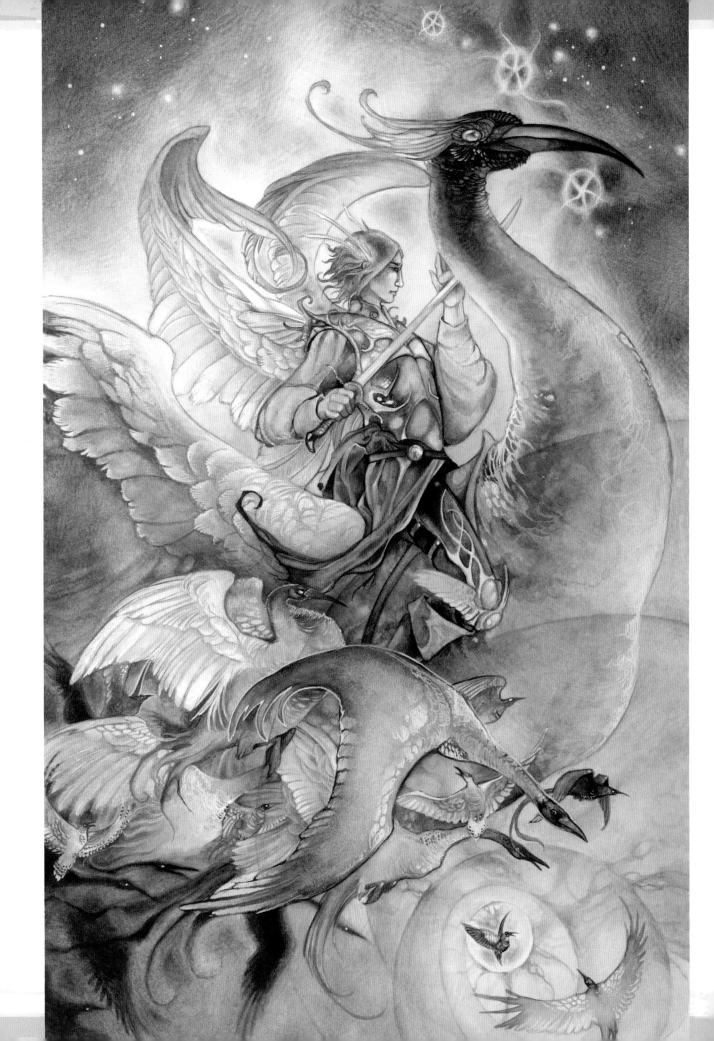

Birds

PERSONALITY AND INDIVIDUALITY CAN BE conveyed through a bird's head and eyes, the same way human expressiveness can be conveyed through the hands.

Egret: Slender long legs for wading through shallow waters, and a sinewy neck and long pointed bill to spear darting fish

Bird Characteristics

A bird's body, bill and feet reflect the characteristics the bird requires to survive in its locale—whether sea, jungle or plains.

Condor: Large hooked bill of a raptor for tearing at meat and prey

Finch: An insect, seed or fruit eater's compact pointed bill for probing into plants and through grasses and bark

Body Language and Sight

The eyes of birds are fixed in their sockets and do not move. A bird must move its entire head in order to watch something, which is why a bird cocks its head to eye items of interest. Keep this in mind when drawing birds to realistically capture the way they look at things.

Head twists to the side when something of interest draws the bird's attention.

Head lifts and stretches out as something catches her attention a little ways off. Hop forward!

Head cocks to the side to examine a bug or twig on the ground

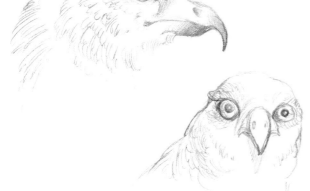

Placement of Eyes

Predators tend to have more developed binocular vision (eyes more toward the front of the skull). Other nonpredatory birds have eyes at the sides of their heads for an all-around view. Take note of how the feathers frame the eyes and bill area. There is an order to the pattern. The feathers grow in a fan around the eyes and proceed outward, down the sides of the face and the back of the head.

Receive a free bonus demonstration from the original *Dreamscapes* at **impact-books.com/DreamscapesMenagerie**

Demonstration
PAINT BIRD EYES

Most of the time you won't zoom in enough to paint this level of detail. Close-up, however, the eyes of a bird seem to glow with a captivating intensity and a gem-like quality.

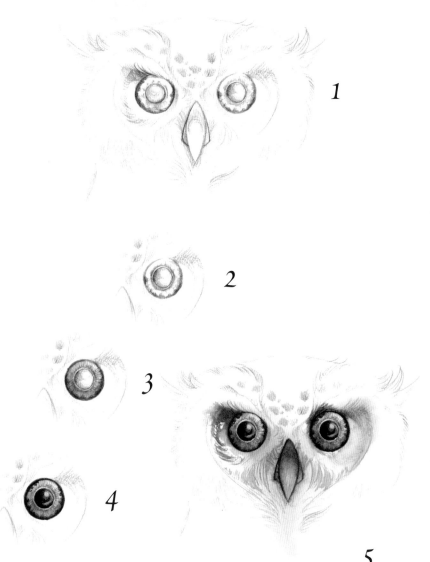

MATERIALS LIST

Surface — illustration board

Brushes — nos. 0, 2 rounds

Watercolors — Burnt Sienna, Cadmium Orange, Payne's Grey, Sap Green, Ultramarine Violet

1 Sketch the Piece
Finer detail in the pencil sketch can aid in contributing bits of shadow and texture.

2 Begin Painting the Iris
Using a no. 2 round, paint Sap Green on the iris around the rim of pupil. Leave a boarder of white between pupil and iris.

3 Continue With the Iris
With Cadmium Orange and a no. 2 round, continue painting the iris, blending the edges into the Sap Green. With a no. 0 round and Burnt Sienna, add texture by painting radiating lines out from the center.

4 Paint the Pupil
With a no. 2 round, paint Payne's Grey into the pupil. Leave white bits for highlights and blend with water to smooth the edges. Add some Payne's Grey around the edges of the iris.

5 Add Feathers to Finish
Using a no. 0 round, brush in some Ultramarine Violet for the feathers around the eyes. Use loose strokes that move outward. Then brush over lightly with clear water to soften the edges of these lines.

Wings and Feathers

Types of Feathers

- **Down feathers** are short, soft and fluffy. They help insulate the bird. You only see them peeking out between gaps of larger feathers.
- **Contour feathers** have a more defined form. These surface feathers show a bird's colors and patterns, and are what you draw the most of when sketching a bird. They have interlocking barbs that give the filaments along the length of the feather a smooth appearance.
- **Flight feathers** are the large feathers that make up the wings and tail.
- **Plumes** are long with loose vanes running along their length. They can be colorful or patterned for courtship displays.

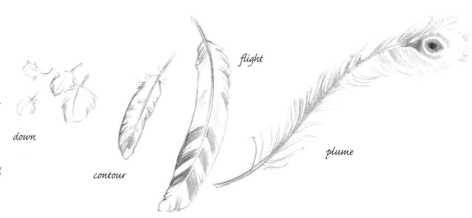

down

contour

flight

plume

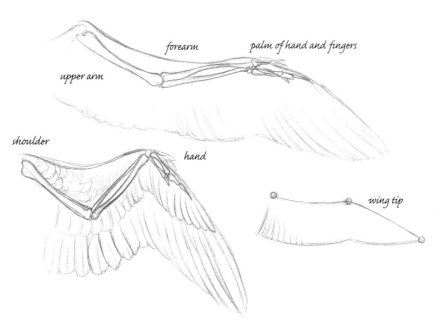

upper arm

forearm

palm of hand and fingers

shoulder

hand

wing tip

Wing Structure

The structure underlying a wing is much like that of a human arm. The muscles connect to make a smooth curve from the shoulder to the hand. Because there is not as much of a crease at the elbow as with a human arm, the prominent angles you see are shoulder, hand and wing tip. The wing tip extends far beyond where the fingers actually end. The feathers give a tapering triangular shape to the wing overall.

Sketching Wings and Feathers

Don't worry about details at first. Draw the basic form and sketch in some guidelines for laying out the feathers. Then proceed with the finer details and fill in the specifics of the feathers. The feathers of the wings and tail overlap laterally so they can form a flat plane. When not in flight, the wings fold up and tuck in at the sides of the body.

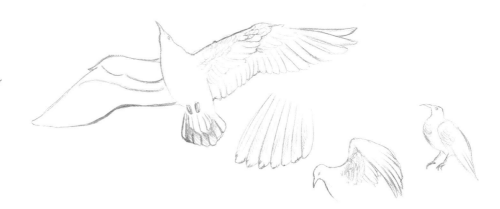

\mathcal{F}light

WHEN DRAWING BIRDS, THINK OF ACTION.
Their wings are in constant motion as they move
through the skies.

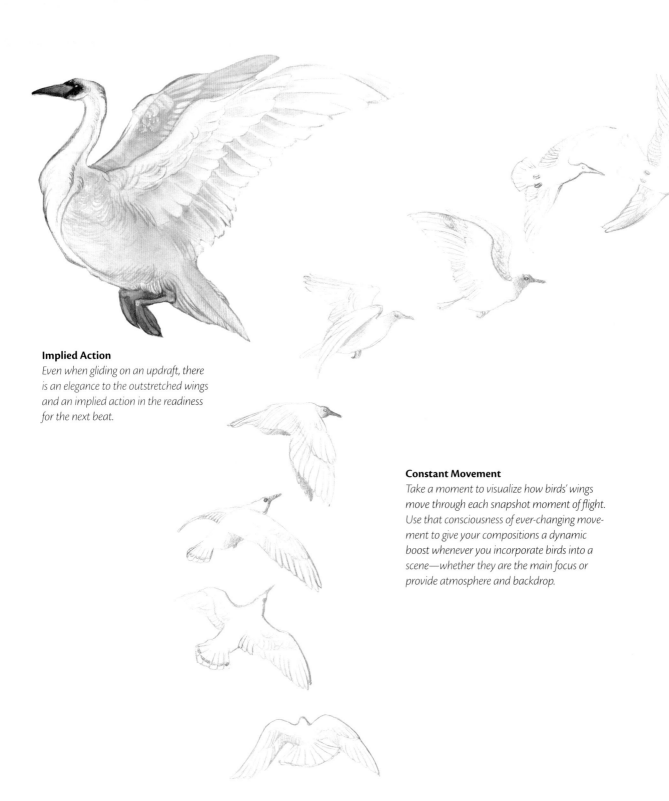

Implied Action
*Even when gliding on an updraft, there
is an elegance to the outstretched wings
and an implied action in the readiness
for the next beat.*

Constant Movement
*Take a moment to visualize how birds' wings
move through each snapshot moment of flight.
Use that consciousness of ever-changing move-
ment to give your compositions a dynamic
boost whenever you incorporate birds into a
scene—whether they are the main focus or
provide atmosphere and backdrop.*

Demonstration
PAINT A MOURNING DOVE

A mourning dove's lament is a distinct song in the morning air. The cooing of the males during nesting season is a sign of early spring. Doves symbolize peace, spirit, faith and hope. In the Bible, Noah sent a dove from the ark to seek dry land. The dove returned with an olive leaf, a hopeful green sign that in the terrible drowning sea there was a tree somewhere, and land at last.

MATERIALS LIST

Surface ~ 5" × 6" (13cm × 15cm) illustration board

Brushes ~ ½-inch (12mm) flat, nos. 0, 1, 2, 4 rounds

Watercolors ~ Burnt Umber, Cadmium Red, Naples Yellow, Payne's Grey, Prussian Blue, Ultramarine Blue, Ultramarine Violet

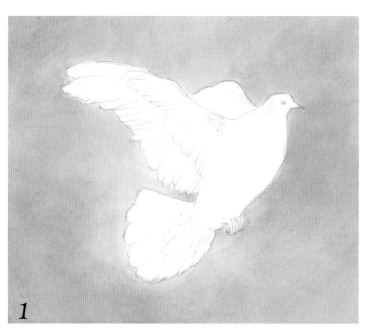

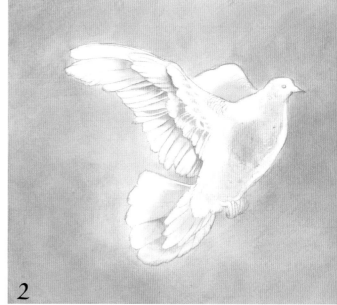

1 Sketch the Dove and Apply the First Layer of Background Color
Sketch the dove and paint a wash of Prussian Blue in the background with a ½-inch (12mm) flat. Use a no. 4 round if you need a finer point to get into the corners around the wings and feet.

2 Add Shadows
Using a no. 4 round, paint shadows on the wings and tail with a mixture of Payne's Grey + Ultramarine Blue. Paint Ultramarine Violet shadows on the body and head. Don't be afraid to let the mixture of colors vary in tone.

3 Add Color

With a no. 4 round, add a light glaze of Burnt Umber over the dove's breast. Glaze Naples Yellow over the head and lower body, and glaze Payne's Grey over the wings and tail. Keep these glazes fairly diluted so their intense colors are not overwhelming.

4 Paint the Color Patterns, and Detail the Feathers

Mix Payne's Grey + Ultramarine Blue. Using a no. 2 round, blend a glaze of color inward from the edges of the wings and tail. Add the heavier-colored markings on the tail as well. Use a no. 0 round to add finer details along the larger wing tip feathers and edges of the layers of feathers by drybrushing in light parallel strokes.

5 Add More Feather Details

With a no. 2 round, dab in Ultramarine Violet on the breast feathers. Use short curved strokes and dabs on the small feathers in the upper parts of the wings. Mix a little bit of Burnt Umber + Naples Yellow and run this lightly around the eye, leaving a rim of white around the eye. Use this same mixture for added color in the tail feathers.

6 Add Texture to the Feathers and Feet

Using a no. 0 round, paint with short parallel strokes along the feather filaments with Payne's Grey. Switch to Burnt Umber and use short curved strokes to add definition on the edge of the breast. Dot the cheek and back of the head with Burnt Umber to add more feather markings. Paint a light glaze of Cadmium Red on the feet with a no. 1 round, and add shadows and definition to them with Burnt Umber.

7 Paint the Eyes and Beak, Blend Tones to Finish

Moisten a no. 4 round with clean water and brush lightly over the body and wing to blend the textures and tones and soften the edges. Be careful not to overdo this or you will obliterate your details. The goal is to simply blend the shadings and markings a bit. With a no. 0 round and Payne's Grey, darken the tips of the wings, the shadowy area above the feet, and the eyes and beak.

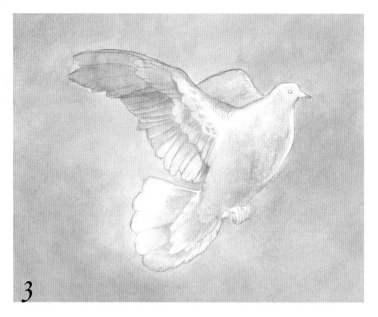

3

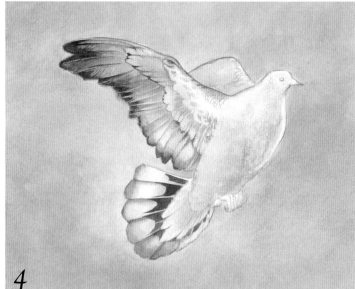

4

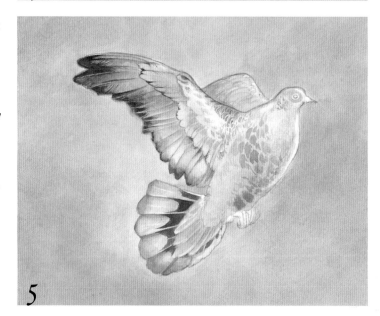

5

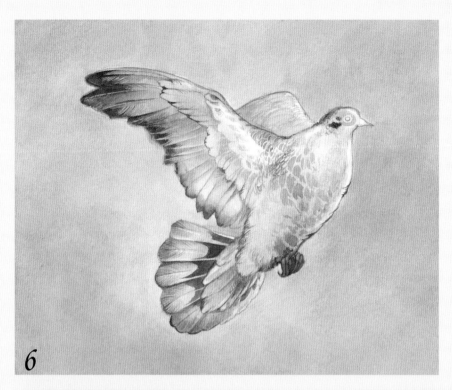

6

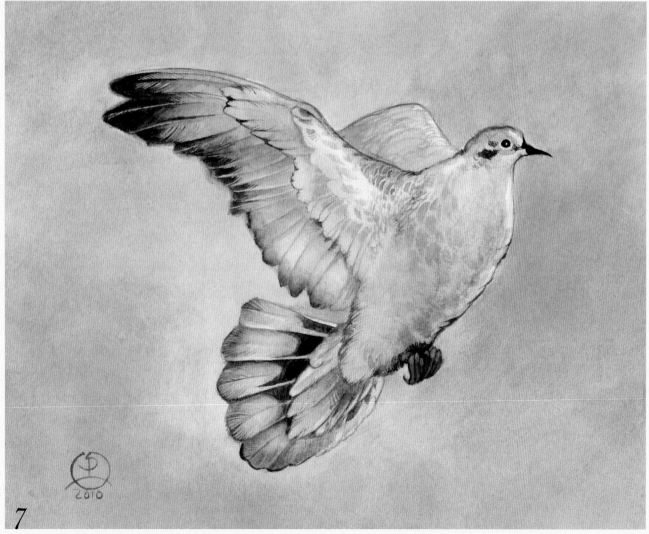

7

Demonstration
PAINT RAVENS

Ravens are creatures of wisdom, prophecy and omen—harbingers and bringers of change. They are messenger creatures who exist in the portals between worlds. They are carrion eaters and thus present upon the fields of death. The war goddess of Celtic mythology, the Morrigan, is often tied to the raven. In Norse myth, the god Odin has a pair of ravens named Huginn (Thought) and Muninn (Memory). The birds flew across the world, bringing back information to whisper to him each night.

MATERIALS LIST

Surface ∼ 6" × 6" (15cm × 15cm) illustration board

Brushes ∼ ½-inch (12mm) flat, nos. 0, 1, 2, 3, 4 rounds

Watercolors ∼ Alizarin Red Lake, Burnt Umber, Payne's Grey, Prussian Blue, Raw Umber, Sap Green, Ultramarine Blue, Ultramarine Violet, Viridian Green

Other ∼ paper towels

1 Sketch the Piece and Paint the Greenery
Sketch a pair of ravens perched on a bare branch high in a treetop. Using a ½-inch (12mm) flat, paint a background wash starting with Raw Umber in the upper third, blending to Sap Green in the middle, and Viridian Green at the bottom. Switch to a no. 4 round to get in the smaller corners and areas around the ravens' legs. Don't worry about painting over the smaller branches.

2 Paint the Tree Branch Base Layer
Mix Prussian Blue + Burnt Umber. Using a no. 3 round, drybrush the tree branch. Leave an edge of white on the outer sides of the branch, and let the brush skip over the texture of the paper to give a base tree bark texture to work from later.

3 Add More Color, Shadows and Details to the Tree Branch
Paint a glaze of Sap Green over the tree branch with a no. 2 round. Leave a lesser rim of white than in the previous layer. Use a no. 1 round to trail the color off into the smaller twigs, pulling the paint up and out and dabbing at the end with a paper towel to clear away excess moisture and pigment.

Use a no. 0 round to paint Ultramarine Violet bark texture. Switch to a no. 1 round to glaze Ultramarine Violet shadows under the birds.

1

2

3

4 Lay in a Base Coat

With a no. 2 round, mix Ultramarine Blue + Ultramarine Violet and lay in the birds' base coat. Leave bits of white highlights on feathers in the breasts and faces. This layer will show through on the highlights of the ravens' black feathers. It does not need to be smooth or seamless. In fact, variations will help lend texture to the end result.

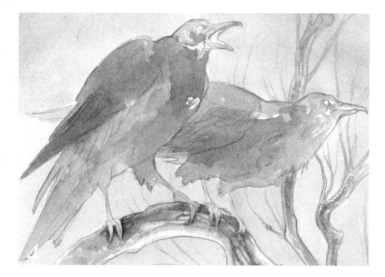

5 Add Shadows and Definition

Mix Ultramarine Blue + Payne's Grey + Burnt Umber and use a no. 1 round to glaze shadows and definition over the ravens. Leave highlights of purple from the previous step showing through. Use finer strokes near the breasts and around the heads, but be sure to follow the direction and contours of the feathers. Use a no. 0 round to detail the smaller feathers, beaks, eyes and talons. Then wet a no. 2 round with clean water and brush lightly over the ravens to soften the edges of the feathers.

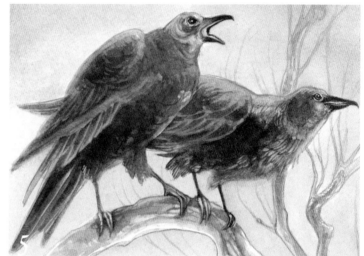

Painting Black

Though the ravens you just painted are black, no black paint was used at all. A raven's feathers are not dull. They reflect light and colors from their surroundings. This is why we painted these ravens with multiple layers of purple, green and blue—to bring to life the iridescent, shifting quality of their shiny black feathers.

Black is a "dead" color. Using it in large areas will flatten your painting and make your objects appear very matte. If you use black sparingly when you paint, your images will be much more interesting. This does not mean to never use black, however. It can be used to great effect for contrast and emphasis, or if you are purposely trying to create a flattened field of depth.

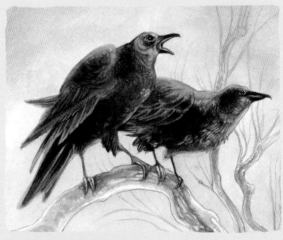

Compare With Black Paint Only
When the ravens are painted using only black, they appear cut out and placed into their surroundings instead of like a living part of the environment.

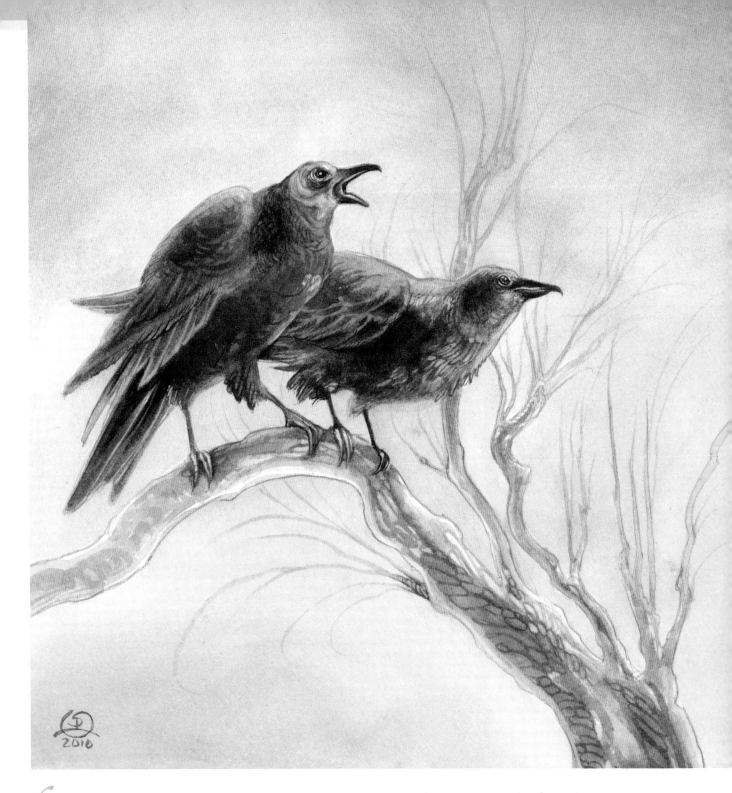

6 **Emphasize the Shadows to Finish**
In the ravens' darkest areas, use a no. 1 brush to lightly glaze Viridian Green with short curved strokes that mimic the feathers. The layering of the many colors helps give the "black" a more lively and iridescent look. Be careful not to overdo this, or you'll end up with a green-colored bird. Use very diluted paint. You can always add more.

Add some dark definition to areas that have become too light during the previous step of washing over with clean water. Using a no. 0 round, paint into all the dark corners under the wing tips, under the tails, the tips of the beaks and around the eyes with Payne's Grey. Add just a touch of Alizarin Red Lake to the inside of the raven's open beak with a no. 0 round.

Demonstration
PAINT AN OWL

Owls are silent hunters of the night with their enormous liquid eyes, sharp hooked bills, powerful talons and strong, stealthy wings. They hunt under the cover of darkness and occasionally at those nether hours of dawn and dusk.

In folklore, owls are harbingers of death and the supernatural guardians of spirits in their passage between worlds. The Aztec god of death, Mictlantecuhtli, was often depicted with owls as his companions and owl feathers in his headdress. In ancient Greece, the owl was a symbol of Athena, goddess of wisdom and learning. In some African cultures the owl was a companion to mystics and keeper of sacred knowledge. And in the Middle Ages owls were often feared as witch familiars or even as shape-changed witches.

MATERIALS LIST

Surface ～ 7" × 6" (18cm × 15cm) illustration board

Brushes ～ ½-inch (12mm) flat, nos. 0, 1, 2, 4 rounds

Watercolors ～ Burnt Sienna, Burnt Umber, Naples Yellow, Payne's Grey, Ultramarine Blue, Ultramarine Violet

Other ～ paper towels

1 Sketch the Piece and Apply the First Wash

Sketch an owl lifting off on silent wings through the autumn twilight. Wet the lower third of the page, turn the painting upside down, and hold it at a slight slant toward you. With a ½-inch (12mm) flat, paint a strip of Ultramarine Violet across the "top" of the page and let the color bleed downward, wet-on-wet. If it does not bleed out enough, try again with more water, holding the painting at a sharper incline. (This is easier if your paper is taped to a drawing board.) You can also try blowing the pigment to help it flow in the direction you want. Dab away any excessive or extremely dark drips with a paper towel.

1

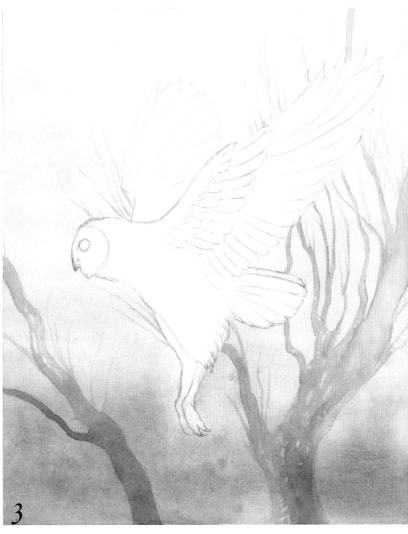

2 Wash in the Hazy Light
When the paper is dry, turn it right side up. Use a ½-inch (12mm) flat to paint a wash across the entire background with Naples Yellow, glazing on top of the previously painted Ultramarine Violet.

3 Paint the Trees
Use a no. 2 round to paint the stark tree trunks in the background with Ultramarine Violet. Leave little bits of the previous layers showing through on the larger trunks to give the impression of light striking the rough bark. Trail outward with the point of the brush for the tips of the branches and twigs.

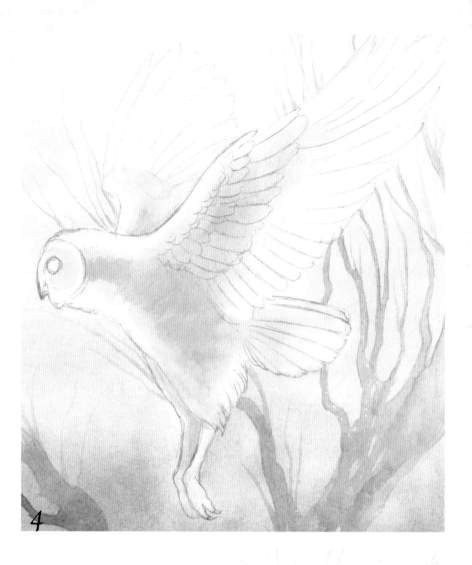

Add Shadows on the Owl

4 Mix Ultramarine Violet + Payne's Grey. Wet the body and the nearest wing of the owl with clear water. Paint shadows on the owl, wet-on-wet, with a no. 2 round. Keep the tones darkest toward the core and leave white around the edges.

Paint the Brown Feathers

5 Use a no. 2 round to apply a mixture of Naples Yellow + Burnt Umber along the back of the head and backs of the wings, as well as a little bit along the beak. Let the two colors of the mixture vary so you get a range of tones from yellow to brown.

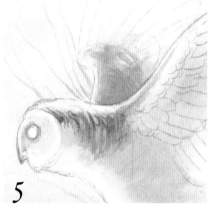

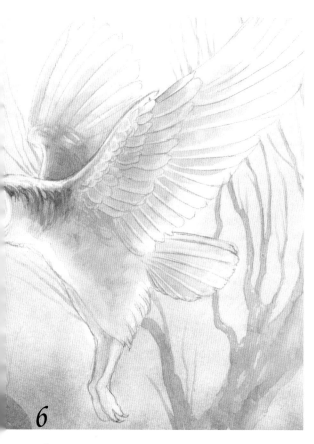

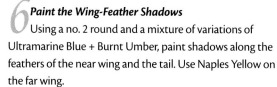

6

6 Paint the Wing-Feather Shadows
Using a no. 2 round and a mixture of variations of Ultramarine Blue + Burnt Umber, paint shadows along the feathers of the near wing and the tail. Use Naples Yellow on the far wing.

7 Add Feather Details
With a no. 4 round, brush clean water over the wings and tail to blend and soften the edges of the shadows. Use a mixture of Payne's Grey + Burnt Umber with a no. 0 round to add texture and paint fine details on feathers with short parallel strokes. Leave the tips of the feathers white to enhance the effect of the dawn light shining through those white edges. Paint Burnt Umber around the feathers that fringe the face and the eye, then emphasize with a thin line of Payne's Grey.

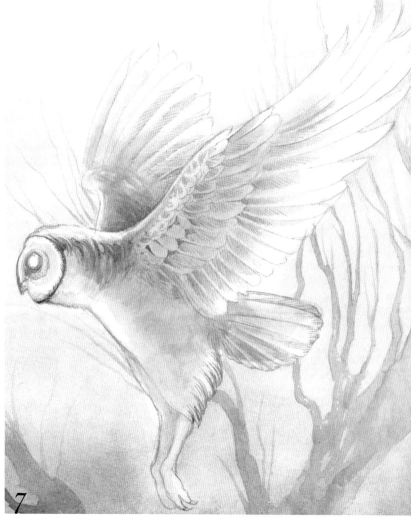

7

8 Paint the Feather Markings

With a no. 2 round, dot in some Burnt Sienna on the feathers of the far wing in order to create the barred pattern. On the underside of the closer wing, use Burnt Umber.

9 Add Pattern Details

Using a no. 1 round, add more detail to the feather markings by dotting the center of each feather's bar with a mixture of Burnt Umber + Ultramarine Violet. Add a few concentrated specks along the shoulders, breast and back of the head.

With the same mixture and a no. 2 round, apply a very light wash to add a bit more shadow into the area between the tail and wing as well as on the legs.

10 Paint the Eye, Bill, Talons and Claws to Finish

With a no. 0 round, paint the eye with Payne's Grey. Glaze a bit of Naples Yellow on the bill and talons. Finish the tips of the bill and claws with Payne's Grey.

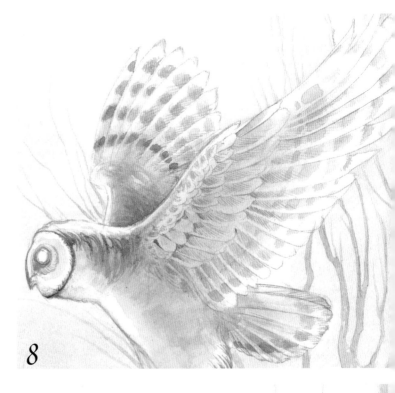

8

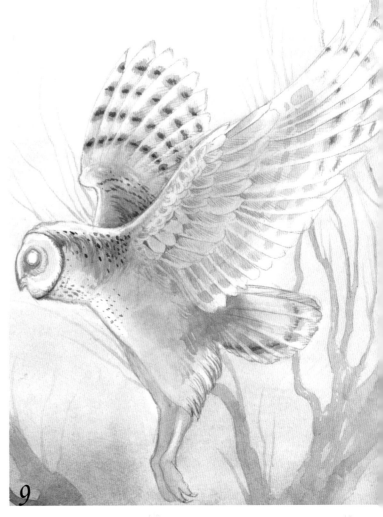

9

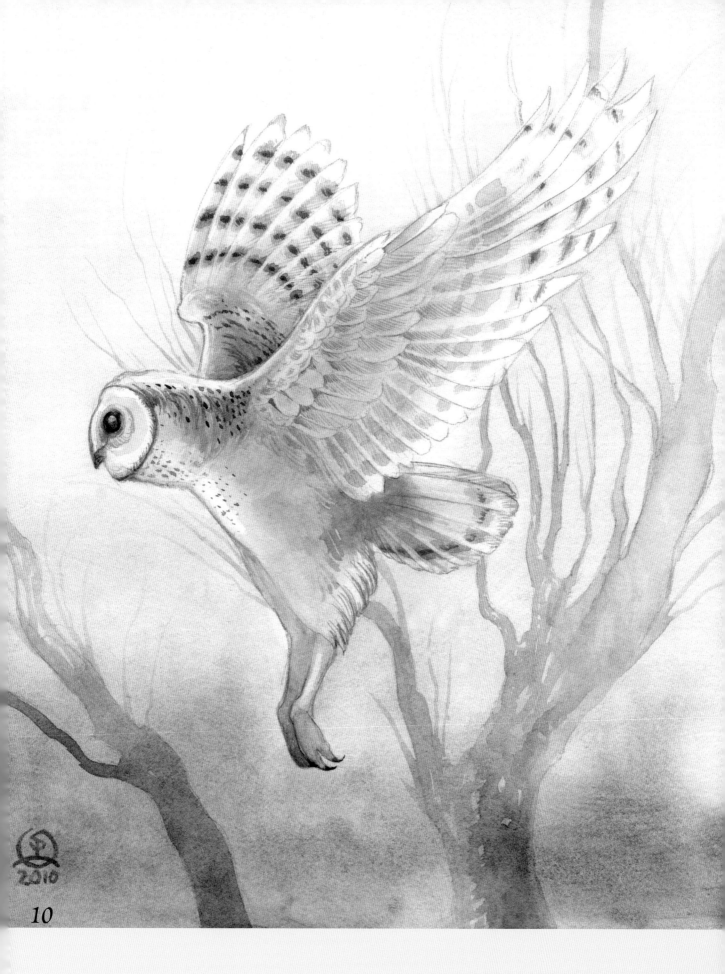

10

Demonstration
PAINT A RAPTOR

With their fierce and proud visage, raptors are often symbols of courage, nobility and divine spirit. Hawks were sacred to the ancient Egyptian god Ra, solar deity and creator of all. He sometimes took the form of a human body with the head of a hawk.

Horus, the god of the sky, was also represented by a raptor—a falcon soaring high and free in the heavens and ruling that airy domain.

MATERIALS LIST

Surface — 5" x 7" (13cm x 18cm) illustration board

Brushes — nos. 0, 1, 2, 4 rounds

Watercolors — Burnt Umber, Cobalt Blue, Ivory Black, Naples Yellow, Payne's Grey, Prussian Blue, Raw Umber, Ultramarine Blue, Ultramarine Violet

1 Sketch the Piece and Paint the Sky
Sketch a peregrine falcon gazing out on the world from his perch on a branch. Mix Cobalt Blue + Ultramarine Violet, and with a no. 4 round paint wet-on-wet for the background. Swirl the blues in the upper left in a dynamic spiral of clouds. Use a mix heavier on the Ultramarine Violet for the lower right and left corners, and more Cobalt Blue for the upper half.

2 Paint the Perch Shadows
Drybrush Payne's Grey on the branch using a no. 2 round.

3 Add Color and Details to the Perch
Paint a glaze of Burnt Umber over the branch with a no. 2 round. Use a no. 0 round and Prussian Blue to add some fine detail of bark texture to the wood. Shade with a little bit of Payne's Grey under the talons to create shadows.

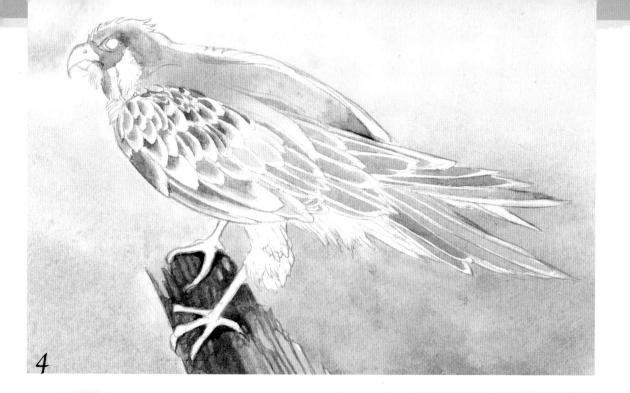

4

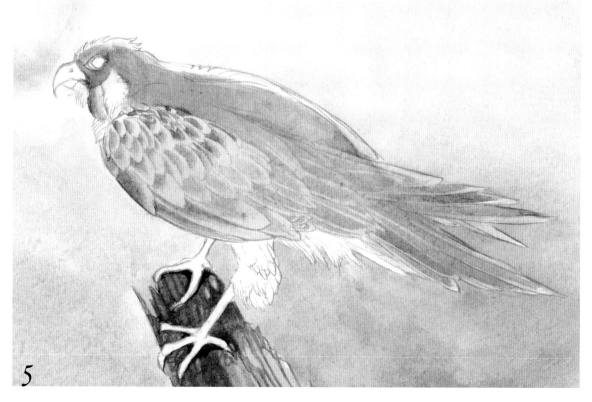

5

Paint the Falcon Shadows
Use a no. 1 round with a mixture of Ultramarine Violet + Burnt Umber for the shadows on the feathers. Use Payne's Grey for the tail feathers.

Paint the Main Colors of the Falcon
Glaze diluted Raw Umber over the wings and Payne's Grey over the head and tail to blend and soften the edges of the shadows. Make sure the glaze is not too heavy, or you will obliterate the delicate shading. Be sure to leave white along the cheeks, breast, leg and upper tail areas.

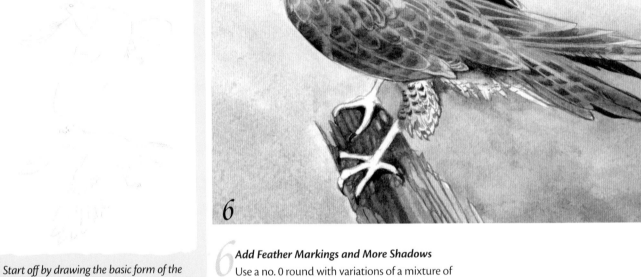

6

- *Start off by drawing the basic form of the creature. Don't worry about details of the features or patterns and colors. The details can be worked in after you get the basic shapes drawn, and you can wait to worry about the patterns and colors when you get to painting.*
- *Sometimes it is useful to lightly sketch some guidelines for the layers of feathers to follow. You can erase these afterwards, but it aids in keeping the feathers from looking like they are drawn haphazardly.*
- *Only after you are satisfied with the overall shape and pose should you fill in the details. Nothing is more frustrating than spending a great deal of time perfecting the details of the face, only to find that the angle was all wrong for the rest of the body. Avoid putting yourself in a discouraging situation by always getting the major forms correct before moving on to the smaller things.*

6 Add Feather Markings and More Shadows

Use a no. 0 round with variations of a mixture of Ultramarine Blue + Burnt Umber to drybrush a bar pattern on the feathers. Blend with clear water. Be sure to leave unpainted edges of light around the contours of the feathers. Mix Burnt Umber + Ivory Black to paint the tail markings. Use this in the white feathers under the tail and the leg also.

With a no. 1 round, paint some shadows in Payne's Grey and blend with water. Apply a mixture of Payne's Grey + Ultramarine Blue to the tip of the bill and talons using a no. 0 round. Paint the eye, the very tip of the beak and the nostril with Ivory Black with a no. 0 round.

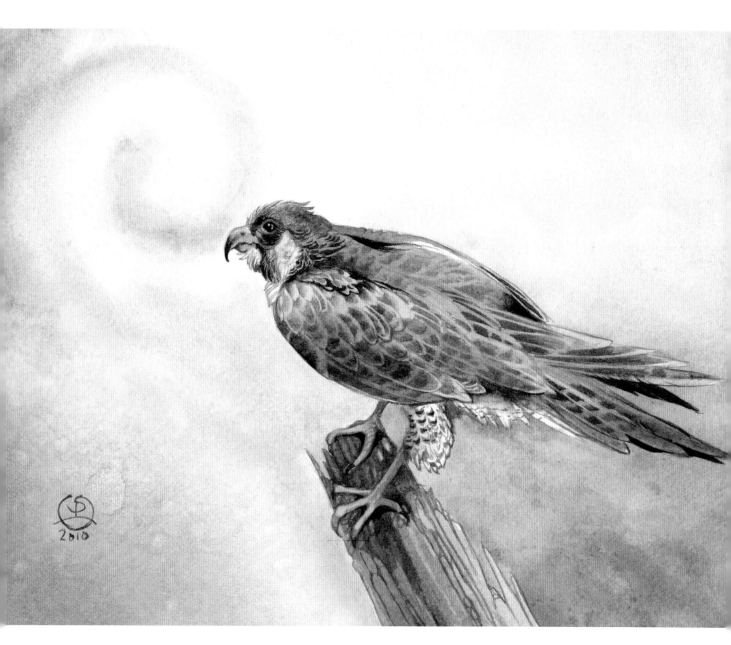

7 Paint the Bill and Talons, Add Final Touches

With a no. 0 round, paint a glaze of Naples Yellow on the bill, the edges of the white feathers along the face and the talons. Shade the talons with Burnt Umber.

Demonstration
PAINT A PEACOCK

With the dazzling beauty of its plumes, the peacock has long been a symbol of dignity, beauty and immortality. In the seventeenth century, the Mughal emperor had a throne crafted for himself. The Peacock Throne, as it was called, was made of gold, and enameled and encrusted with precious gems–rubies, emeralds, pearls, sapphires. It was later stolen by the Persians, and though the original creation was eventually lost, thereafter peacocks became entwined with and symbolic of Persian royalty. Saraswati, Hindu goddess of knowledge, music and the arts, was sometimes depicted riding a peacock. She instructs others to rein in arrogance and pride of one's beauty, and to seek inner truth instead.

MATERIALS LIST

Surface ~ 8" × 5" (20cm × 13cm) illustration board

Brushes ~ ½-inch (12mm) flat, nos. 0, 1, 2, 4 rounds

Watercolors ~ Alizarin Crimson, Burnt Umber, Cerulean Blue, Ivory Black, Lemon Yellow, Naples Yellow, Payne's Grey, Prussian Blue, Raw Umber, Sap Green, Ultramarine Blue, Ultramarine Violet, Viridian Green

Other ~ rubbing alcohol

1 Sketch the Piece and Paint the Background Greens
Sketch a peacock with his long train of feathers falling in an opulent spread. With a ½-inch (12mm) flat, paint a wash of Viridian Green in the lower half of the background. Let it fade into the white paper about halfway up. To create texture for the foliage, splatter with rubbing alcohol using a no. 2 round while the paint is still wet.

2 Layer the Background
Mix Lemon Yellow + Naples Yellow with a touch of Viridian Green. Paint a wash over the entire background (including over the previous layer of Viridian Green) with a ½-inch (12mm) flat. Using a no. 4 round, add wet-on-wet streaks of distant foliage with Viridian Green. In the lower third add some Prussian Blue along the edges, allowing it to fade into the greens.

3 Sketch in Some Leaves
With a pencil, sketch in some foliage based on the irregular splotches the wet-on-wet application and rubbing alcohol created.

1

2

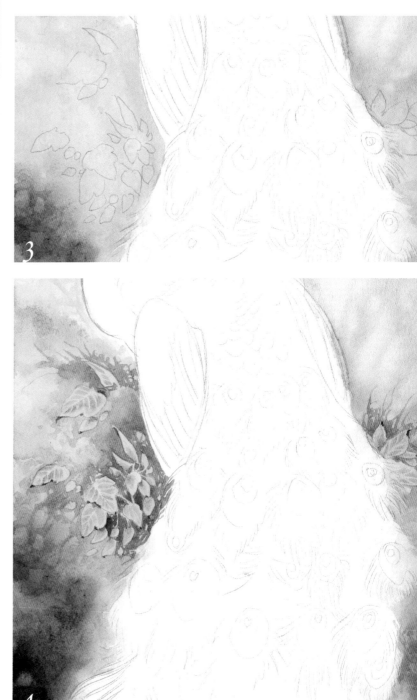

3

4

4 Add Shadowy Leaves and Leaf Details

Mix Viridian Green + Ultramarine Violet. With a no. 2 round, paint the negative space around the sketched leaves to push the shadows around them back. Blend into the surrounding areas by trailing off into twiggy branches in the upper part and smoothing the edges out with clear water into the lower, darker areas.

Use a no. 1 round to paint some Sap Green shading on the leaves. Leave the lighter color of previous layers showing through for veins on some of the bigger leaves and along the leaf edges. With a no. 0 round, dot Payne's Grey accents at the tips of the leaves.

5 Start on the Plume Markings
With a mixture of Cerulean Blue + Lemon Yellow, paint around each eye in the tail with a no. 2 round.

6 Blend Greens and Define the Feathers
With a no. 2 round, blend the Cerulean Blue circles into a carpet of verdant feathers painted with a mixture of Sap Green + Viridian Green.

Use a mixture of Prussian Blue + Viridian Green to paint the shadows around the feathers with a no. 1 round. Mix in some Ultramarine Violet for variations of the shadows. Let the previous layers of lighter greens show through by painting in the negative space around the feathery tendrils.

7 Paint the Eyes of the Train
For each eye of the train feathers, use a no. 0 round to paint an outer circle of Lemon Yellow + Cerulean Blue. Then apply an inner circle of mixed Burnt Umber + Ultramarine Violet, letting the edges blend into the outer circle with a bit of water. Paint a third inner circle of Cerulean Blue. In the center, add a final bright spot of intense Prussian Blue.

8 Add Shadows and Texture
With a no. 0 round, push the deepest shadows in the train even farther back with a light Alizarin Crimson glaze. Use a no. 0 round with light parallel brushstrokes and a mixture of Prussian Blue + Ultramarine Violet to add texture to some of the closer feather eyes. Soften the texture by brushing over it with clear water and a no. 2 round, Avoid blurring the center Prussian Blue part of the feather eyes.

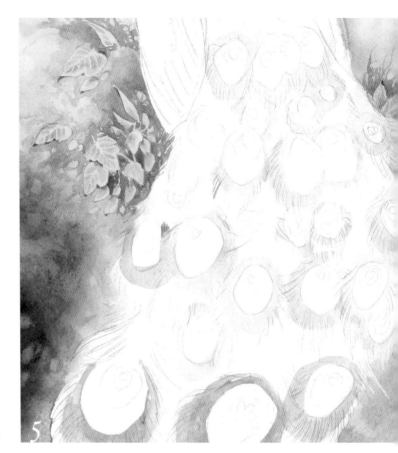

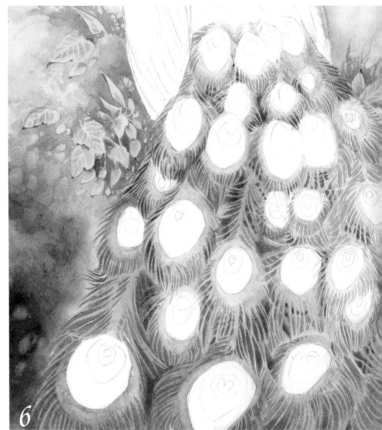

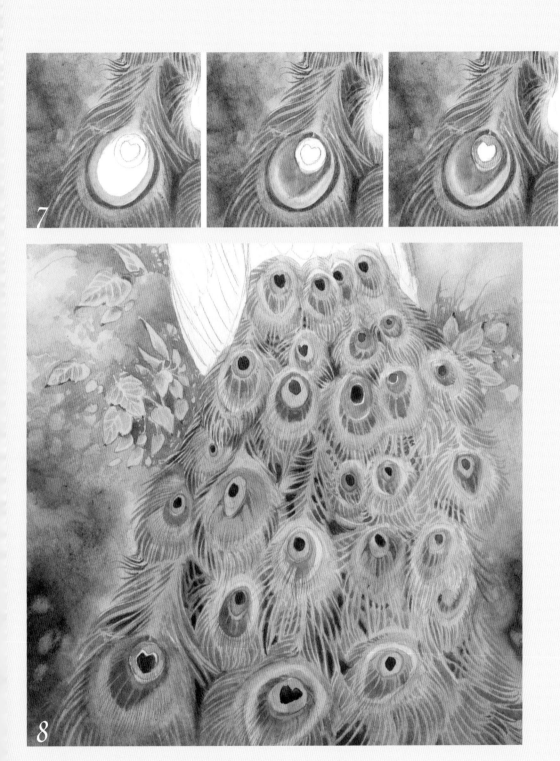

9 Paint the Body Base Colors

With a no. 4 round, paint a glaze of Lemon Yellow on the peacock's back. Working wet-on-wet, fade into a mix of Ultramarine Blue + Prussian Blue for the breast and neck. Fading further wet-on-wet, apply Viridian Green around the face. Use Raw Umber over the tops of the wings.

10 Intensify the Body Colors and Add Shadows

Using a no. 1 round, glaze Alizarin Crimson over the lower part of the breast and neck to give a rich and royal dark purple sheen.

Use a no. 0 round to paint across the back crescent-shaped feathers. Start with Ultramarine Blue near the neck, work downward into a mix of Ultramarine Blue + Viridian Green, ending in just Viridian Green. Allow the negative space of the previous layer of yellow to show through.

With Prussian blue and a no. 0 round, paint the feathers of the crest. Blend them outward into the surrounding background color with water. With a no. 0 round, add more definition and shadows on the feathers closer to the train and near the wings with Prussian Blue.

11 Finish With Final Details on the Wings

With a no. 2 round, paint wet-on-wet a mixture of Burnt Umber + Payne's Grey + a bit of Ultramarine Violet for the bar patterns on the wings. Use a no. 0 round with a little Ivory Black to finish the eye and bill.

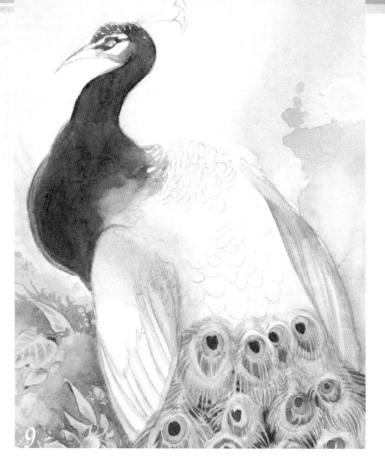

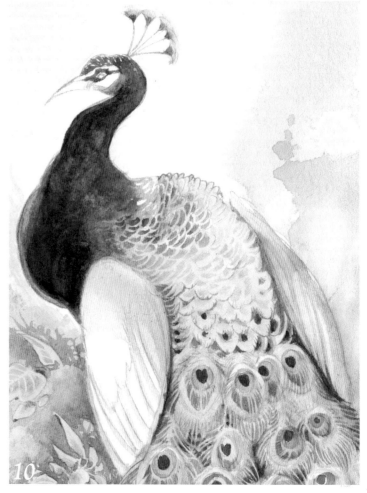

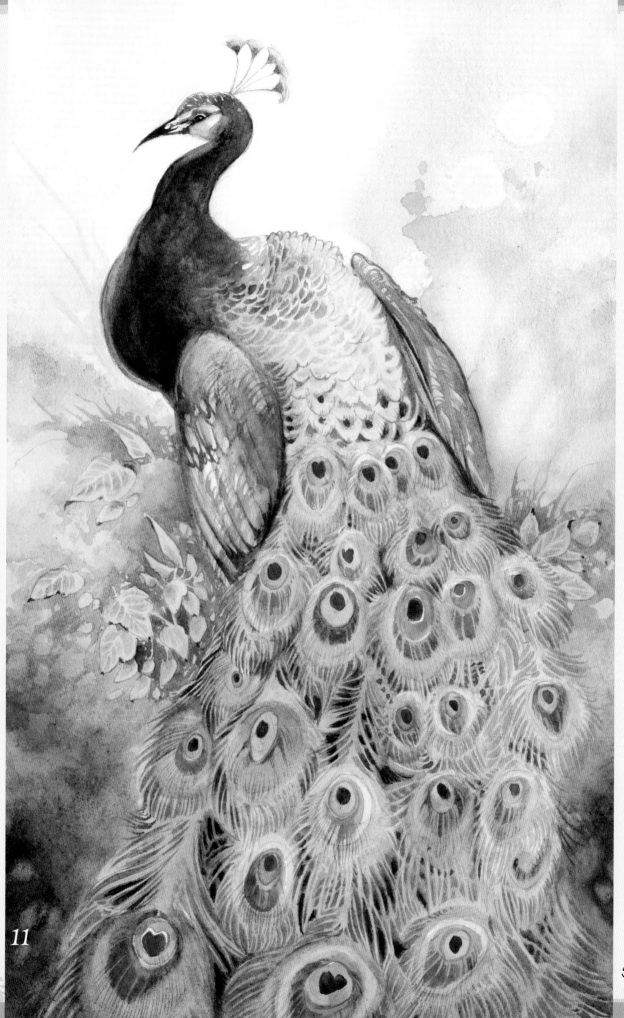

Demonstration
PAINT DISTANT BLACKBIRDS

At times you'll want to paint birds very detailed and close up. Other times you'll want to use them as background elements to establish the environment of a piece or add movement to your composition. When painting birds in the background, don't pack them in with so much detail that they draw the viewer's eye away from the main focus of the piece. Pick and choose what details to focus on. The farther away the birds are in the distance, highlight less and less detail.

MATERIALS LIST

Surface ~ 4" × 4" (10cm × 10cm) illustration board

Brushes ~ ½-inch (12mm) flat, nos. 0, 1, 2 rounds

Watercolors ~ Naples Yellow, Payne's Grey, Prussian Blue, Ultramarine Blue, Ultramarine Violet

Other ~ white gel pen

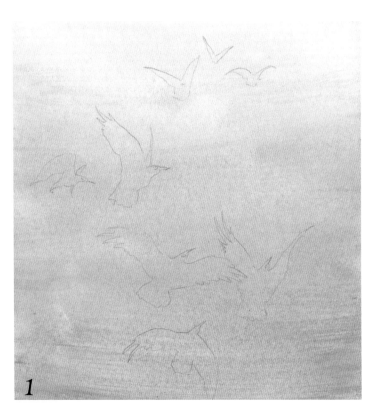

1 **Sketch the Piece and Apply the Background Wash**
Sketch a flock of blackbirds taking off in the distance. Paint a graded wash in the background with a ½-inch (12mm) flat. Use Naples Yellow at the top and fade into Prussian Blue.

2 **Paint the Birds and Blend Into the Background**
With a no. 2 round, apply a light glaze of Ultramarine Blue on each bird. Wet a no. 0 round with clean water and gently brush along the edges of the birds to lift the Ultramarine Blue slightly and blend the hard lines into the background.

3

Add Shadows and Definition

Mix Payne's Grey + Ultramarine Violet. With a no. 1 round, glaze this darker mixture on top of the Ultramarine Blue birds to add definition to their bodies. Since these birds are so small, you cannot add a whole lot of detail. Keep the brushstrokes minimal, while trying to follow the direction of the feathers with your strokes. Let bits of the previous layer of Ultramarine Blue peek through for highlights. For the birds farthest in the distance at the upper right, simply darken each core body and head.

Finish With Highlights

With a white gel pen, add some silhouetted highlights along the upper edges of the wings and heads of the closer birds (the light source originating from above the golden yellow parts of the background). Dot the eyes and add a few pinprick dots to highlight feathers on the breast and upper wing areas.

4

Demonstration
PAINT THE PHOENIX

The legend of the phoenix is ancient, with variations scattered around the world. She is a melding of many different birds: the sinuous neck of a swan, the opulent train of a peacock, the elegance of a crane's wings and the ferocity in a hawk's hooked bill and strong talons. A long-lived but solitary creature, only one of her kind ever exists at one time. Every five hundred years, the phoenix tires of life and of her aging body. She gathers branches together and creates a funeral pyre. When the sun rises, the old phoenix turns to face that blazing light of the sky and ignites. From the ashes, a new phoenix is born.

1

MATERIALS LIST

Surface — 10" × 6" (27cm × 15cm) illustration board

Brushes — nos. 0, 1, 2, 3, 4 rounds

Watercolors — Alizarin Crimson, Burnt Sienna, Cadmium Orange, Cadmium Red, Cadmium Yellow, Lemon Yellow, Naples Yellow, Payne's Grey, Raw Umber, Sap Green, Ultramarine Violet, Viridian Green

Other — salt

1 Sketch the Piece and Paint the Glow
Sketch the phoenix as she spreads her wings and blazes into the sky. With a no. 1 round, paint a Lemon Yellow glow around the phoenix.

2 Fill in the Background
Mix Naples Yellow + Raw Umber + Alizarin Crimson. With a no. 4 round, paint the lower half of the background, blending into the previous layer with clear water. Blend to just Naples Yellow in the top half. Switch to a no. 1 round if needed to get into some of the tighter corners and spaces.

3 Paint the Wispy Background Shadows and Light
Mix Alizarin Crimson + Ultramarine Violet. Add some darker glazes in the lower parts of the background and in the top corners. Blend into the surrounding lighter glow with water. Sprinkle with salt while wet to create texture. When dry, brush the salt away.

4 Intensify the Fire
Use a no. 1 round to add glazes of Cadmium Orange in the upper fiery parts of the composition. Blend out with water.

5 Paint Base Colors on the Body
With a no. 3 round, paint wet-on-wet with a range of Cadmium Yellow on the edges of the wings to Cadmium Orange closer to the body. Use Cadmium Yellow on the main body area and neck. Blend into Alizarin Crimson on the tail. Be sure to leave some white at the edges of the feathers for contrast against the background so the finished wings will be lined with light from the fires.

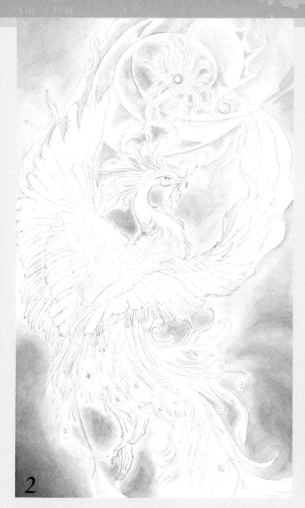

2

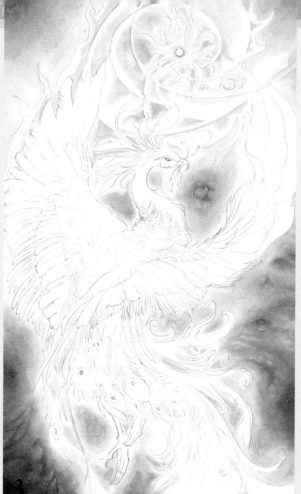

3

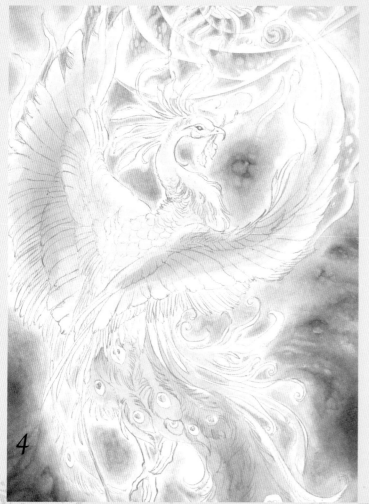

4

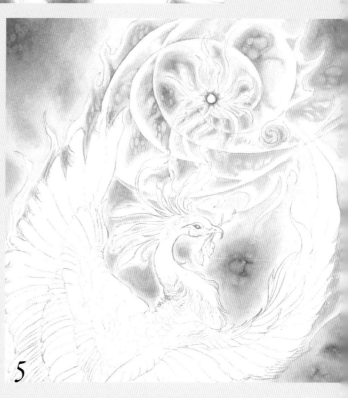

5

6 Add Some Color

Mix Alizarin Crimson + Ultramarine Violet and paint a wash with a no. 2 round over the finer feathers at the base of the wings. When dry, use Ultramarine Violet and a no. 0 round to add intense purples around the base of the wings. Let the lighter colors from the previous washes show through around the edges.

7 Paint Shadows in the Train

Use Burnt Sienna to paint in the negative spaces around the train feathers with a no. 0 round.

8 Paint the Eyes in the Train Feathers

Use a no. 0 round and Cadmium Red around the eyes of the train feathers, blending outward with water. Leave a thin line of white around the edges. Paint the eyes Sap Green with a no. 0 round. Again, leave a thin line of white around the edges. Finish with Viridian Green in the centers.

9 Deepen the Shadows in the Train

With a no. 0 round, add another layer of darker shadows in the train with Alizarin Crimson. This adds another dimension to the feathers. Add some Alizarin Crimson along the shadowed edge of the purple wing feathers as well.

10 Add More Color, Tone and Definition to the Wing Feathers

With a no. 2 round, paint Cadmium Red along the wing feathers. Blend the outer edges with water. Continue adding definition to the rest of the wing feathers with Cadmium Red, melding into Cadmium Orange as you work inward toward the body, and Cadmium Yellow on the back.

11 Paint the Neck and Crest

With a no. 1 round, paint the feathers up the back of the neck with Cadmium Red using short curved strokes. Blend into Alizarin Crimson on the top of the head, and blend into Ultramarine Violet under the head and at the front. Paint the plumes of the crest Naples Yellow. Leave the edges white.

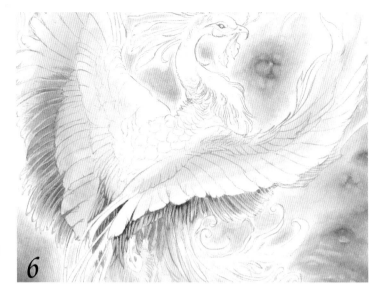

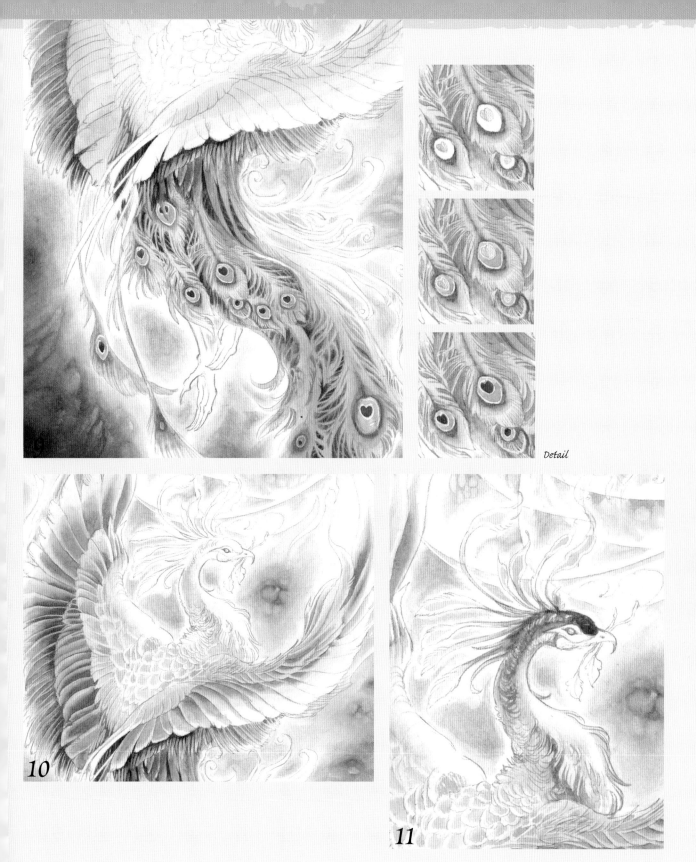

Detail

10

11

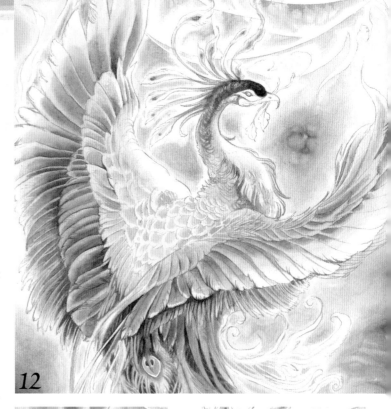

12

12 Paint Cooler Shadowed Edges

For a contrast to all the fiery warm colors, add some cooler shadows with Viridian Green using a no. 0 round under the edges of the feathers. Add some texture with short parallel strokes along the feathers. Glaze Viridian Green over the top of the head. Dot the plumes of the head with a touch of Viridian Green, then use water to blend it out along the contour of the feathers toward the head.

13 Add a Hint of Cooler Colors

With a no. 2 round, glaze Sap Green over the feathers of the back. Keep it very diluted. Shade the feathers along the ruff of the neck with a little bit of Viridian Green using a no. 0 round.

14 Paint the Eye, Bill, Leaves and Talons to Finish

With a no. 0 round, paint Sap Green leaves, lifting the pigment along the right sides of the leaves to highlight. Darken the eye with a no. 0 round using Payne's Grey. For the bill, use a no. 0 round with Burnt Sienna, and shade the tip of the bill with Payne's Grey.

Paint the talons with a no. 1 round using a mixture of Burnt Sienna + Payne's Grey. Lift along the knuckles for some highlights and add shading with Payne's Grey glazes. Darken the tips of the talons with more concentrated Payne's Grey.

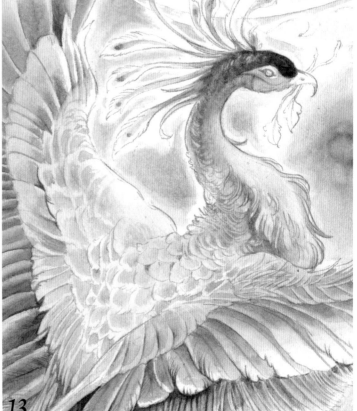

13

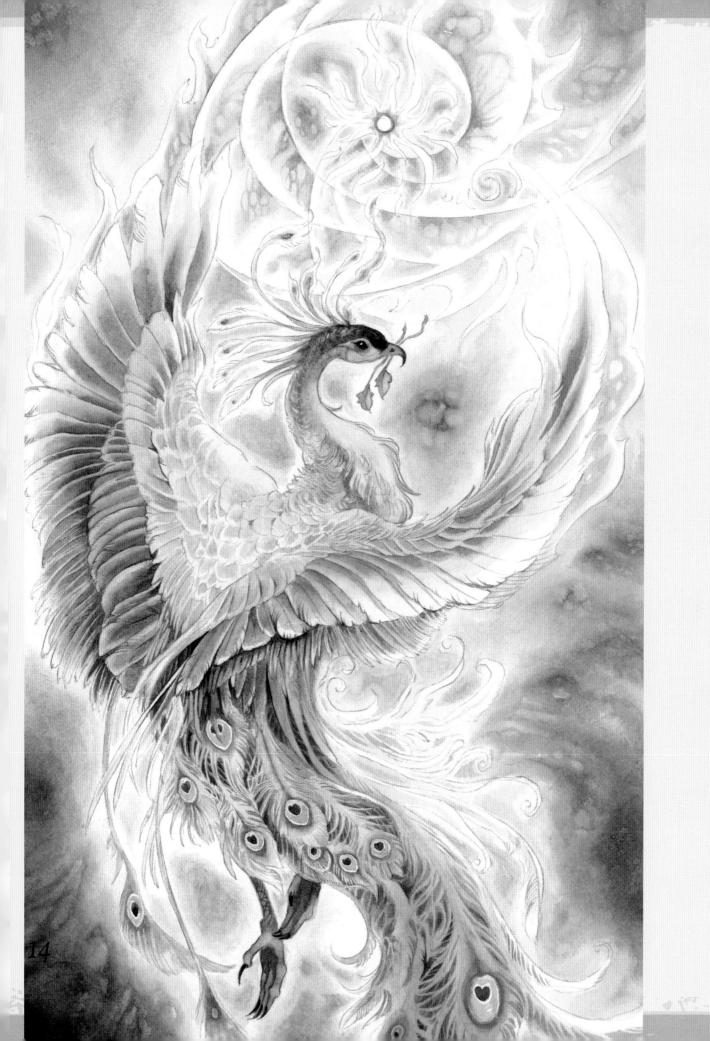

14

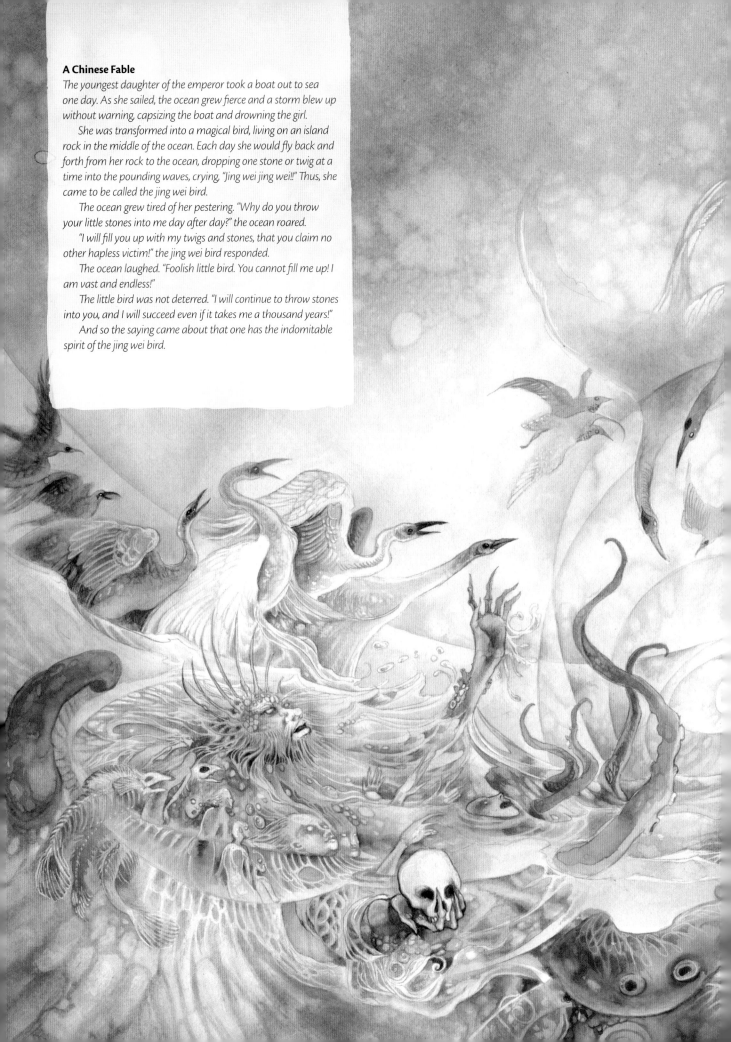

A Chinese Fable

The youngest daughter of the emperor took a boat out to sea one day. As she sailed, the ocean grew fierce and a storm blew up without warning, capsizing the boat and drowning the girl.

She was transformed into a magical bird, living on an island rock in the middle of the ocean. Each day she would fly back and forth from her rock to the ocean, dropping one stone or twig at a time into the pounding waves, crying, "Jing wei jing wei!!" Thus, she came to be called the jing wei bird.

The ocean grew tired of her pestering. "Why do you throw your little stones into me day after day?" the ocean roared.

"I will fill you up with my twigs and stones, that you claim no other hapless victim!" the jing wei bird responded.

The ocean laughed. "Foolish little bird. You cannot fill me up! I am vast and endless!"

The little bird was not deterred. "I will continue to throw stones into you, and I will succeed even if it takes me a thousand years!"

And so the saying came about that one has the indomitable spirit of the jing wei bird.

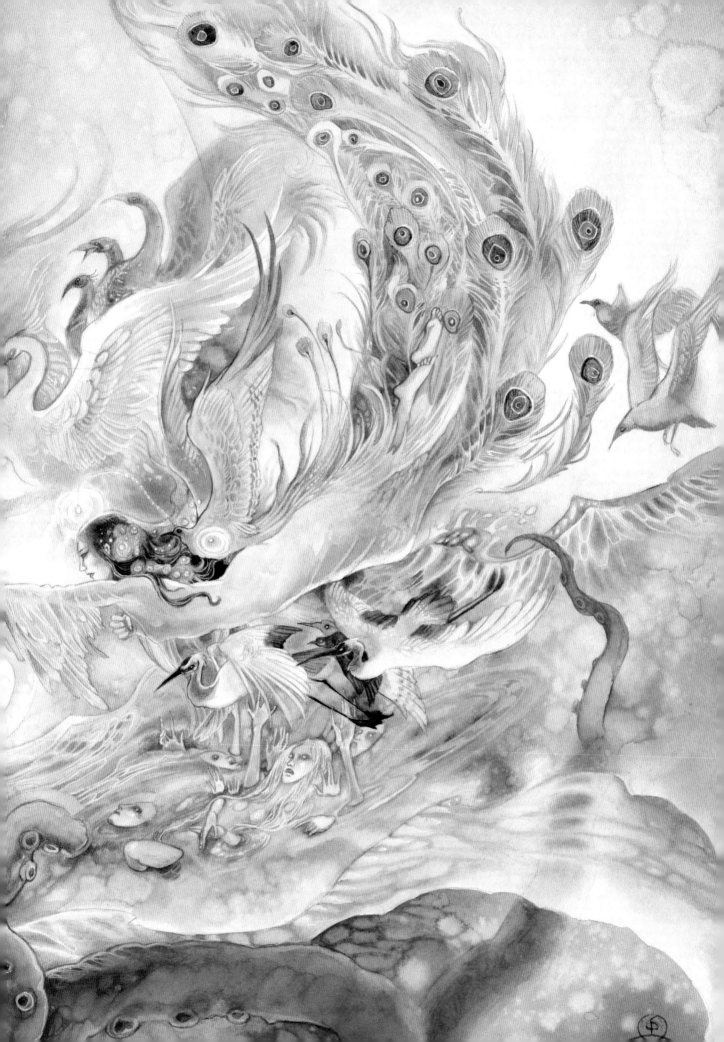

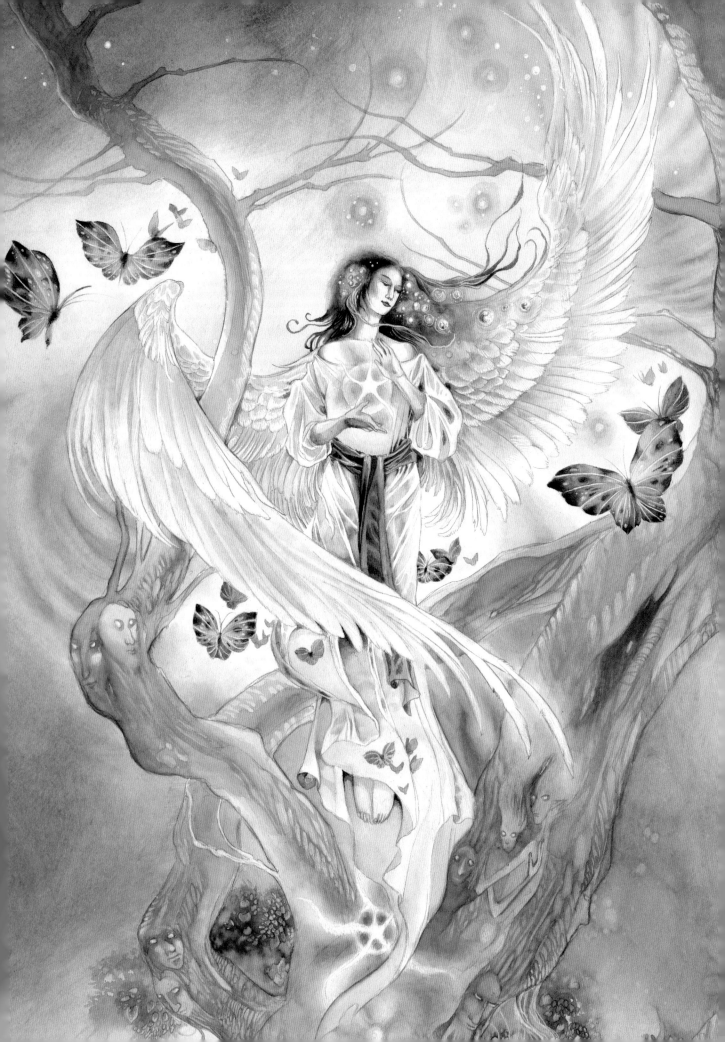

Butterflies

BUTTERFLIES CAN BE A LOT OF FUN TO DRAW and paint. You can use them as they are or borrow aspects of butterflies to apply to fantastical imagery. Faeries are often depicted with butterfly wings. Or perhaps the colorful jewel-like wings become decorative ornaments of a headpiece or jewelry.

Think of the wings on two separate planes, like the pages of a book.

Butterfly Characteristics

You can draw inspiration from real-life specimens. Or if you prefer, don't follow exact markings but make some up on your own. There are over 165,000 species of butterflies with distinct markings, colors and patterns. Their wingspans vary in size and their butterfly bodies range from short and fuzzy to long and slender.

Use the planes as a guide for the wings.

Erase the guides and add details.

Wing Angles

You won't always be drawing a butterfly from such simple viewpoints. While fluttering through the air, a butterfly's wings might be at any number of angles and tilts.

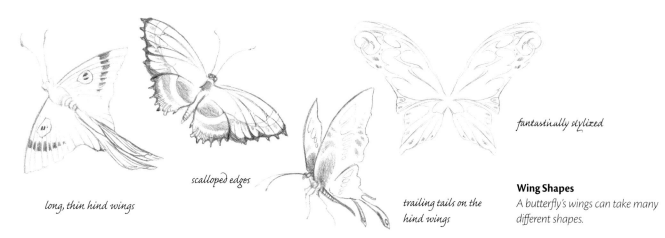

long, thin hind wings

scalloped edges

trailing tails on the hind wings

fantastically stylized

Wing Shapes

A butterfly's wings can take many different shapes.

Demonstration
PAINT A BUTTERFLY KALEIDOSCOPE

Butterflies throughout time have been linked to the soul and the spirit. With the beauty of their myriad colors, like flying flowers, it is easy to attribute some essence of the divine to them. Native American legends tell of how butterflies are the bearers of wishes to the Great Spirit. One Slavic legend tells that after death, the soul takes flight from the body in the form of a butterfly, and a window must be opened to let that soul out into the sky.

MATERIALS LIST

Surface — 6" × 8" (15cm × 20cm) illustration board

Brushes — ½-inch (12mm) flat, nos. 0, 1, 2, 4 rounds

Watercolors — Alizarin Crimson, Burnt Sienna, Burnt Umber, Cadmium Orange, Cadmium Red, Cerulean Blue, Lemon Yellow, Naples Yellow, Payne's Grey, Prussian Blue, Sap Green, Ultramarine Blue, Ultramarine Violet, Viridian Green

Other — white gel pen

1 Sketch the Piece and Lay in Initial Background Colors

Sketch butterflies arrayed around a central glowing light. With a no. 4 round, paint a Lemon Yellow glow around the central light area and around the butterflies. Work from the perimeter of the ring with pigment, and blend using clean water inward toward the center and out toward the edges.

2

3

2 *Lay in More intense Background Colors*

Mix Burnt Sienna + Cadmium Orange, and with a no. 2 round, start painting from the perimeter of the ring. Again, blend inward to the center and outward toward the edges. Keep the areas immediately surrounding the butterflies the lighter Lemon Yellow but darken the spaces between them.

3 *Add Purple Tones*

With a ½-inch (12mm) flat, glaze Ultramarine Violet in the corners, blending into the yellows and oranges by diluting with water.

4 Pull Back the Warmth and Intensity of Color

Glaze with Viridian Green using a ½-inch (12mm) flat. Start in the corners and blend toward the center. To help blend all the transitions of colors and to soften the warm tones of the Ultramarine Violet, keep the paint very diluted. You want the butterflies to be the focus of this piece. The background should complement but not overpower their jewel tones.

5 Apply the Base Colors to the Small Butterflies

Glaze assorted colors for the smaller butterflies with a no. 1 round. Use Viridian Green, Sap Green, Prussian Blue, Ultramarine Blue, Ultramarine Violet, Naples Yellow and Cadmium Orange.

6 Lay in More intense Background Colors

With a no. 2 round, mix Burnt Sienna + Cadmium Orange. Once again, start painting from the perimeter of the ring, blending inward toward the center and outward toward the edges. Keep the areas immediately surrounding the butterflies the lighter Lemon Yellow but darken the spaces between them.

4

5

6

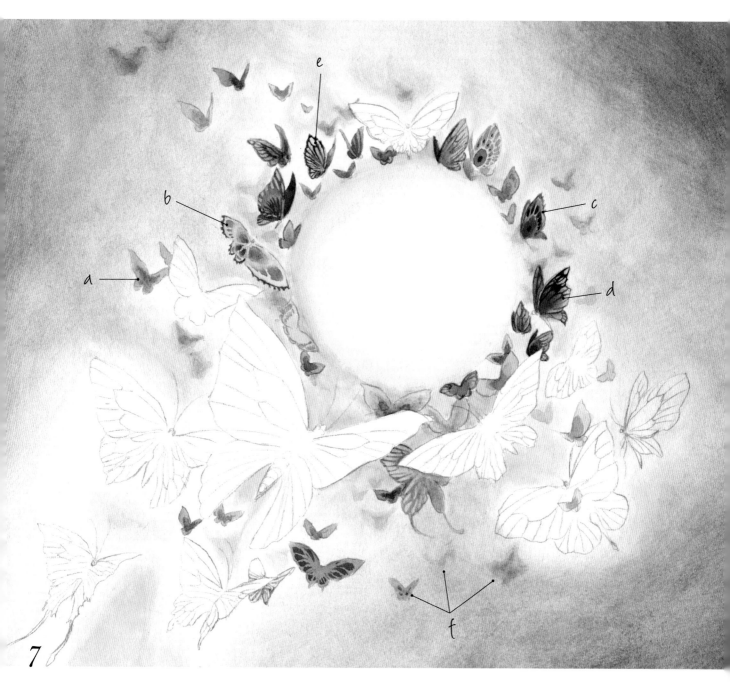

7

7 Add Contrast and Depth

a | Blend in a glaze of more intense or concentrated color on top of the initial wash with a no. 0 round. Here the original Sap Green is intensified in the center with more concentrated Sap Green + Viridian Green.

b | Add a contrasting or secondary color. The base is Lemon Yellow. Toward the center intensify the colors with a mixture of Sap Green + Payne's Grey, blending outward. On the edges of the wings add a bit of Cadmium Orange. Finish with a scalloped edge of Burnt Umber.

c | For the dots, overlay a base of Viridian Green with a dotted pattern of Cadmium Orange, glazed on top with a no. 0 round. Dot a little bit of Payne's Grey over that.

d | Add dark pattern contrasts by intensifying the Cadmium Orange base toward the butterfly's body. Over that, paint a stark webbed pattern with a dark color like Burnt Umber, Payne's Grey or Prussian Blue.

e | Add simpler dark pattern contrasts. Over the base of Prussian Blue, paint a thin web of darker, more concentrated Prussian Blue patterns.

f | Add more depth to the piece with shadowy silhouettes of more distant butterflies using a no. 0 round and a light glaze of Cerulean Blue. Blend the edges of some of these with water or lift with a clean damp brush so they melt into the background.

8 Paint Large Monarch Butterflies With Light Ribs

Paint a glaze with a no. 1 round. Start wet-on-wet with Lemon Yellow toward the body and move to Cadmium Orange on the edges. Mix Cadmium Red + Cadmium Orange, then glaze in the negative space around the ribs of the wings. Use a blend more on the red side for the corners and tips of wings, diluting as you come toward the body. The veins should still be a lighter yellow showing through from the previous layer.

Mix Burnt Umber + Payne's Grey, and use a no. 0 round along the edges of the wings to glaze some darker patterns. Avoid painting on the ribs. Blend inward with water. Add pinpoints of white along the edges of the wings with a white gel pen. Blend the edges of the white into the surrounding area with a no. 0 round and a bit of water. Apply the same colors and patterns to two more of the smaller butterflies.

9 Paint Medium Blue Butterflies With Dark Ribs

Mix Cerulean Blue with a tiny bit of Viridian Green. Paint a base layer glaze with a no. 2 round. Let the mixture vary a little from one butterfly to the next.

Paint Burnt Umber along the edges of the wings with a no. 0 round. Blend into the blue. Add a glaze of Ultramarine Blue along the top center area with a no. 1 round.

Using a no. 0 round, line the veins and edges of the wings with a thin line of Payne's Grey.

With a stiff no. 0 round and clean water, lift along the edges of the veins by running a brush lengthwise in the Cerulean Blue areas.

Take a white gel pen and add pinpoints of white along the edges of the wings and also along the center of the blue on the hind wings for highlights. Blend the edges of the white into the surrounding colors with water and a no. 0 round.

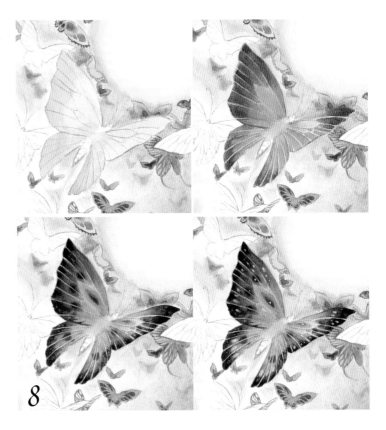

8

10 Apply Multiple Colors

With a no. 2 round, mix Sap Green + Lemon Yellow and paint a base layer color. Take a no. 1 round and add some stripes with Naples Yellow.

With a no. 0 round, add Alizarin Crimson along the edges and paint a spot on each forewing.

Still using the no. 0 round, finish with some Burnt Umber along the veins and soften with water. Add a touch of Payne's Grey at the tips of the forewings.

11 Add Spots and Striking Patterns

Mix Viridian + Sap Green and paint a base layer of color with a no. 2 round. Mix Burnt Umber + Payne's Grey and use a no. 0 round to overlay the greens with a stark pattern.

With a stiff no. 1 round, rub along the spaces between the ribs to lift some of the green with clean water.

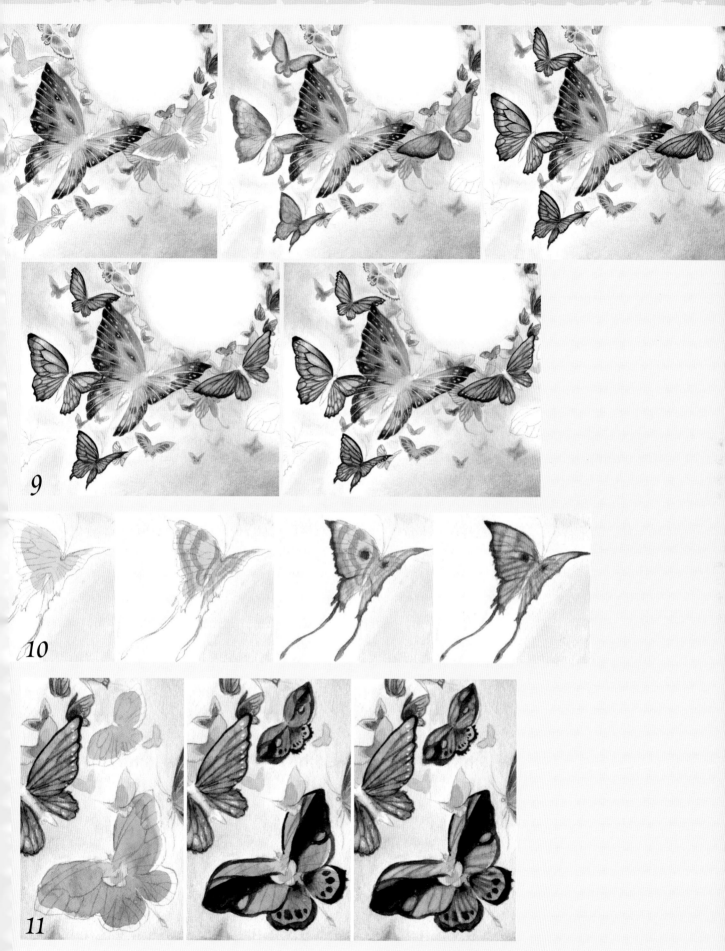

9

10

11

Receive a free bonus demonstration from the original *Dreamscapes* at **impact-books.com/DreamscapesMenagerie**

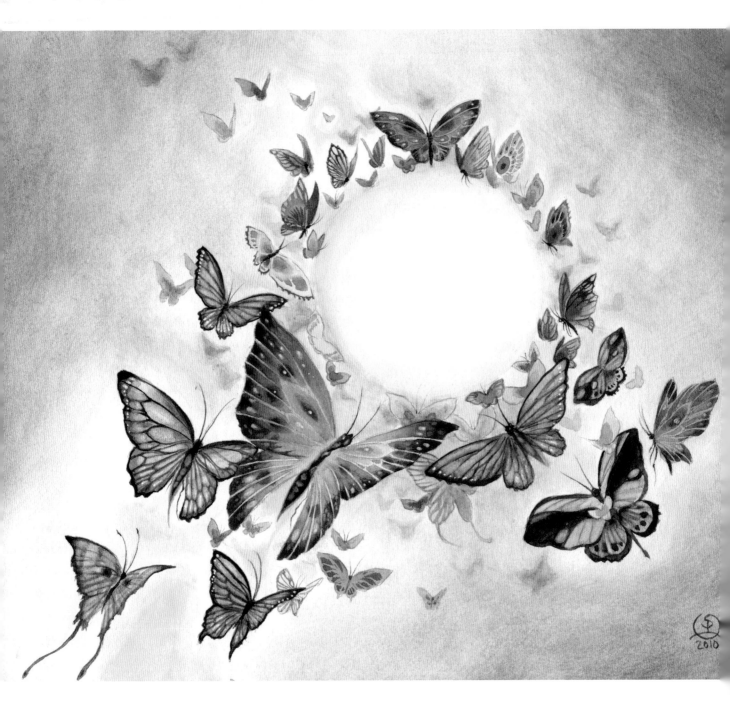

12 Finish the Butterfly Bodies

Use a no. 0 round to apply a mixture of Burnt Umber + Payne's Grey to the bodies of the butterflies. Trail outward for the antennae. On some of the bigger butterflies, lift out highlights on the bodies by rubbing lightly with a dampened no. 1 round. On the smaller and more distant butterflies, leave out these details or slightly dilute the paint with water so the darker shades are not so striking.

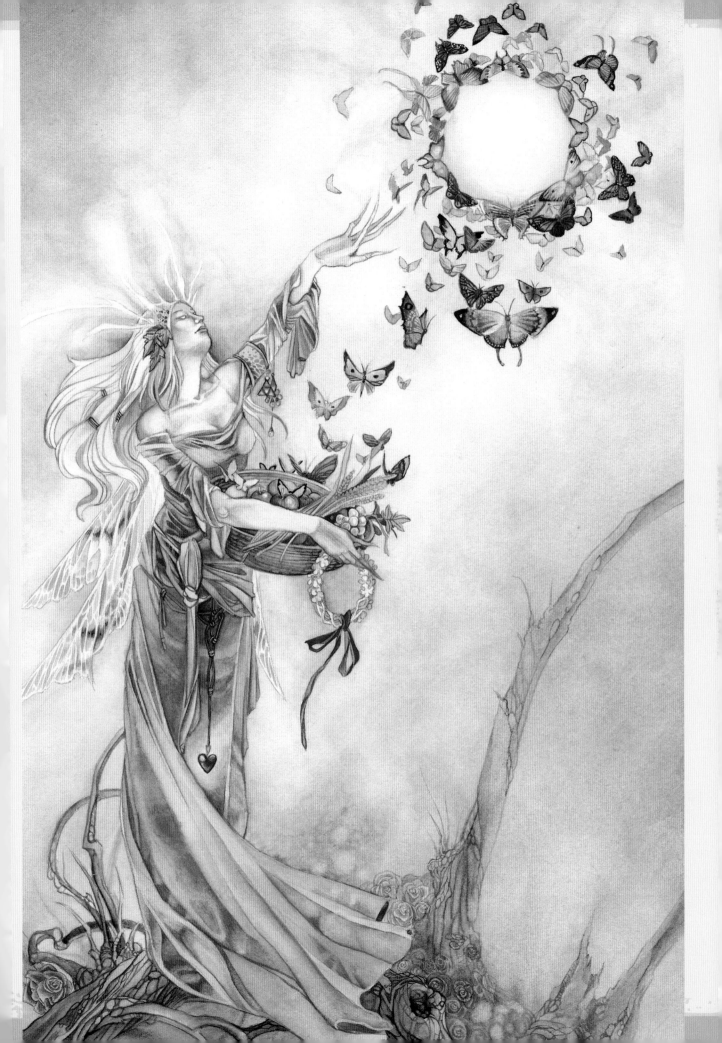

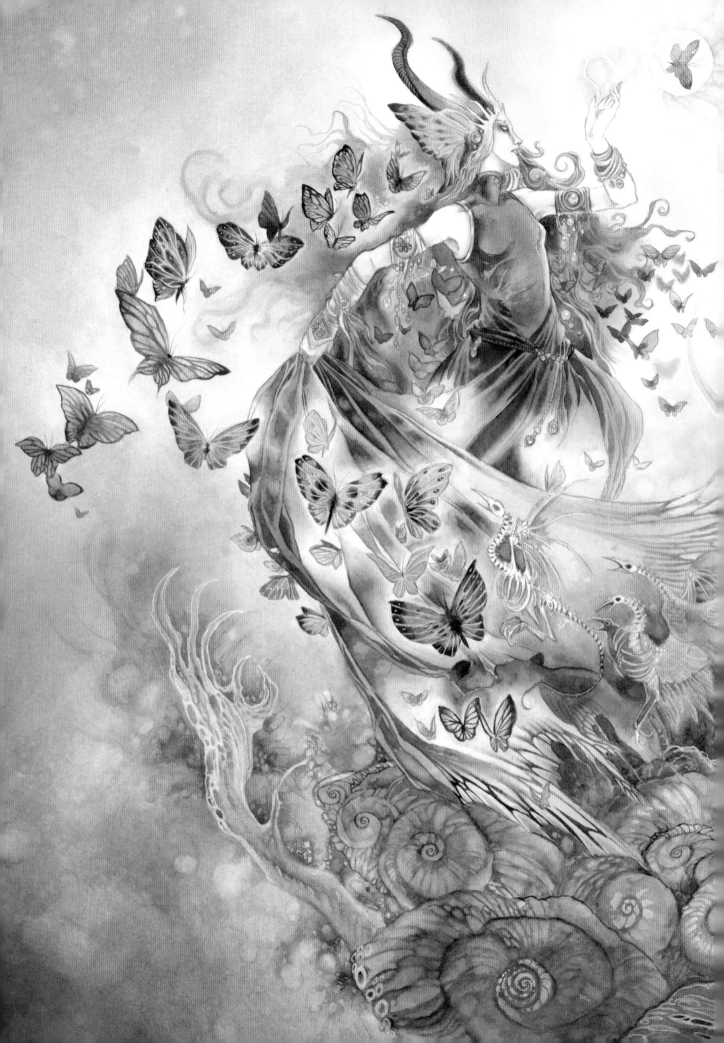

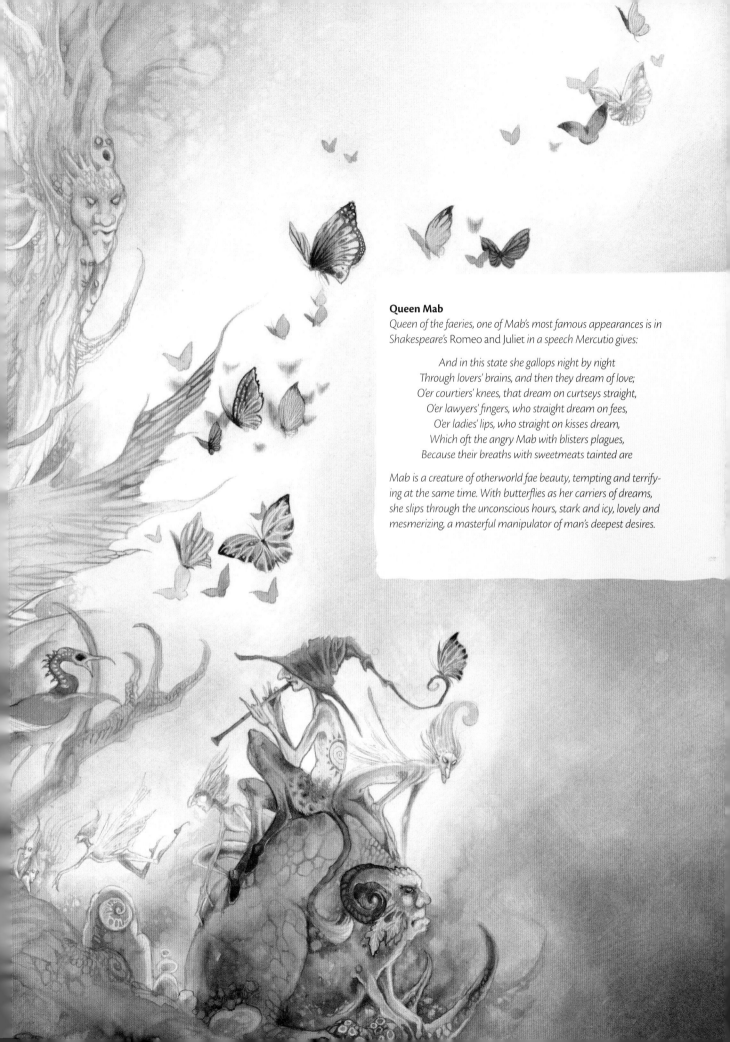

Queen Mab

Queen of the faeries, one of Mab's most famous appearances is in Shakespeare's Romeo and Juliet *in a speech Mercutio gives:*

> *And in this state she gallops night by night*
> *Through lovers' brains, and then they dream of love;*
> *O'er courtiers' knees, that dream on curtseys straight,*
> *O'er lawyers' fingers, who straight dream on fees,*
> *O'er ladies' lips, who straight on kisses dream,*
> *Which oft the angry Mab with blisters plagues,*
> *Because their breaths with sweetmeats tainted are*

Mab is a creature of otherworld fae beauty, tempting and terrifying at the same time. With butterflies as her carriers of dreams, she slips through the unconscious hours, stark and icy, lovely and mesmerizing, a masterful manipulator of man's deepest desires.

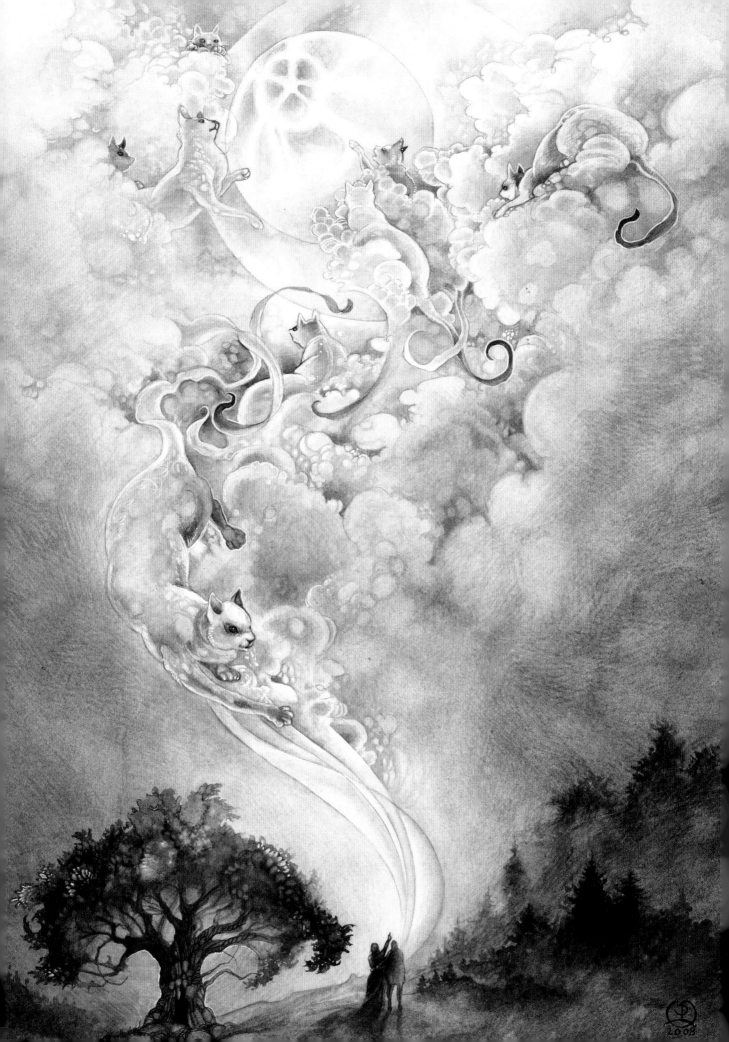

Part Four
WOODS

Brindled fur, stately manes—the woods are full of many kinds of grace in form and motion—from the deadly beauty of a stalking hunter to the fleet-footed dance of a runner. Forests are home to all manner of creatures. The tangled foliage glints with their watchful eyes as they meld silently among leaf and loam.

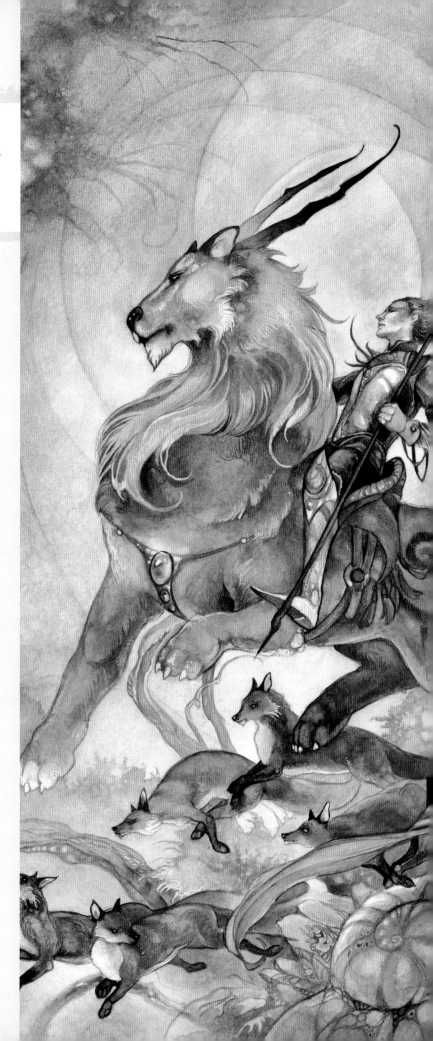

Cats

FELINES, WITH THEIR GRACE, SLEEK POWER and mercurial nature, have always been a fond subject for story tellers. Examples range from the mystery embodied in the ancient Egyptian sphinx to the terror and ferocity of the Nemean lion and his impervious golden fur in ancient Greek mythology, to the sly, shadowy cats believed to be witch familiars.

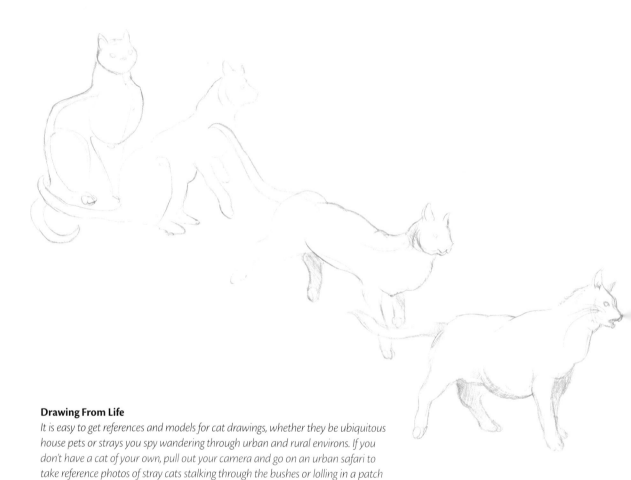

Drawing From Life

It is easy to get references and models for cat drawings, whether they be ubiquitous house pets or strays you spy wandering through urban and rural environs. If you don't have a cat of your own, pull out your camera and go on an urban safari to take reference photos of stray cats stalking through the bushes or lolling in a patch of sunlight.

Or even better, find a cat and try to draw it in motion, capturing the gestures of its movements in quick mental snapshots. This can be tricky with a creature that is constantly in motion, but the more you practice, the better you are able to distill the basic shapes and movements onto the page.

Start with the basic shapes. When drawing a cat from life, be minimal with your lines. Try to capture the tilt of the head, the arch of the back, the placement of the paws and the line that the tail trails off to. Once you have these basic shapes, add the details. Finish off with the fur and shadows. These are more static elements you can work on last, once you catch the motion and life of the cat in a pose.

Feline Grace

A cat moves with a lithe and fluid grace. Think of the arching curve of the spine and how it connects everything from the head down through the tip of the tail. This dictates movement and is the key to the interconnections of the various shapes of a cat's body—the triangular head, the angular edges of the shoulder blades, the roundness of the ribs and belly, the compact muscles in the haunches, and the flexible tail. Keep this flow in mind to capitalize on the sinuous nature of cats and to capture action and movement.

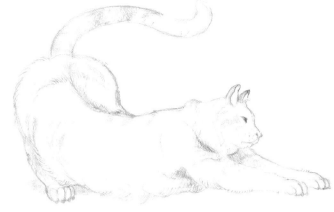

Even in Stillness

There is a casual and laid-back grace to a cat in repose. A cat can stretch out, and the body is very flat to the ground. Note the way the paws tuck underneath, the roundness of the belly, the way the legs stretch out and back.

A cat can also pull up into a very compact ball. Note how curved all the lines are. Short or long fur can further emphasize either pose.

Fantastical Cats

When working with fantastical subject matter, you can draw from features of various creatures to create the mood and feel you need. Sphinx cats (named for their physical similarities to the Egyptian Sphinx sculptures) can be an interesting springboard to work from. The hairlessness accentuates the musculature and slender, long limbs. It also makes the cat's wedge-shaped head very angular and pixie like with huge eyes. Using this as a base to work from, you can create a very fey-looking cat.

Demonstration
PAINT A CAT

In Scottish folklore, the Highland faery cat called Cait Sith is an unusually large creature, identified by its black coat with a white spot on the chest. Some believed Cait Siths were transformed witches. There are also tales of the grimalkin, which was a spirit, a fey grey cat or a witch's familiar. The name is scattered throughout literature as well. In Thomas Middleton's play *The Witch*, Hecate, Queen of the Witches, says as she flies away:

> *Now I go, now I fly,*
> *Malkin my sweet spirit and I.*
> *Oh, what a dainty pleasure 'tis*
> *To ride in the air*
> *When the moon shines fair*
> *And sing, and dance, and toy, and kiss….*

MATERIALS LIST

Surface — 6" × 6" (15cm × 15cm) illustration board

Brushes — nos. 0, 1, 2, 4, 6 rounds

Watercolors — Alizarin Crimson, Burnt Umber, Cadmium Red, Cadmium Yellow, Cobalt Blue, Lemon Yellow, Naples Yellow, Payne's Grey, Prussian Blue, Raw Umber, Sap Green, Ultramarine Violet, Viridian Green

1 Sketch the Piece and Paint the Distant Background Greens

Sketch a cat in a wooded setting. With a no. 6 round, paint wet-on-wet with a mixture of Viridian Green + Ultramarine Violet in the upper corners and Naples Yellow toward the areas surrounding the cat. Let the darker color bleed from above.

2 Paint the Distant Trees

With a no. 4 round, paint Sap Green on the ground. Then use a no. 2 round to glaze the distant branches with Sap Green. Trail the brushstrokes upward to extend into the branches.

3 Paint the Distant Ground

Mix Sap Green + Ultramarine Violet. With a no. 2 round, dab in some ground texture, letting the lighter previous layer show through for the upper highlights of the mossy mounds. Let the mixture vary in tone. Brush over with clean water using a no. 4 round to blend and soften the edges.

4 Paint the Base Layers of the Trees

Mix Payne's Grey + Raw Umber + Sap Green for a neutral tone with a mossy tint. With a no. 2 round, drybrush a base layer for the core of the tree trunks. Leave white along the edges and let the brush skip a bit to get texture.

1

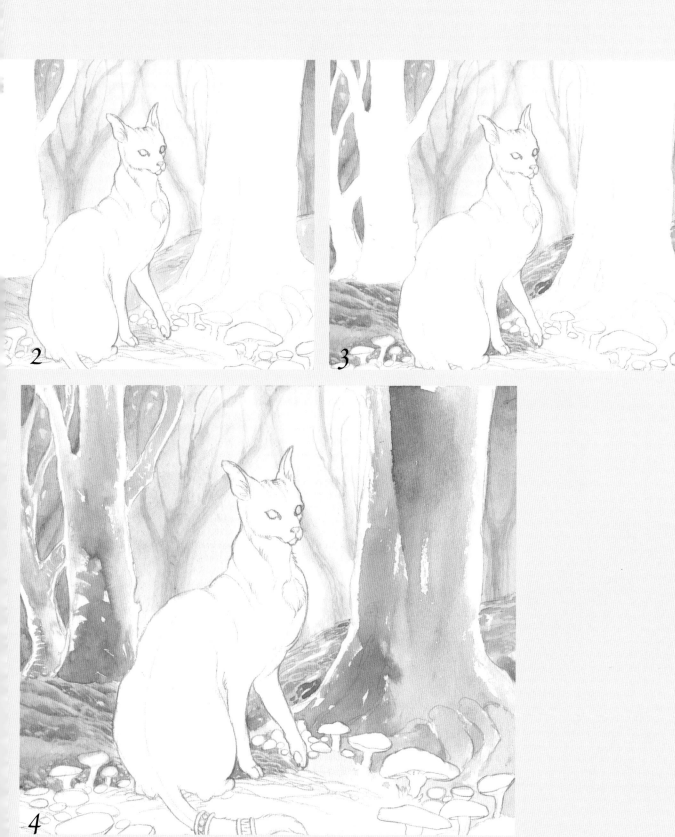

2

3

4

Continue Painting the Trees

5 Mix Prussian Blue + Payne's Grey + Naples Yellow and paint in some bark texture with a no. 1 round. Keep the edges of the trunks white for highlights.

With a stiff no. 2 round, swipe parallel to the edges of the trees to soften the hard edges that border the background. Brush lightly over the core of the tree with water to soften the textures.

Go back with a no. 1 round and mix Prussian Blue + Viridian Green. Add some deeper shadows to help pull out definition that may have become too blurred with the lifting. Also blend some of the same mixture into the shadowy foliage around the edges of the branches to make the white edges contrast and stand out more.

Paint the Ground Details and Shadows Under the Cat

6 With a no. 2 round, dab in Ultramarine Violet outside the ring of mushrooms. On the inside of the ring, use Raw Umber mixed with a tiny amount of Sap Green.

With a no. 1 round, mix Payne's Grey + Viridian Green and paint in some shadows and details in the purple foreground. Let the previous purple layer show through as highlights on the upper edges of rocks and mounds. Use small, fine strokes with the point of the brush in the center area to help focus attention there. Use broader dry brushstrokes with the side of the brush along the edges. In the center of the mushroom ring, use a no. 1 round to paint in the rocky and grassy shadows with Raw Umber.

Use a no. 1 round to glaze Burnt Umber shadows under the cat. Use some clean water on the brush to lift and blend some highlights in the ground.

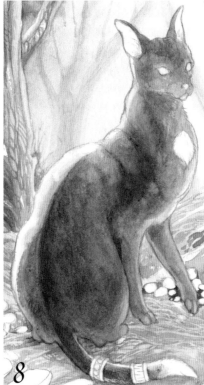

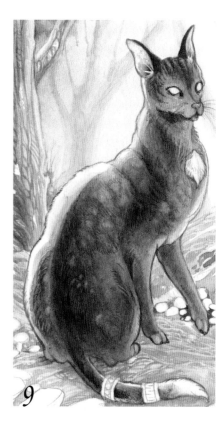

Paint the Cat Base Layers

7 Use a no. 2 round with Ultramarine Violet to paint the core of the cat. Run a streak of Lemon Yellow along the curve of the back and chest for reflected light. Keep the white on the very edge.

Add Tone and Shadow

8 Mix Payne's Grey + Cobalt Blue and glaze a layer over the cat's whole body. Mix Payne's Grey + Burnt Umber, and with a no. 2 round, glaze shadows and start to define the form and musculature.

Highlight and Detail the Fur

9 Use a no. 0 round and paint with short parallel strokes using Payne's Grey for the fur. Follow the contours of the body. Add definition around the eyes and mouth. Darken the ears.

With a no. 2 round, glaze a light layer of Cobalt Blue over the core of the cat's body to blend and soften the fur strokes a bit. Then scrub in spots of dappled light by lifting the paint along the back.

Use no. 0 round to paint Alizarin Crimson in the ears and nose. Lightly trail the whiskers out with diluted Payne's Grey.

10 Paint the Eyes

With a no. 0 round, paint the eyes Sap Green. Leave white highlights along the rims and reflected points. Glaze Lemon Yellow around the rims of the eyes. Finish with Payne's Grey pupils.

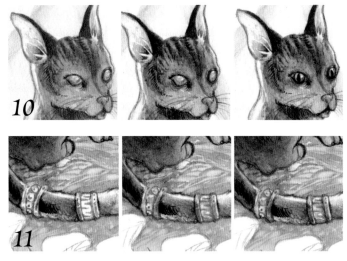

11 Paint the Jewelry

With a no. 0 round, paint Raw Umber shadows on the gold jewelry. Glaze with Cadmium Yellow, but allow some highlights of white to show through. Add some final deeper shadows with Viridian Green to highlight the reliefs.

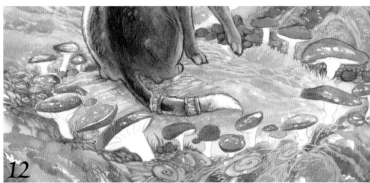

12 Paint the Mushroom Caps

Use different mixtures of Cadmium Red + Raw Umber to work your way around the ring of mushrooms. Paint with a no. 2 round, starting with just the Cadmium Red along the sides, then blending in Raw Umber as you come closer to the front center mushrooms. Leave bits of white showing through for white spots on the caps.

13 Shade and Lift Out to Finish

Mix Viridian Green + Ultramarine Violet and use a no. 1 round to add shading on the caps. For the stems of mushrooms, shade with Burnt Umber, keeping the edges white. With a stiff no. 2 round, scrub little spots of dappled light by lifting the paint along the back.

Demonstration
PAINT A LION

Lions have a long association with the sun. A lion's mane is like a nimbus of light. The sun and the lion were symbols of Persian royalty and motifs found in Turkish and Mongolian art. The Turkish hero Alp Kara Aslan was said to have been raised and suckled by a lioness. (*Aslan* means lion in Turkish). Aslan is also the name of the king of the beasts in C.S. Lewis' *Chronicles of Narnia*. The character is an allegory of Christ. A lion is an embodiment of strength and of fierce but righteous power.

MATERIALS LIST

Surface ~ 8" × 7" (20cm × 18cm) illustration board

Brushes ~ ½-inch (12mm) flat, nos. 0, 1, 2, 4 round

Watercolors ~ Brown Madder, Burnt Sienna, Burnt Umber, Cadmium Red, Naples Yellow, Payne's Grey, Raw Umber, Sap Green, Ultramarine Violet, Viridian Green

Other ~ salt

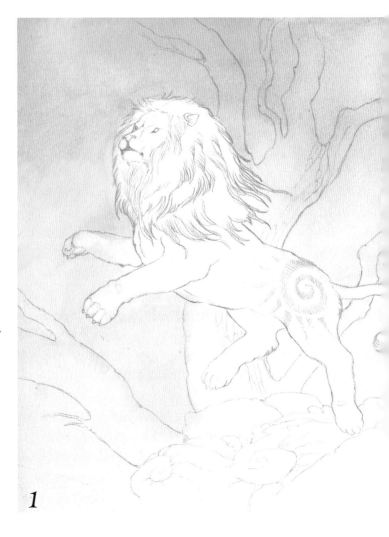

1 *Sketch the Piece and Lay in Background Tones*
Sketch a lion in all his magnificent splendor. With a ½-inch (12mm) flat, paint the background with a graded wash of Naples Yellow. Keep it darkest at the top. Paint directly over the background tree. Try to paint around the lion, but don't worry if you cannot avoid painting over him a little bit—it won't matter too much because this is a similar color to his final hues.

2 *Darken the Background and Add Texture*
Mix Viridian Green + Payne's Grey. Glaze the lower half of the background with a no. 4 round. Paint around the tree this time. Sprinkle salt into the wet paint. Once dry, lightly brush the salt away.

3 *Paint the Distant Foliage*
Using the textures that the salt created, enhance the patterns to create foliage. With a no. 2 round, dot Raw Umber for the upper part of the tree and blend with water downward into the salted area. At the top of the painting, add foliage with a mixture of Viridian Green + Raw Umber. Blend outward with water.

4 *Paint the Base Layer on the Tree*
Paint a base layer for the tree using a no. 2 round and Raw Umber.

1

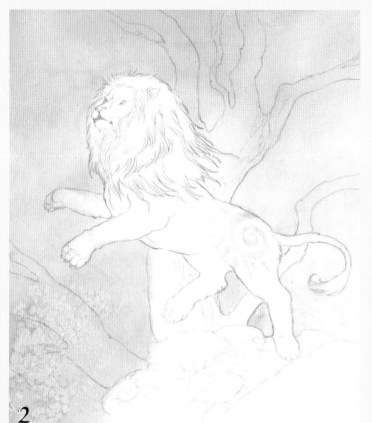

2

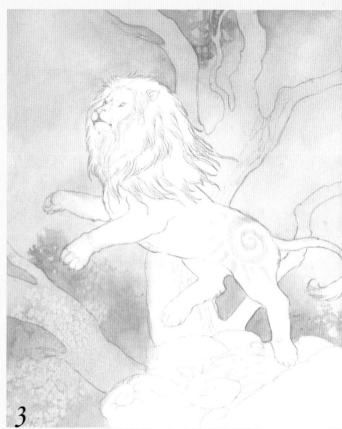

3

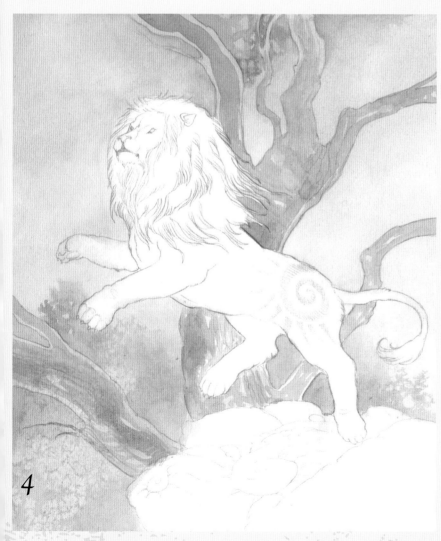

4

127

5 Add Highlights, Depth and Shadows to the Tree

Paint shadows on the tree in Viridian Green with a no. 1 round. With a bit of clean water on the brush, stroke along the edges of the tree and in the lighter areas of the bark texture to lift highlights.

Glaze core shadows into the tree with Ultramarine Violet using a no. 4 round.

Use a no. 0 round to paint the twigs with diluted Ultramarine Violet. Trail the brush up and outward along the twigs. Then mix Ultramarine Violet + Viridian Green to add darker shadow details on the bark chips.

6 Paint the Lion Base Layer

With a no. 4 round, glaze Burnt Sienna on the body of the lion. Make sure to keep an edge of white around the body.

7 Add Shadows to the Lion

Paint shadows and some fur texture on the lion with a no. 1 round and a mixture of Cadmium Red + Burnt Umber. Use short curved strokes around the contours of muscles to shape the lion. For the mane, paint around the strands of hair—do not paint the actual hairs. Think of the negative space each strand makes.

8 Blend in a Golden Tint

Glaze Naples Yellow over the body with a no. 2 round to give the lion's fur a golden tint.

9 Add Deep Shadows

Use a no. 0 round to add deeper shadows with Ultramarine Violet, again shaping around the lion's form with fur strokes. Be sure that your strokes move in the same direction as the fur. Use the same kind of strokes to paint the sun pattern marking on the haunch.

10 Paint Richer Golds and Dappled Light

With Payne's Grey, use a no. 0 round to paint the lion's eyes and to darken the centers of the darker spots along the sun pattern.

Use Brown Madder to glaze the belly and back legs with a no. 2 round. This will blend and soften the fur texture. Then glaze a diluted bit of Sap Green along the top edges of the lion.

Wet a stiff no. 2 round and lift dappled sunlight and highlights along the back, tops of the paws and belly.

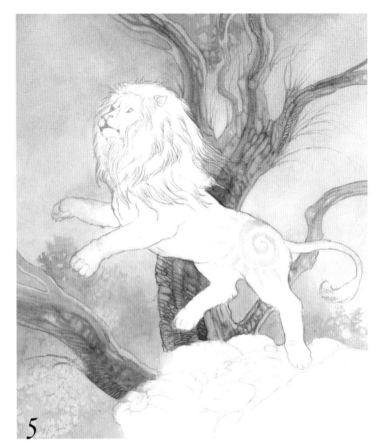

5

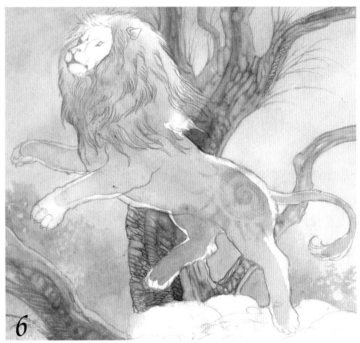

6

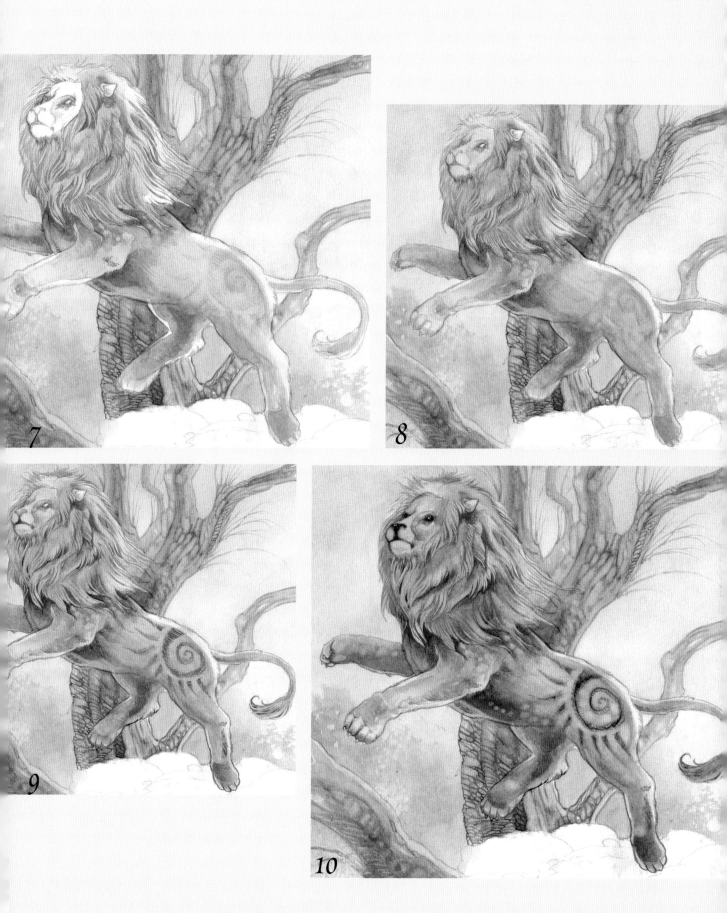

7

8

9

10

11 *Prepare the Ground*

With a ½-inch (12mm) flat, paint wet-on-wet with Sap Green and Ultramarine Violet on the foreground stones. Keep the green along the edges, and the purple closer to the bottom right. Sprinkle the wet paint with salt. When the paint dries, brush the salt crystals away.

12 *Define the Spiral Stonework*

With a no. 2 round, add definition to the spiral stonework. Use Viridian Green in the upper areas and blend toward Ultramarine Violet in the lower parts.

13 *Create Highlights on the Ground*

Lift out highlights with a wet no. 2 round.

14 *Deepen the Shadows and Crevices to Finish*

Mix Payne's Grey + Viridian Green. Use a no. 0 round to darken and accentuate the deepest crevices.

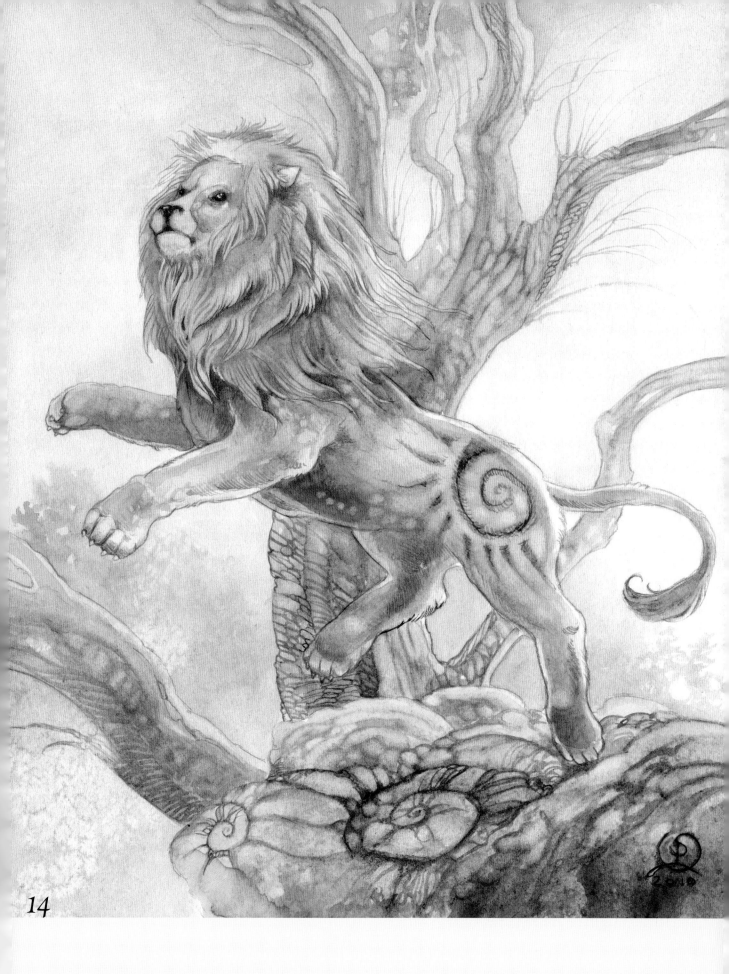

14

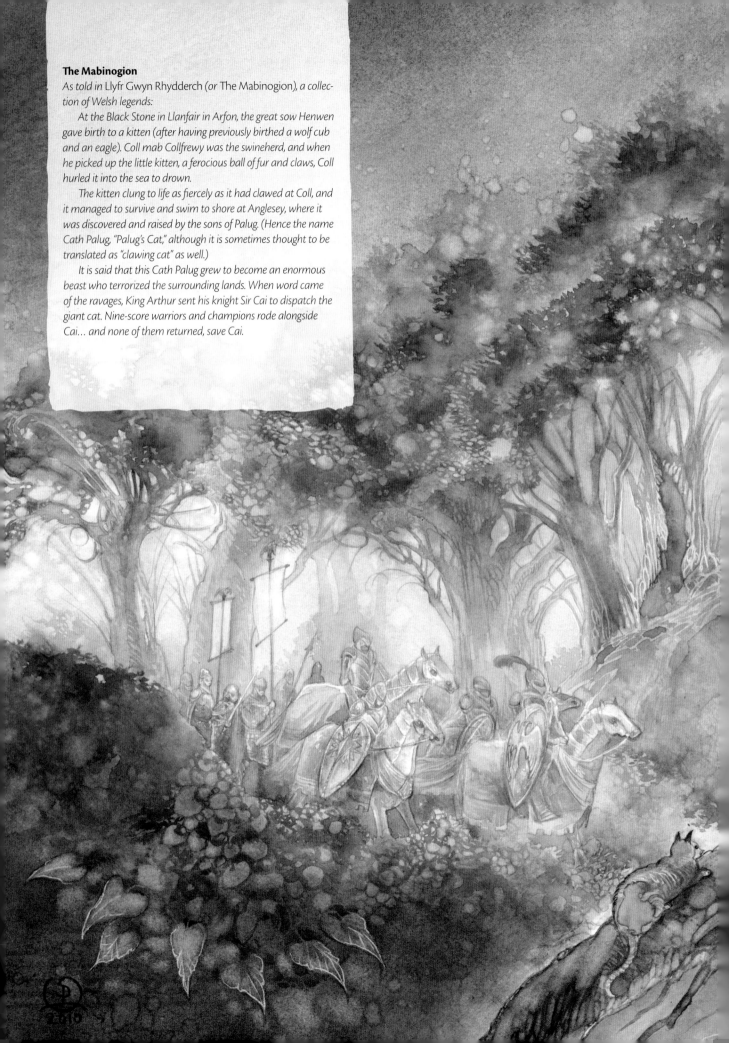

The Mabinogion

As told in Llyfr Gwyn Rhydderch (or The Mabinogion), a collection of Welsh legends:

At the Black Stone in Llanfair in Arfon, the great sow Henwen gave birth to a kitten (after having previously birthed a wolf cub and an eagle). Coll mab Collfrewy was the swineherd, and when he picked up the little kitten, a ferocious ball of fur and claws, Coll hurled it into the sea to drown.

The kitten clung to life as fiercely as it had clawed at Coll, and it managed to survive and swim to shore at Anglesey, where it was discovered and raised by the sons of Palug. (Hence the name Cath Palug, "Palug's Cat," although it is sometimes thought to be translated as "clawing cat" as well.)

It is said that this Cath Palug grew to become an enormous beast who terrorized the surrounding lands. When word came of the ravages, King Arthur sent his knight Sir Cai to dispatch the giant cat. Nine-score warriors and champions rode alongside Cai… and none of them returned, save Cai.

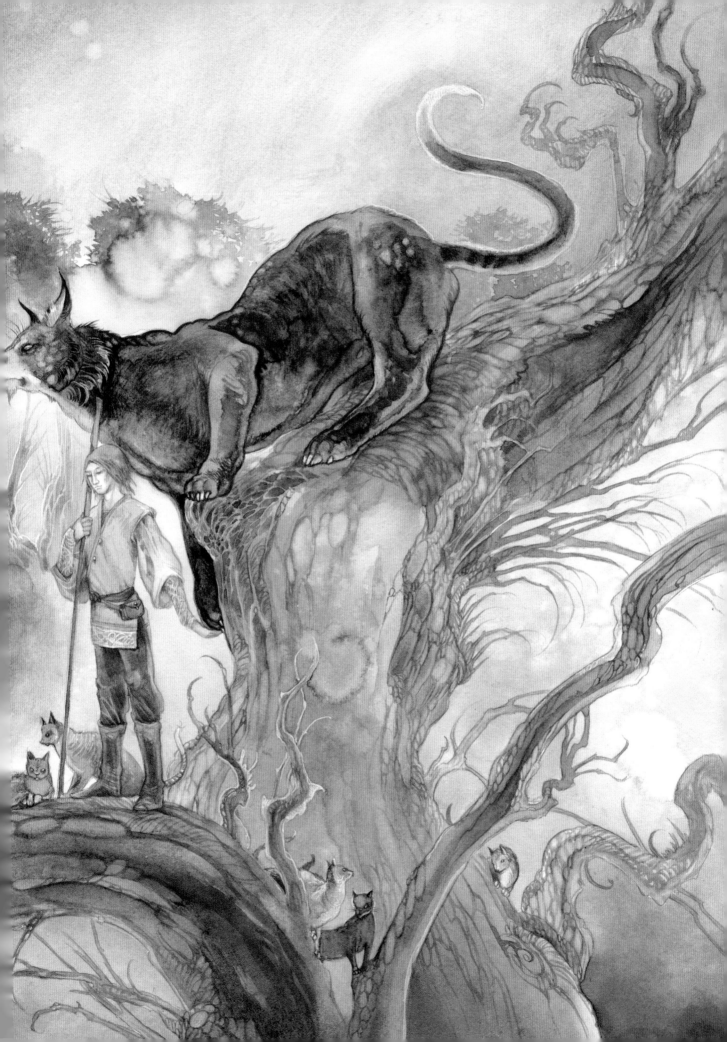

Foxes

Foxes frequently embody cleverness in the tales in which they appear, though wit is not often tied to wisdom, and their pranks and tricks can lead to trouble. This is the case with France's legendary Reynard the Fox, who appears in many folktales and fables.

Likewise in Asian stories, many fox spirits start off young and foolish and gain the ability to mimic and shape-shift into human form as they grow older and wiser.

In the Pacific Northwest, the Atsugewi tribe have a story of how Silver-Fox created the world. Silver-Fox climbed down from the sky to the water and stretched and pushed with his feet in all directions to transform his little island into the vast world, filled with forests and streams and animals, that we know today.

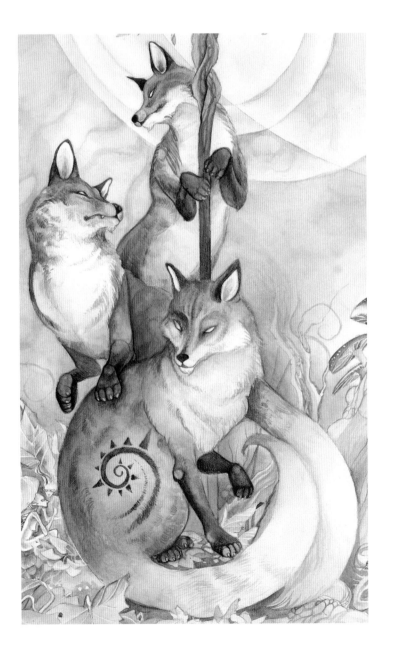

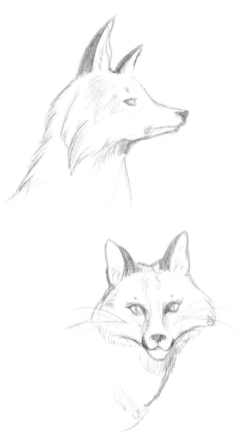

Facial Features

Foxes possess large pointed ears that stand up on top of the head, golden eyes with slick black pupils, and long trailing whiskers. They have wide faces with slender, tapered muzzles. The upper half of the face is usually colored, while the bottom half has longer white fur, which makes the face appear even wider.

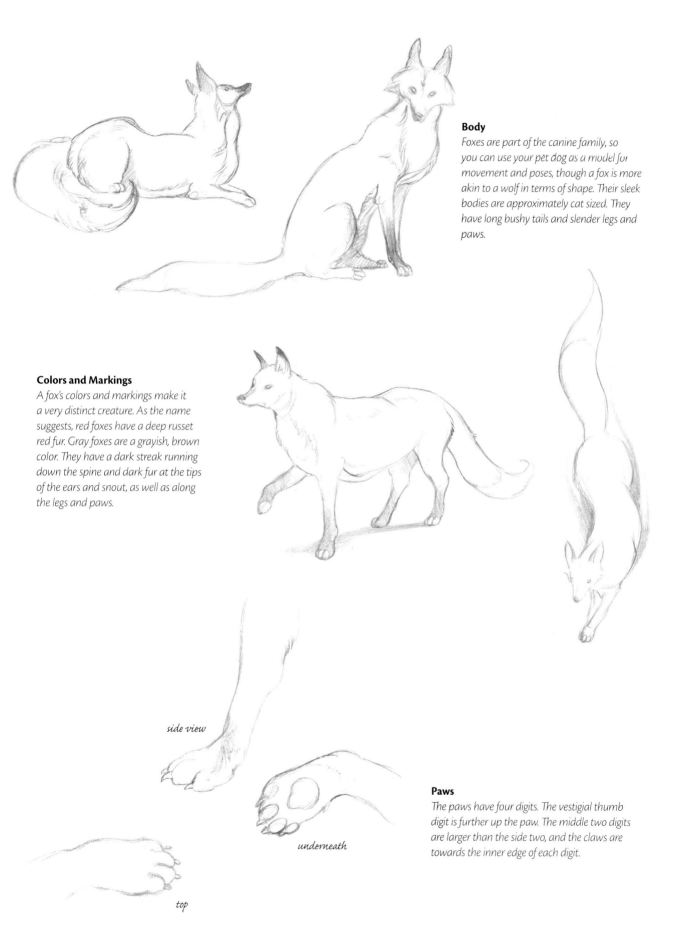

Body

Foxes are part of the canine family, so you can use your pet dog as a model for movement and poses, though a fox is more akin to a wolf in terms of shape. Their sleek bodies are approximately cat sized. They have long bushy tails and slender legs and paws.

Colors and Markings

A fox's colors and markings make it a very distinct creature. As the name suggests, red foxes have a deep russet red fur. Gray foxes are a grayish, brown color. They have a dark streak running down the spine and dark fur at the tips of the ears and snout, as well as along the legs and paws.

side view

underneath

top

Paws

The paws have four digits. The vestigial thumb digit is further up the paw. The middle two digits are larger than the side two, and the claws are towards the inner edge of each digit.

Demonstration
PAINT A FOX

The Japanese kami Inari has foxes as sacred messengers. Inari's foxes are pure white, and male and female pairs of these kitsune (fox spirits) are frequently found guarding the entrances to Inari's shrines. Kitsune, the Korean Kumiho and the Chinese version called Huli jing are trickster spirits that are capricious and often shape-change into human form and interact with humans who were unaware of their supernatural nature. Frequently they appear as beautiful girls. Sometimes they are dangerous and soul draining. Other times they are simply curious and mischievous.

MATERIALS LIST

Surface — 5" × 7" (13cm × 18cm) illustration board

Brushes — nos. 0, 1, 2, 4 rounds

Watercolors — Brown Madder, Burnt Sienna, Burnt Umber, Cobalt Blue, Lemon Yellow, Naples Yellow, Payne's Grey, Prussian Blue, Sap Green, Ultramarine Violet, Viridian Green

Other — salt, small sponge

1 Sketch the Piece and Paint the Background Greens

After sketching your piece, use a no. 4 round to paint wet-on-wet with Viridian Green in the upper left and right corners of the distant background. Let the darker greens bleed in toward the center. While still wet, use a no. 2 round and a mixture of Sap Green + Prussian Blue to trail some darker foliage shadows across the upper left corner. Then sprinkle the wet paint with salt. Brush the salt away when the surface has dried.

2 Paint the Background Branches

Mix Viridian Green + Ultramarine Violet and add more depth to the background greenery with a no. 2 round. Work with the texture that the salt left, keeping whiter areas as highlights and darkening some of the deeper areas, especially closer to the ground elements. With a no. 0 round, trail diluted paint upward into thin branches.

3 Add a Neutral Base Tone for the Ground

Mix Sap Green + Payne's Grey and paint the ground with neutral tones. Blend in a bit of Prussian Blue for the standing stones. Sprinkle the wet paint of the ground and stones with salt. When the paint has dried, brush the salt away.

1

4 Add Depth to the Ground

Use a no. 4 round to glaze Sap Green over the ground. Leave highlights showing on the edges of the stones and the top edges of the mossy mounds. Use minimal brushstrokes so as to not disturb the salt texture too much. You want some of that texture to show through the glazes.

With a no. 2 round, use a mix of Payne's Grey + Prussian Blue for the shadows on the stones. Lift out some highlights along the edges.

2

3

4

5 Deepen the Greens

With a no. 1 round, mix Viridian Green + Ultramarine Violet. Add verdant shadows on the mossy mounds and under the leaves. Paint into the negative spaces around the leaves so the surfaces themselves remain lightly colored.

6 Add Color to the Leaves

Use various mixtures of Lemon Yellow, Sap Green and Naples Yellow to glaze the centers of the leaves. Make sure you retain the white edges.

7 Add Dark Bits in the Background

With a no. 0 round, darken the spiral carvings on the standing stones with Payne's Grey, and dot shadowy bits into the ground foliage.

8 Paint the Stone Lantern Base

For a base layer, mix Payne's Grey + Cobalt Blue. Use a no. 2 round to paint the lantern. While still wet, press a small sponge into the paint for texture.

Do not paint the upper right half of the lantern. It will be painted with Sap Green as a bright base for moss later on.

9 Define the Form and Blend in More Moss

Define the form of the lantern by painting shadows in Payne's Grey with a no. 1 round. Glaze Sap Green along the left edge of the top. On the base, trail little mossy creeper tendrils outward into the gray of the stone.

For the mossy right half of the top, wet a no. 1 round with clean water and lift small circular dots to give the moss the appearance of slight rounding mounds.

10 Paint the Lantern Shadows

Glaze the deepest shadows on the lantern with a mixture of Burnt Umber + Payne's Grey, using a no. 1 round.

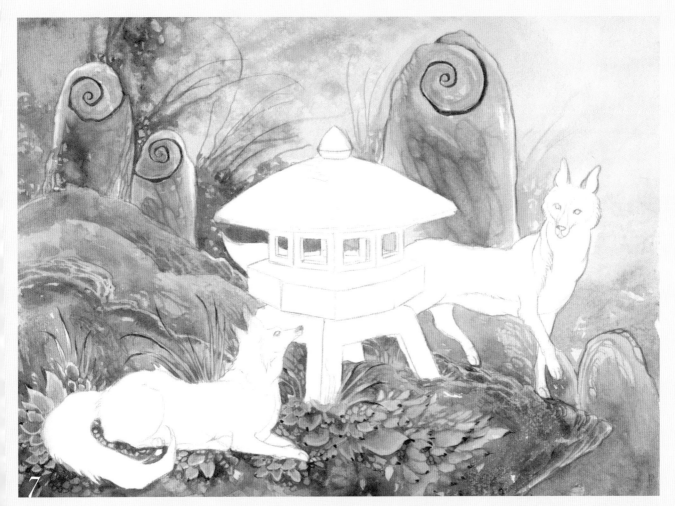

7

8

9

10

11 Paint the Base Layer on the Foxes
Paint a base layer of Burnt Sienna on the foxes with a no. 2 round.

12 Add Shading
Using Brown Madder, add shading on the foxes with a no. 1 round. Paint with short parallel strokes in the direction of the fur as you move around their bodies.

13 Define the Markings
With clean water and a no. 1 round, stroke parallel with the edges of the white fur on the chests, tail and stomachs to lift some of the hard edges of color and blend in the surrounding colors.

Glaze a mixture of Burnt Umber + Payne's Grey on the paws, ears and noses. Use more concentrated Payne's Grey for the tips of the ears and the eyes.

14 Add Highlights and Blend the Fur to Finish
Using a no. 1 round, glaze diluted Ultramarine Violet on the white fur, and glaze a bit of Lemon Yellow along the edges of the bodies, as reflected color from the background. With a no. 2 round, glaze a diluted bit of Viridian Green in the core shadows of the bodies. This will help soften the strokes made for the fur.

Using a no. 1 round, lift out soft-edged spots as dappled bits of highlights along the foxes' backs. Define the toes by lifting out a little bit of the brown with a no. 1 round.

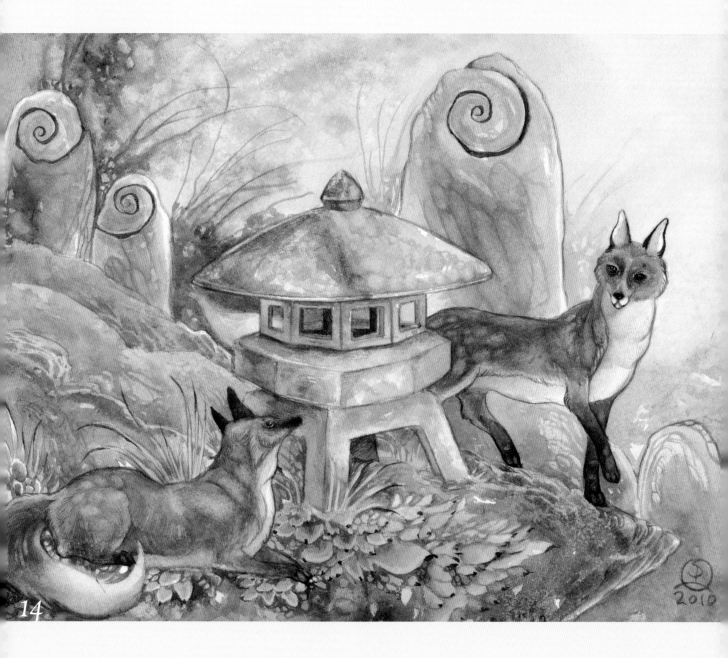

14

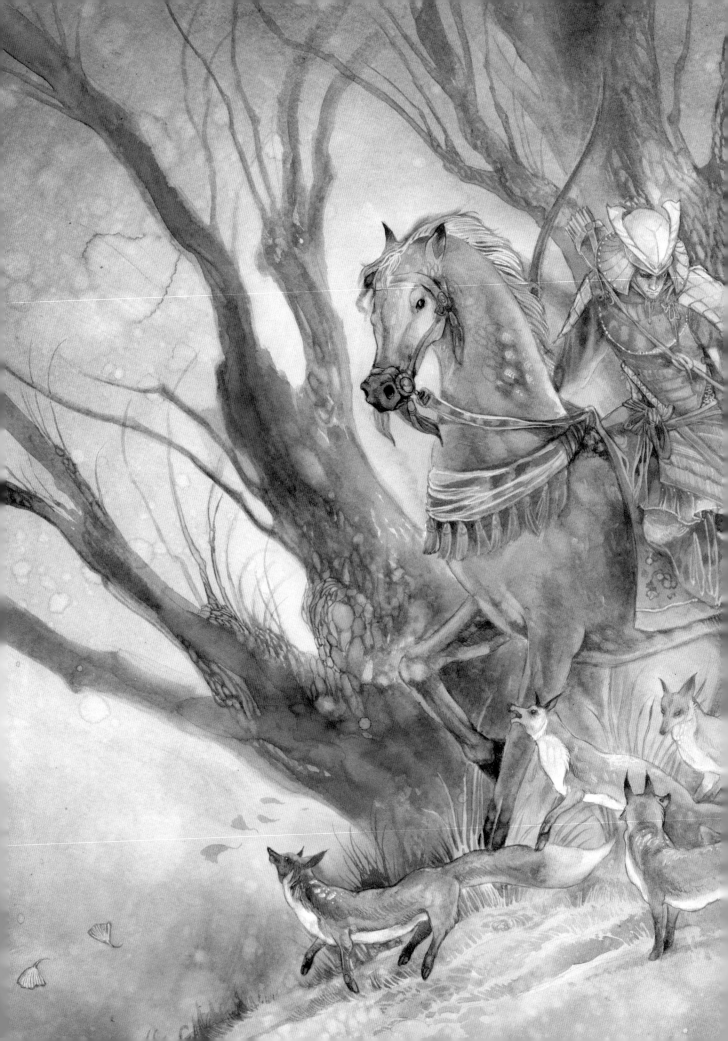

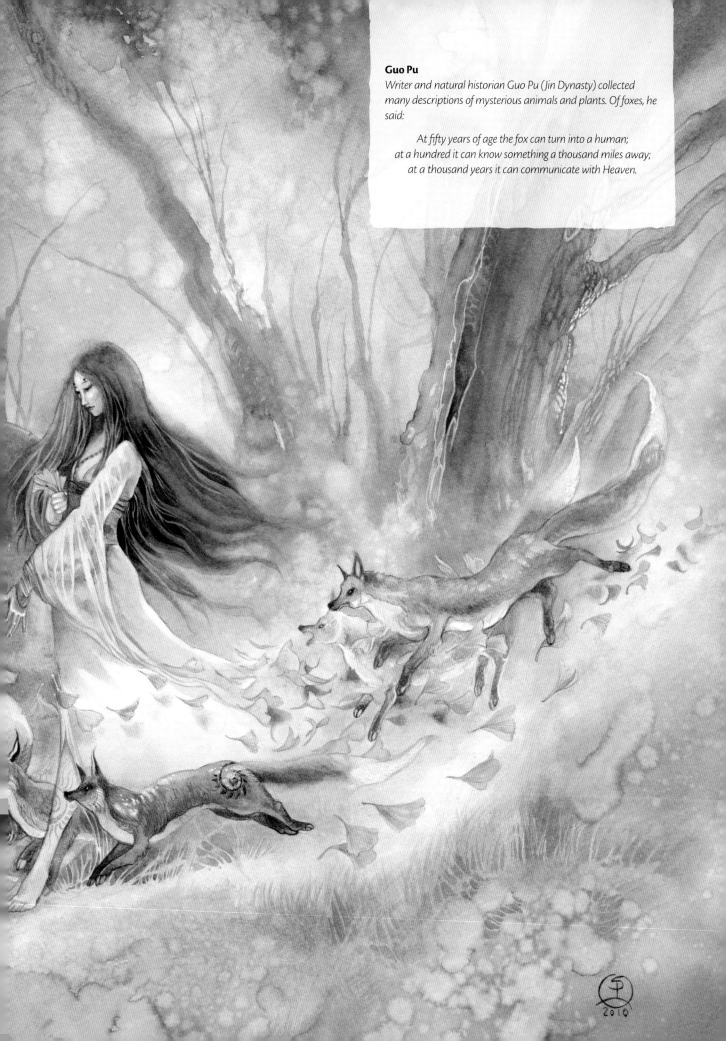

Guo Pu

Writer and natural historian Guo Pu (Jin Dynasty) collected many descriptions of mysterious animals and plants. Of foxes, he said:

At fifty years of age the fox can turn into a human;
at a hundred it can know something a thousand miles away;
at a thousand years it can communicate with Heaven.

Horses

Magical horses appear in many myths, with frequent associations to the gods. In Norse mythology, Odin rides a splendid eight-legged steed named Sleipnir, born from the shape-changed trickster god Loki. Sleipnir was swift and fearless, and never tired.

Horses are often associated with the sun, being linked with charioteers who drive the flaming sphere across the skies each day. Surya, the Hindu solar incarnation, drove a chariot across the heavens pulled by seven red mares called Harits. As they race across the sky, their presence banishes darkness and ushers in the warmth and light of day.

And then there is Pegasus, the fantastic winged horse whom the ancient Greek goddess Athena grants Bellerophon power over with a magic golden bridle. Pegasus was companion to the hero on many adventures, including when they fought and slew the monster Chimera. Bellerophon eventually became arrogant in his victories and determined to become a god himself. He mounted Pegasus to storm Mount Olympus. Zeus was angered by this presumption and sent a gadfly to sting Pegasus, who bucked and threw his foolish rider to the earth far below.

Understanding Basic Skeletal Structure

When you start drawing horses, familiarize yourself with the basics of the skeletal structure. By understanding how the body is put together, you can see how the horse's outer form is a reflection of this. If you ignore the underlying structure, you might miss the subtle curves, bulges and tapering along the body.

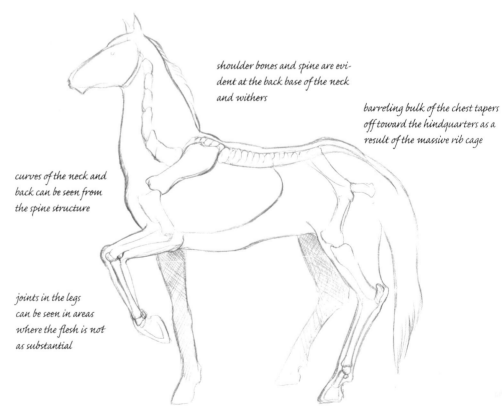

shoulder bones and spine are evident at the back base of the neck and withers

barreling bulk of the chest tapers off toward the hindquarters as a result of the massive rib cage

curves of the neck and back can be seen from the spine structure

joints in the legs can be seen in areas where the flesh is not as substantial

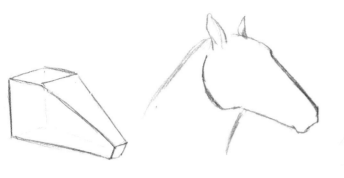

Practice Drawing a Horse Head

Start by drawing a basic wedge shape. Round out the jawbone area, going narrower underneath and behind the mouth. Make the ears narrow and pointed, and raise the brow around the eye sockets.

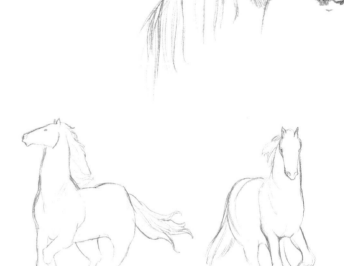

Side View: The flow of the mane and tail indicate motion to the viewer, as well as the position of the legs in full gallop.

Front: The roundness and the muscles girding the hindquarters can be seen. The head is long and narrow and less wedge-shaped from this angle.

Three-Quarters: The width of the chest can be seen at an angled view, along with the muscles that flank the rib cage and round out the body.

Galloping Horse

It can be tricky to figure out how a horse's legs coordinate when in motion. Watch a video of a horse galloping and freeze the frames as it moves so you get the feel of the motion.

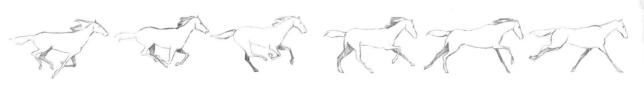

Receive a free bonus demonstration from the original *Dreamscapes* at **impact-books.com/DreamscapesMenagerie**

Demonstration
PAINT A WILD HORSE

A herd of wild horses comes charging across the grassy hillside. The wind whips through the long manes and tails, and the air has a charged, crystal quality.

MATERIALS LIST

Surface — 6" × 8" (15cm × 20cm) illustration board

Brushes — ½-inch (12mm) flats, nos. 0, 1, 2 rounds

Watercolors — Burnt Sienna, Burnt Umber, Lemon Yellow, Payne's Grey, Prussian Blue, Raw Umber, Ultramarine Blue, Ultramarine Violet

Other — small sponge

1 Sketch the Piece and Paint the Cloudy Sky

Once you've sketched your horses, use a ½-inch (12mm) flat to paint the sky Ultramarine Blue. While the paint is still wet, take a slightly damp sponge and lift out some paint to make fluffy clouds in the lower sky.

2 Glaze the Grass and Sky

With a ½-inch (12mm) flat, glaze Raw Umber onto the grass. Use broad horizontal strokes, blending up into the horizon with water.

Glaze the upper third of the sky with Ultramarine Violet. Dilute the lower edge with water to blend.

3 Paint the Distant Horses

Use a no. 1 round to add some detail to the distant horses with Ultramarine Blue. Keep the shapes general and block in the shadows, blurring the edges with water. Don't add too much definition to these distant elements, or they will compete with the foreground. Glaze the lower grass foreground with Lemon Yellow using a ½-inch (12mm) flat.

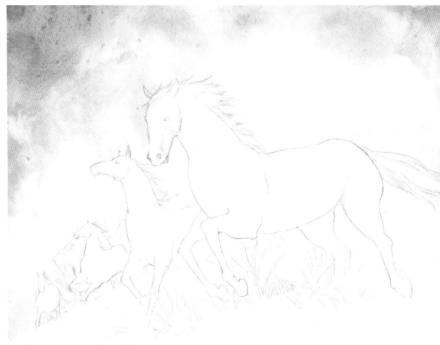

1

4 Add More Grassy Detail

With a no. 1 round and Raw Umber, paint the shadows of negative space around the grass in the foreground. Use water to trail the upper edges into shadowy, more distant blades and clumps of grass. In the foreground, use a fairly dry ½-inch (12mm) flat with Raw Umber to add more grassy texture. Pull the flat part of the brush in curved upward strokes.

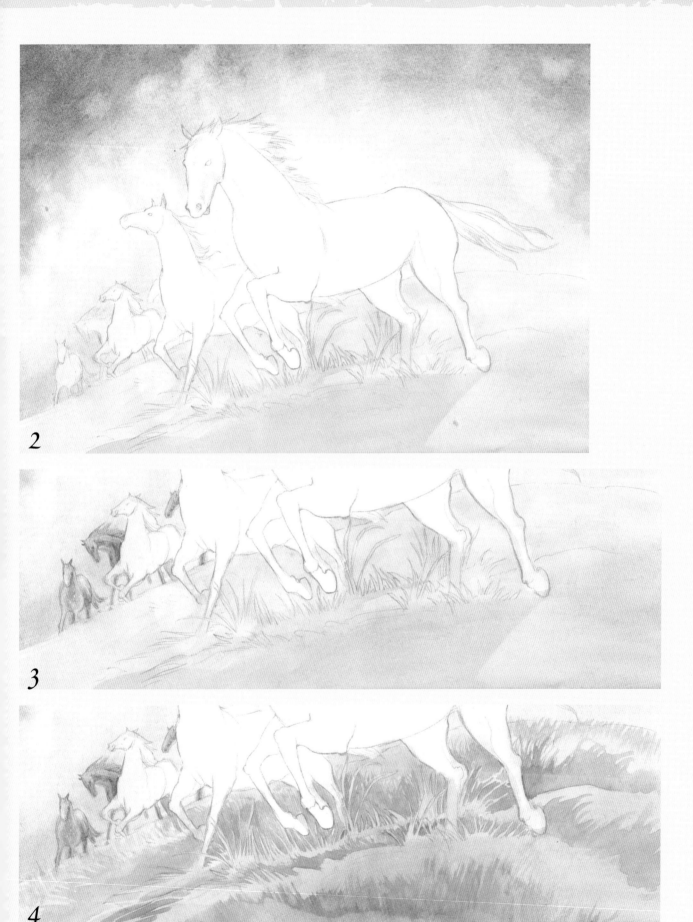

2

3

4

5 Paint Base Layers on the Horses

Mix Burnt Umber + Payne's Grey and lay in a base for the horses with a no. 2 round. Keep some highlights of white paper along the backs and necks.

6 Add Shadows

With a no. 2 round, mix Prussian Blue + Burnt Umber, and add shadows on the horses' bodies. Keep the darkest shadows toward the underside of the horse and to the left, as the light is hazy and diffuse and comes from the top right area. Use clean water on the brush to lift highlights. Scrub lightly to blend the edges of the shadows and create muscle definition.

7 Vary the Tones

Glaze diluted Lemon Yellow on the distant horse using a no. 2 round. Glaze diluted Burnt Sienna on the middle horse. Keep the edges light for highlights, and focus the color more to the core.

On the foreground horse, apply Payne's Grey to the eye, hooves, mane and tail with a no. 2 round. Use a no. 0 round to add more detailed shadows along the body with a mix of Ultramarine Violet + Payne's Grey. Use short parallel strokes that follow the contours of the body and hair. Blend sharp-edged lines with some clean water and a no. 2 round.

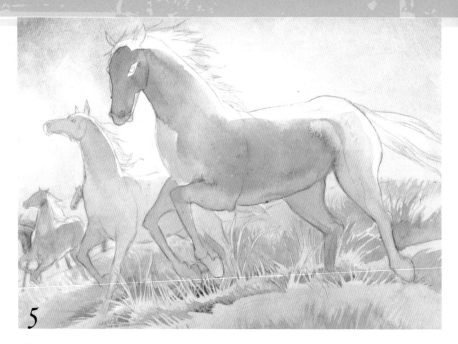

5

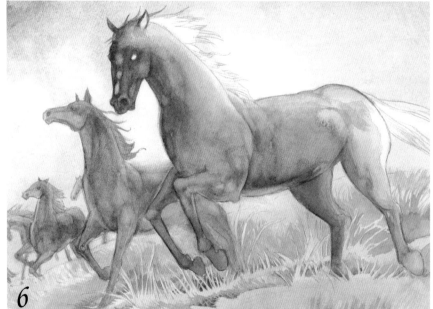

6

7

148

8 Detail the Mane and Tail to Finish

Finish the mane and tail with a mix of Prussian Blue + Payne's Grey. Use a no. 0 round to paint the shadows in the hair. Paint in the negative space around the long strands (just like the grass), and trail outward to the right. Blend outward along the tendril tips with water on a no. 1 round.

Demonstration
PAINT A PEGASUS

Pegasus, a winged horse in ancient Greek mythology, sprang from the blood of Medusa and was fathered by Poseidon, god of the sea and horses. Where Pegasus's hooves struck the earth, magical fountains of inspiration burst forth. The springs on Mount Helicon became sacred to the Muses. Thus Pegasus became symbolic of art, music and poetry.

Pegasus is a creature of both earth and sky. When designing this magnificent steed, think about what characteristics should be pulled together in the horse and wings.

MATERIALS LIST

Surface — 7" × 10" (18cm × 25cm) illustration board

Brushes — ½-inch (12mm) flats, nos. 0, 1, 2, 4 rounds

Watercolors — Alizarin Crimson, Burnt Sienna, Burnt Umber, Cerulean Blue, Lemon Yellow, Naples Yellow, Payne's Grey, Raw Umber, Ultramarine Blue, Ultramarine Violet, Viridian Green

Other — rubbing alcohol

1

1 Sketch the Piece and Apply the Background Wash

Sketch the elegant and sleek form of Pegasus based on an Arabian horse. The features meld well with the delicacy implied in a creature of the air. Give him an active pose—the flow of the mane and tail indicate movement.

The background for this piece is a wall relief with a stylized sun dotted by mosaic-like tiles. Use a ½-inch (12mm) flat and start with Raw Umber in the upper left corner. Mix that with a bit of Lemon Yellow for the middle areas. Move downward and diagonally, gradually blending into Ultramarine Violet on the lower right. Keep the sunburst carving lighter in color than the surrounding areas. You can dab at it with a paper towel if too much pigment settles in there. Switch to a no. 4 round to get into the tighter corners around Pegasus's body and wings.

2 Add Shadows on the Relief

Use a no. 2 round to glaze Raw Umber and Payne's Grey shadows around the relief and around the tiles and cracks.

3 Deepen the Colors

With a ½-inch (12mm) flat, glaze Ultramarine Violet in the corners.

4 Add Warmer Tones

Mix Alizarin Crimson + Ultramarine Violet and use a ½-inch (12mm) flat to glaze some warmer hues into the corners. Splatter with rubbing alcohol using a no. 2 round for added texture.

2

3

4

5 Add Shadows on the Walls

Mix Burnt Umber + Viridian Green. Glaze some darker shadows around the relief with a no. 1 round. Add some Ultramarine Violet to the mixture, and glaze in some shadows behind Pegasus with a no. 4 round. Blend the edges into the surrounding wall background with a bit of water.

6 Paint Cracks on the Walls

With a no. 0 round, paint the cracks on the walls with Payne's Grey.

7 Paint Shadows on Pegasus

Paint the shadows on Pegasus's body and wings with a no. 1 round using Ultramarine Violet. Use clean water to blend the edges out into the white of the paper.

8 Detail the Hooves and Face

With a no. 1 round, use a mixture of Burnt Umber + Payne's Grey to paint the details on the face and hooves.

9 Add Reflected Color and Light

Use a very diluted mixture of Raw Umber + a tiny bit of Cerulean Blue. Paint washes across the legs in the back and in the core shadows of the main body with a no. 4 round. Leave the white paper showing through at the edges. Use a very diluted wash of Naples Yellow and a no. 2 round to create shadows on the wings, mane and tail.

Glaze Lemon Yellow on the outer surface of the wings. Be sure to leave the white highlights of the paper showing— overdoing the shadows and reflected color highlights will turn this white Pegasus multihued. Keep the glazed colors very diluted. You can always add more washes, but working back up to white is very difficult.

10 Deepen the Shadows

Mix Ultramarine Blue + Burnt Umber and paint more detailed deep shadows on the mane, tail and underside of the wing with a no. 0 round. Paint some feathery tendril shadows along the underside of the wing near the body, pulling down and away from the feathers and blending out with water.

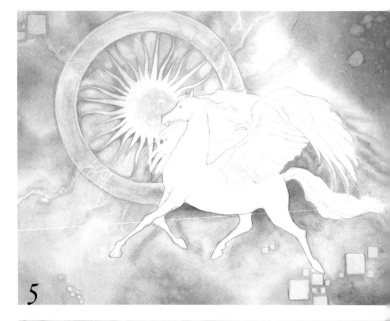

5

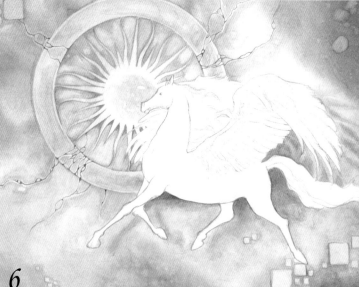

6

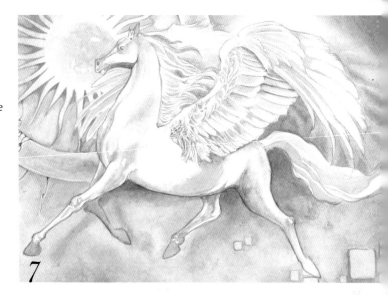

7

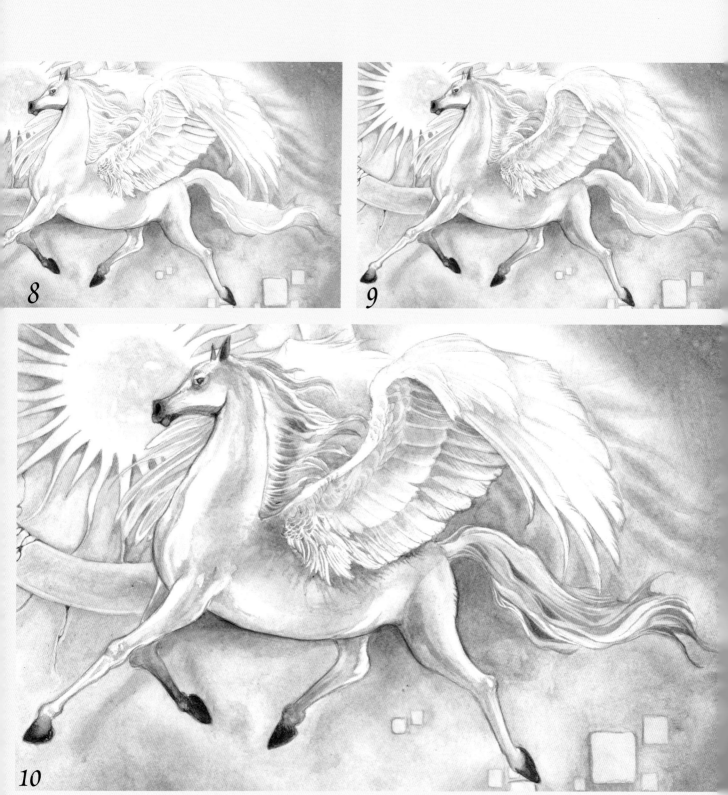

8

9

10

153

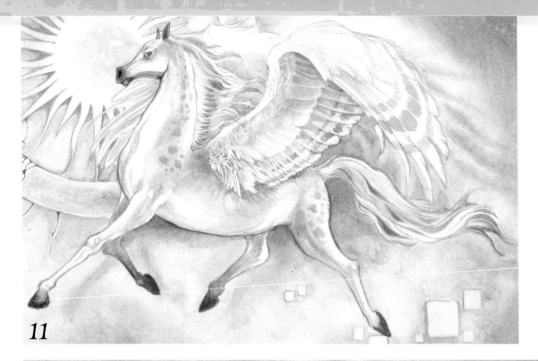

11

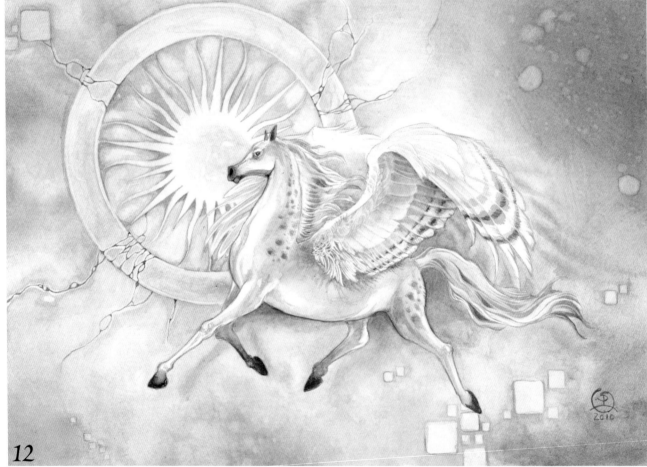

12

11 *Paint Patterns on the Feathers*
Use a no. 0 round to paint Burnt Sienna bars on the wing feathers. Dot some patterns along the neck and legs. Paint with short parallel strokes in the direction of the hair.

12 *Darken the Feather Pattern to Finish*
Use a no. 1 round and Payne's Grey to add a second, darker band pattern on top of the previous layer.

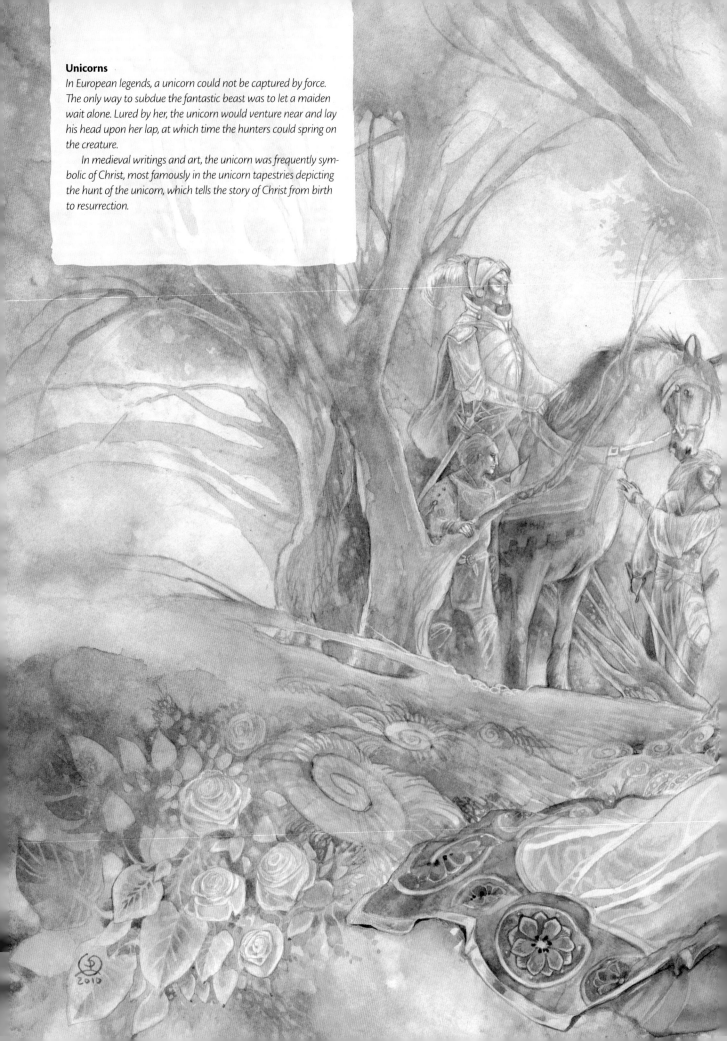

Unicorns

In European legends, a unicorn could not be captured by force. The only way to subdue the fantastic beast was to let a maiden wait alone. Lured by her, the unicorn would venture near and lay his head upon her lap, at which time the hunters could spring on the creature.

In medieval writings and art, the unicorn was frequently symbolic of Christ, most famously in the unicorn tapestries depicting the hunt of the unicorn, which tells the story of Christ from birth to resurrection.

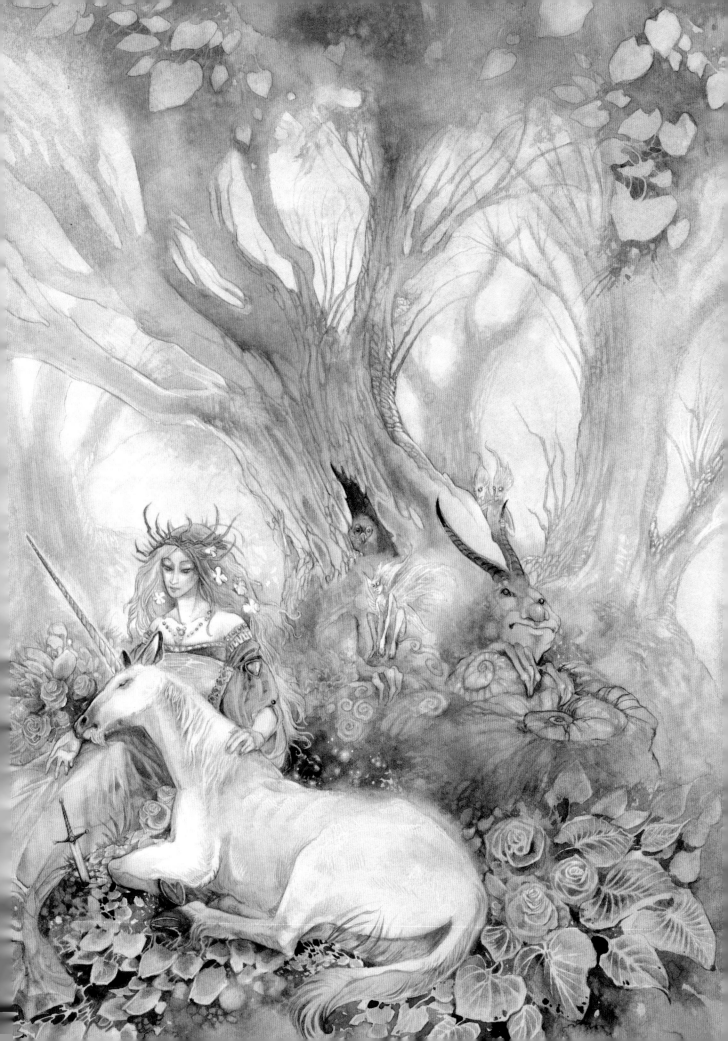

Earth Dragons

EARTH DRAGONS LURK IN LOAMY GREEN
woods, hidden dark caverns, beneath the ley-lines
of the world and the spines of hills and mountains.
Elemental beasts of scale and claw and horn, they
are reptilian but fantastical and majestic beyond
any mundane creature.

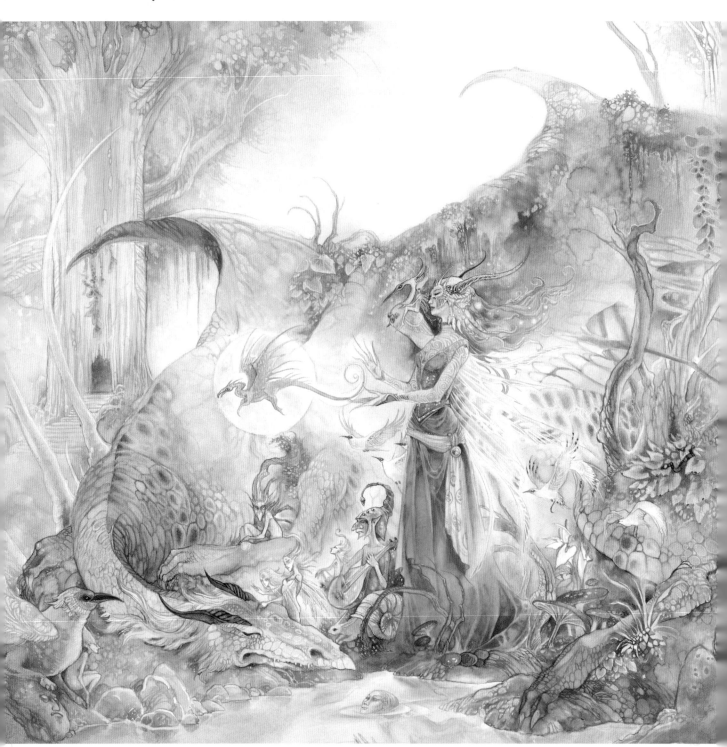

Mammalian Dragon Characteristics

Mammalian dragons possess muzzles and pointed ears similar to horses and deer. Tufted fur around the jowls fringes the face, and magnificent antlers adorn the head. Long manes flow around the face, down the crest and along the spine.

Reptilian Dragon Characteristics

Reptilian dragons have sharp exoskeletons with ridges, plated scales and leathery webbing along their protective spines. Their snouts are hard and pointed, like a bird's bill.

Dragon Bodies

*Dragons are usually depicted with four legs. This makes winged dragons truly a fantasy creation because, technically, with the wings they become six-limbed creatures. You can design a dragon without forelegs, with only hind legs and wings like a bird. This form is usually called a **wyvern** or a **wyrm**, and many medieval dragon depictions took this form.*

Dragon Body Types

Many varieties of dragons exist Here are a few body types to play around with.

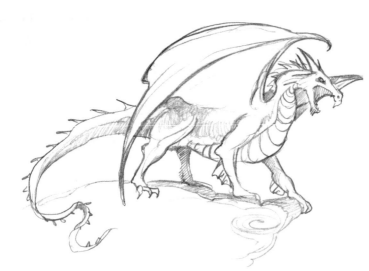

Airy

Lithe and slender, these creatures have delicate, elongated serpentine bodies with comparatively small heads. They are graceful spirits of land and air.

Earthy Power

Aggression, strength and coiled power are implicit in the stout muscled forms of these dragons. This is the type of fearful beast a knight is most likely to slay.

Impish

Wiry-bodied dragons have wiry limbs , short necks and large heads. They are impish, gremlin-like creatures of stone, fire and earth.

Slumbering Ancients

Round-bodied dragons have small or only vestigial wings, for these ancients haven't flown for centuries.

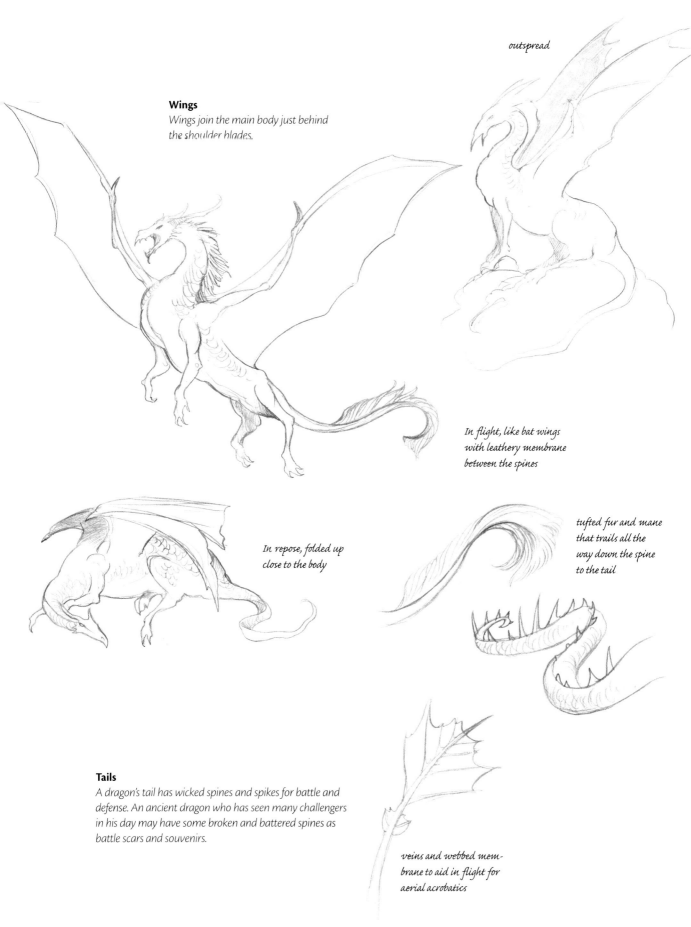

Wings

Wings join the main body just behind the shoulder blades.

outspread

In flight, like bat wings with leathery membrane between the spines

In repose, folded up close to the body

tufted fur and mane that trails all the way down the spine to the tail

Tails

A dragon's tail has wicked spines and spikes for battle and defense. An ancient dragon who has seen many challengers in his day may have some broken and battered spines as battle scars and souvenirs.

veins and webbed membrane to aid in flight for aerial acrobatics

Demonstration
PAINT AN EARTH DRAGON

Old as the land itself, the dragon lies in wait. The trees grow around him as he slumbers through the centuries. He will not waken until an upstart knight disturbs him.

The craggy hills and mountains have silhouetted peaks that echo the plated spines along the dragon's back. The similarities of the dragon to his environs remind us that his very nature is tied to the world and the ancient earth.

MATERIALS LIST

Surface — 8" × 10" (20cm × 25cm) illustration board

Brushes — ½-inch (12mm) flat, nos. 0, 1, 2, 4 rounds

Watercolors — Alizarin Crimson, Burnt Umber, Cadmium Orange, Cadmium Yellow, Naples Yellow, Payne's Grey, Prussian Blue, Raw Umber, Sap Green, Ultramarine Violet, Viridian Green

Other — salt

1 Sketch the Piece and Paint the Upper Skies
Once you have sketched your piece, use a ½-inch (12mm) flat to paint the upper portion of the paper with Ultramarine Violet. Blend out and downward with clean water around the sun. Don't worry about painting over the distant mountain peaks.

2 Add Depth to the Sky and Paint the Green Hills and Ground
With a ½-inch (12mm) flat, add some Raw Umber through the middle of the page. Blend upward and downward with water.

With a no. 4 round, glaze a mixture of Sap Green + Raw Umber on the hills. Bring the color in close to the dragon, but try to paint around him. Then paint a mixture of Viridian Green + Burnt Umber into the foreground below the dragon.

While the paint is wet, sprinkle both areas with salt. Brush the salt away after the paint has dried.

3 Paint the Sun
Using a no. 4 round, blend Naples Yellow outward from the edge of the sun. In the center of the sun, blend Cadmium Yellow outward toward the perimeter.

4 Paint the Distant Hills
Use a combination of nos. 0, 1 and 2 rounds to dab Ultramarine Violet wet-on-wet onto the distant hills. Blend the edges with water and while it is still wet, trail in textures with a mixture of Raw Umber + Sap Green, letting the lines bleed.

Blend more Ultramarine Violet into the background around some of the slopes to contrast the highlighted edges. Soften the outer edges by brushing the dry mountains with a slightly damp brush. Leave highlights of previous layers showing through.

2

3

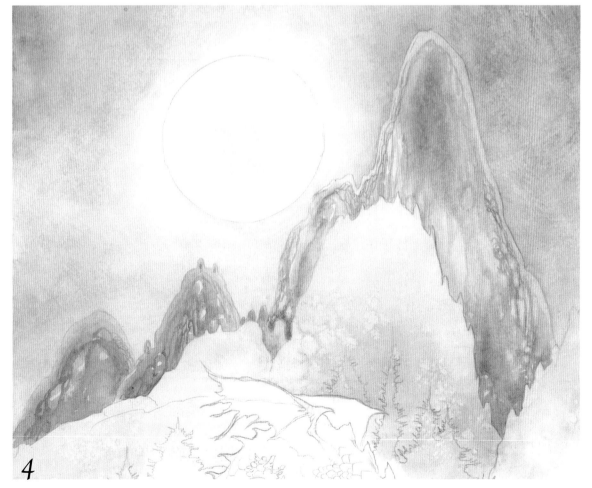

4

5 Glaze the Lower Hills
With a no. 2 round, use various mixtures of Sap Green, Raw Umber and Viridian Green to glaze the lower hills. While the paint is still wet, sprinkle with salt. Brush the salt away when the paint has dried.

6 Add Details to the Lower Hills
Working with the salt speckling, create additional texturing on the closer hills with varying mixtures of Viridian Green, Payne's Grey and Sap Green using nos. 0 and 1 rounds. Use the same techniques for the distant hills.

7 Paint the Pine Trees
With a no. 1 round, use a mixture of Payne's Grey + Viridian Green + a little Prussian Blue to paint the pine trees behind the dragon. Use short, dotted overlapping strokes. Leave bits of lighter green from previous layers showing through for highlights. Blend and soften the trailing branches of the pine trees with water. Use this same mixture of colors to add more depth to the foreground beneath the dragon.

8 Lay in the Dragon Base Colors
With a no. 2 round, paint wet-on-wet with Sap Green along the dragon's spine and head. Use Viridian Green for the rest of the body. Allow the plates along the spine white. Blend the Viridian Green out into a glaze over the foreground. The overlap helps ground and integrate the dragon.

9 Begin the Scales
Using nos. 0 and 1 rounds, paint a glaze of Viridian Green on the inner overlapping edges of the scales. Leave the outer edges of each scale to show the previous lighter layers.

10 Blend the Scales
With a no. 2 round, take some very diluted Viridian Green and blend the scales by brushing over them lightly. A brush with stiffer bristles will blend the edges more easily, but be careful not to overdo it, or you'll lose texture on the scales.

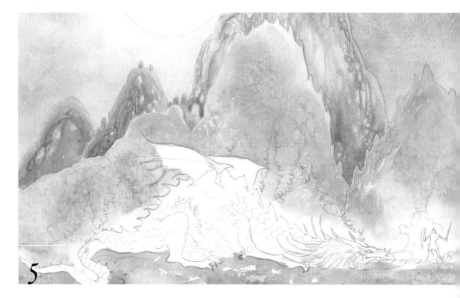

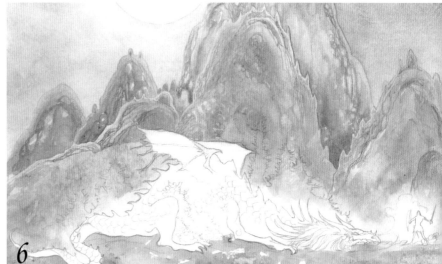

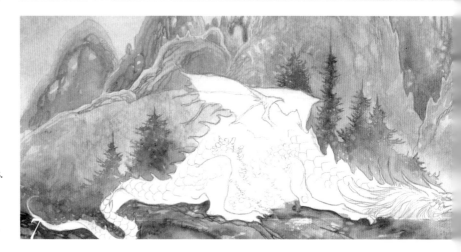

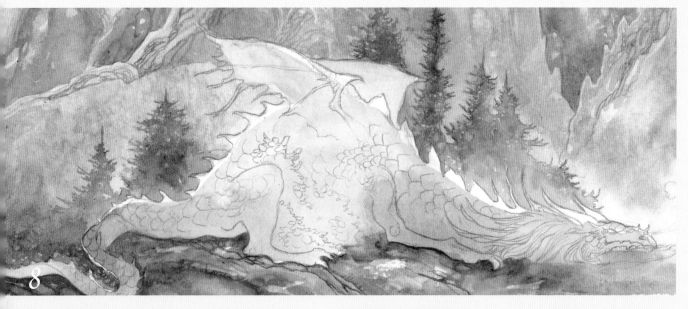

8

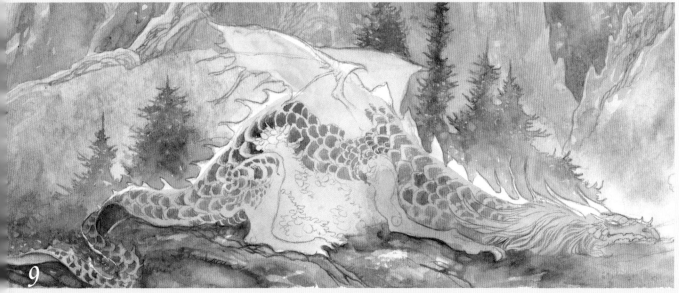

9

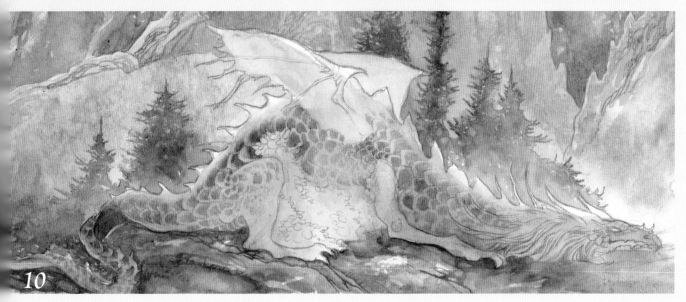

10

11 Define the Scales

With a mixture of Prussian Blue + Alizarin Crimson, use a no. 0 round to go back and add more shadows to the scales (especially along the inner overlapping edges of the scales where the previous step may have blurred the lines too much). Also use this mixture to add definition to the face and details of scales on the legs.

12 Add More Shadows and Foliage

Using a mixture of Payne's Grey + Viridian Green and a no. 0 round, paint the foliage that grows up around the dragon. While the paint is still wet, sprinkle with salt. Brush the salt away after the paint has dried.

Add more of this mixture of colors to the distant trees to contrast the dragon's spines. Also use it to paint the horns and dot some shadows along the spine plates.

Emphasize the eye and corner of the mouth with concentrated Payne's Grey using a no. 0 round.

Add shading on the near wing with Raw Umber, and blend with water. For the far wing, add shadows with a mixture of Payne's Grey + Viridian Green.

13 Add Warmer Sun Highlights

With a no. 0 round, use a mixture of Cadmium Orange + Cadmium Yellow to add just a tinge of golden warm light along the upper edges of the dragon's body. This is a hint of the sun's glow shining along the dragon's back. Blend with a bit of clean water. Dot Cadmium Orange in the eye.

14 Paint the Knight

With a no. 0 round, use varying diluted mixtures of Ultramarine Violet + Cadmium Orange to glaze the ashy smoke puffing out toward the knight.

Use a less diluted version of the same mixture to paint in hints of definition on the knight. Make sure you leave white highlights. Hint at shadows and defined edges more than explicit outlines.

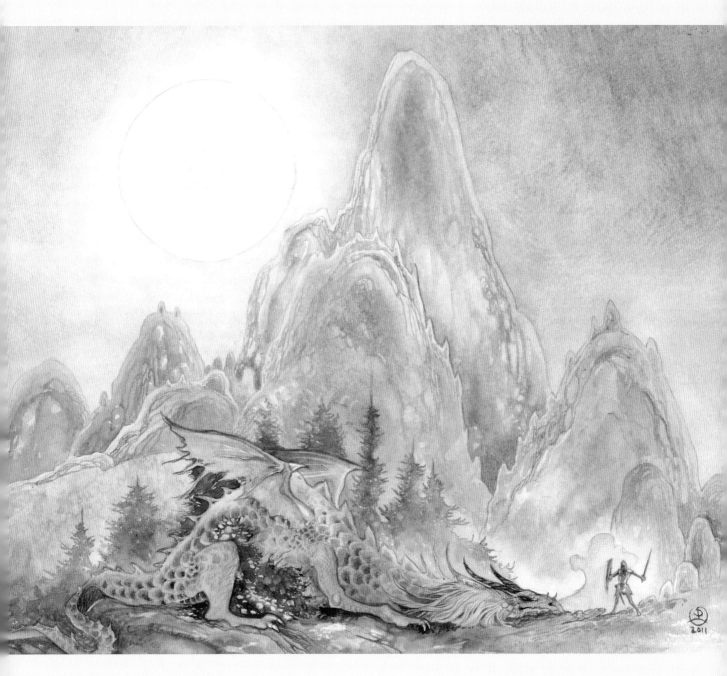

15 Add Shadows to the Knight to Finish

With a mixture of Viridian Green + Payne's Grey, use a no. 0 round to paint some darker shadows on the knight. Keep it vague, as he is so distant and small. Hinting at the shapes is much more effective than overdoing it.

Epic Struggle

Dragons are emblematic of primordial chaos and creatures of raw power that came into existence in the early throes of the world's creation. Molded from the undifferentiated morality of chaos, these elder beings became symbolic of the devil in many Christian societies.

The unicorn was frequently symbolic of Christ in medieval times. Seen in this light, the epic enmity between a unicorn and a dragon (light and dark, good and evil) gains another layer of significance.

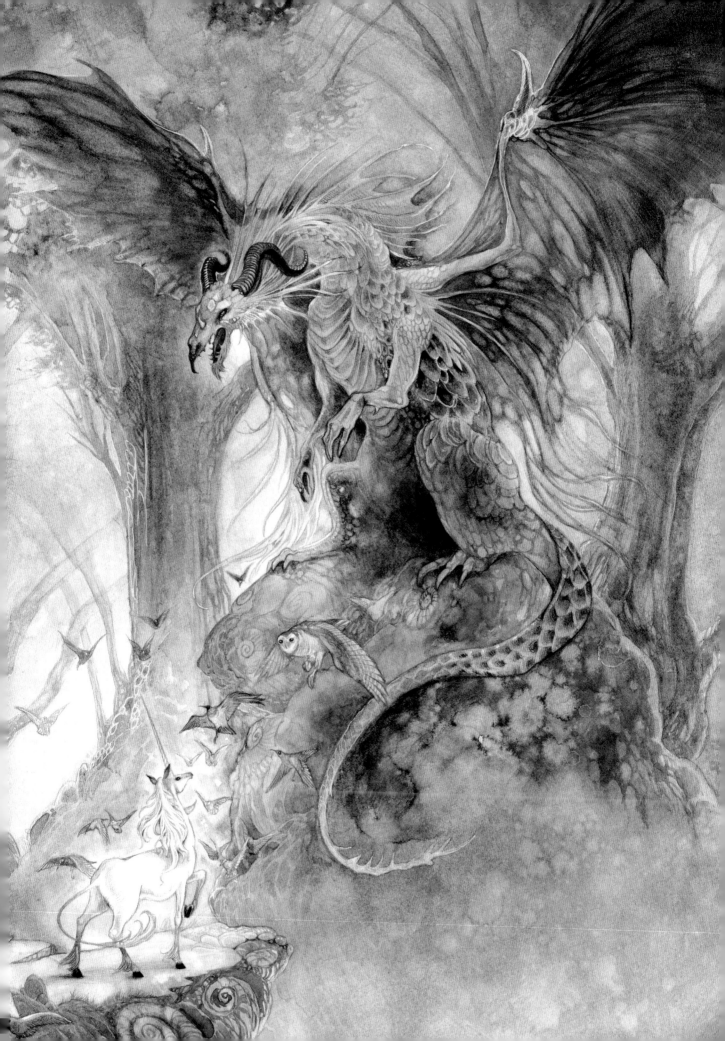

*I*ndex

About the Author

Stephanie Pui-Mun law has been painting fantastic other-worlds since early childhood, though her art career did not begin until 1998 when she graduated from a Computer Science program. After three years of programming for a software company by day and rushing home to paint into the midnight hours, she left the world of typed logic and numbers for the painted worlds of dreams and the fae.

Her illustrations have been used for various game and publishing clients, including Wizards of the Coast, HarperCollins, LUNA Books, Tachyon Books, White Wolf, Green Ronin and Alderac Entertainment. She has authored and illustrated *Dreamscapes* and *Dreamscapes Myth & Magic* (published by IMPACT Books in 2008 and 2010), books on watercolor and technique for fantasy. Stephanie is also the creator of the Shadowscapes Tarot deck (Llewellyn Publishing).

In addition to her commissioned projects, she has spent a great deal of time working up a personal body of work whose inspiration stems from mythology, legend and folklore. She has also been greatly influenced by the art of the Impressionists, Pre-Raphaelites, Surrealists and the master hand of Nature. Swirling echoes of sinuous oak branches, watermarked leaf stains and the endless palette of the skies are her signature.

Her background as a flamenco dancer for over a decade is evident in the movement and composition of her paintings. Every aspect of her paintings moves in a choreographed flow, and the dancers are not only those with human limbs. What Stephanie tries to convey with her art is not simply fantasy, but the fantastic, a sense of wonder, that which is sacred.

While most of Stephanie's work is done with watercolors, she also experiments with pen and ink, intaglio printing, acrylic and digital painting.

Visit her website at shadowscapes.com.

Other fine IMPACT Books are available from your favorite bookstore, art supply store or online supplier. Visit our website at fwmedia.com.

16 15 14 13 12 5 4 3 2 1

DISTRIBUTED IN CANADA BY FRASER DIRECT
100 Armstrong Avenue
Georgetown, ON, Canada L7G 5S4
Tel: (905) 877-4411

DISTRIBUTED IN THE U.K. AND EUROPE
BY F&W MEDIA INTERNATIONAL LTD
Brunel House, Forde Close, Newton Abbot, TQ12 4PU, UK
Tel: (+44) 1626 323200, Fax: (+44) 1626 323319
Email: enquiries@fwmedia.com

DISTRIBUTED IN AUSTRALIA BY CAPRICORN LINK
P.O. Box 704, S. Windsor NSW, 2756 Australia
Tel: (02) 4577-3555

Edited by Christina Richards
Cover design by Guy Kelly
Production coordinated by Mark Griffin

Metric Conversion Chart		
To convert	*to*	*multiply by*
Inches	Centimeters	2.54
Centimeters	Inches	0.4
Feet	Centimeters	30.5
Centimeters	Feet	0.03
Yards	Meters	0.9
Meters	Yards	1.1

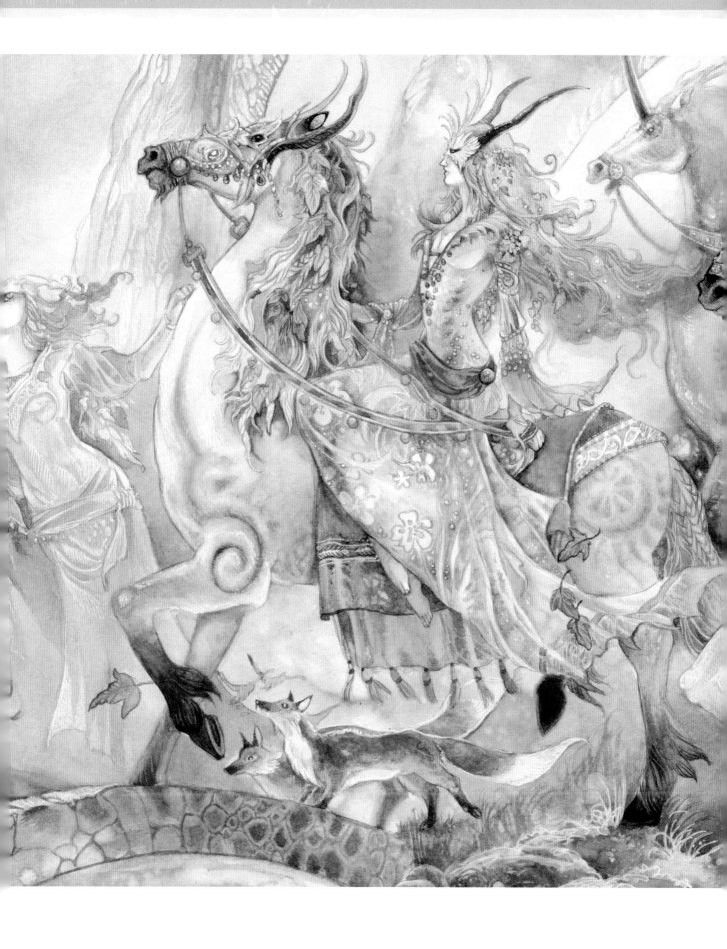